POSITIVE PLEASURES

EARLY PHOTOGRAPHY AND HUMOR

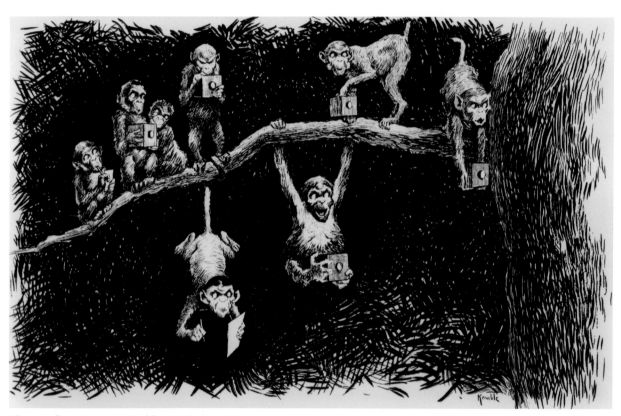

Photo-safari. *Harper's Weekly*, 1909.

HEINZ K. HENISCH AND BRIDGET A. HENISCH

POSITIVE PLEASURES

EARLY PHOTOGRAPHY AND HUMOR

THE PENNSYLVANIA STATE UNIVERSITY PRESS
UNIVERSITY PARK, PENNSYLVANIA

Library of Congress Cataloging-in-Publication Data

Henisch, Heinz K.
　　Positive pleasures : early photography and humor / Heinz K.
　Henisch and Bridget A. Henisch.

　　　　p.　　cm.
　　Includes bibliographical references and index.
　　ISBN 0-271-01671-X (alk. paper)
　　1. Photography, Humorous—History.　I. Henisch, Bridget Ann.
　II. Title.
　TR679.5.H46　1998
　770′.2′07—dc21　　　　　　　　　　　　　　　　97-18490
　　　　　　　　　　　　　　　　　　　　　　　　　　CIP

It is the policy of The Pennsylvania State University Press to use acid-free paper for the first printing of all clothbound books. Publications on uncoated stock satisfy the minimum requirements of American National Standard for Information Sciences—Permanence of Paper for Printed Library Materials, ANSI Z39.48–1992.

To
H. and H.

CONTENTS

PREFACE AND ACKNOWLEDGMENTS

Nothing quenches mirth more effectively than the announcement that a joke is on its way; needless to say, no danger of that kind is threatened by the authors of this book. There is, after all, a very real sense in which humor is no laughing matter. People tend to be serious about subjects that concern them deeply and, for that very reason, there is a need to look at such matters in perspective, including light-hearted perspective. There is an enormous difference between the "joke" that is meant to cause a guffaw, and the "wry comment" that is intended to make us smile and, above all, to make us think. The didactic intent of photographic humor may lie somewhere below the surface, but it is always there, and a mining of its many seams amounts to a mining of critical and popular responses to photography, at times expressed more convincingly in that way than in the heavyweight literature of the subject. Humor is here considered in earnest. By this we do not mean that we have strenuously tried to make it unfunny, but that tribute has been paid to laughter as a social phenomenon. When a joke succeeds as "entertain-ment," it does so just because it is in tune with the tastes and temper of its own age. In this mirror it is possible to find a clear reflection of contemporary hopes and fears.

High technology and its impact on society have always been grist for the cartoonist's mill. It was so when the railways came, and has remained so ever since. The car, the aeroplane, radio, television, rocketry, and now humanity's best friend, the computer, have taken it in turns to serve as the butt of popular jokes. To some extent, the mirth is a common defense used as a mask for embarrassment in the face of perplexing problems.

Photography's effect on life was not only profound but intimate. As a subject for the attention of humorists it has proved inexhaustible. This has no doubt been helped by the fact that the outward appearance of photographic paraphernalia has changed over the years, providing each generation of cartoonists with new challenges. And yet, photographers have never been content to be merely the object of other people's merriment; they have been humorists in their own

right, sometimes in the field as interpreters of reality, sometimes as graphic artists in the darkroom, and sometimes in their capacity as self-appointed stage directors, in charge of photo-sitcom productions. There is room for the photographic joke, to be sure, but also for that humbler species, so aptly named "photo-drollery." Nor, indeed, is all the humor pictorial; it can be found in the realm of the technical manual, the literary essay, and even that of poetry or, at any rate, of rhyme (Chapter 8). Allowance must also be made for the fact that humor may be intentional or unintentional, without any certainty as to whether the photographer, the client, or the detached observer has the last laugh.

In this study, the authors have attempted to provide a panorama of photographic humor in its varied aspects, pictorial and literary. There are no pretensions to completeness, partly because the field is vast, and partly because "humor" is a notoriously open-ended concept. The survey covers the early stage of photography to 1888, when Kodak came upon the scene, and continues into the 1920s when, increasingly, the popularization of miniature cameras once again changed the photographic landscape. By then, photography had lost its pioneering innocence; it had ceased to be "early." Even so, traces of early "photographic language" can still be found in our own time as, for instance, on the menu of a country restaurant in Central Pennsylvania that proudly offers "Steaks grilled to your likeness." Humor, nostalgia, and innocent illiteracy could fight for the honors in this case, with the last as all-time champion.

The material here used has been taken from public sources, from the authors' own collection, and from generous lenders, acknowledged below and *in situ*. Throughout, *Die Fotografie in der Karikatur* by Rolf H. Krauss (Heering Verlag, 1978), the first book of its kind in any language, has been a guide and inspiration, as has Uwe Scheid's *Als Photographieren noch ein Abenteuer war* (Harenberg Verlag, 1983). In the English-language world, Bill Jay's *Cyanide and Spirits* and *Some Rollicking Bull* (Nazraeli Press, 1991 and 1994) have brought many long-hidden treasures to the surface, and have presented them with charm to new readers.

We owe a great debt to Michel Braive of Paris, and to the late Rudolf Skopec of Prague, whose work first opened our eyes to the myriad ways in which society's response to photography is mirrored in the jokes and ephemera of the passing hour. These authors showed us in most delightful ways how one can learn from jokes as well as laugh at them. Special tributes are due as well to Gillian Greenhill-Hannum and the late Leslie Greenhill, who helped long ago to mine the photographic riches of *Punch,* and to Kathleen Collins and Thomas M. Weprich, whose prospecting skills led to golden nuggets in the American photographic literature.

Van Deren Coke, John and Carol Wood, Jay and Janis Ruby, and George and Marianne Mauner have introduced us to good jokes, stoically endured bad ones, and given their staunch support over the years. We would also like to thank many other friends for their discoveries and their forbearance: William B. and Fran Becker, Bonny Farmer, Ron and Sandra Filippelli, the late Tim Gidal, George Gilbert, Michael Hallett, Mark Haworth-Booth, Estelle Jussim, Elizabeth Linquist-Cock, Charles Mann, Nolene Martin, Jinny Moe, Peter E. Palmquist, Linda Riess, Bill Rodgers, Ernst Schürer, Susan Scott, Graham Smith, Wolfgang Sommergruber, S. F. Spira, Stanley and Rodelle Weintraub, Philip and Marion Winsor, and Vicky Ziegler.

The staff of the Rare Books Room and of the Interlibrary Loan Service at the Pennsylvania State University's Pattee Library have been helpful at every turn, as has the University Photographic Service.

1

THE CAMERA AND THE COMIC MUSE

When photography first came upon the scene in 1839, with all its inherently startling possibilities, it was inevitable that it should serve as a butt for caricaturists. Their long-established art had always focused on new fashions and scientific marvels as its targets, including various optical shows and entertainments that enjoyed wide popularity in pre-photographic days, such as the Eidophusikon, the Magic Lantern, and the Panorama; see Fig. 1-1 a and b; Altick (1978); and Humphries (1989). In one sense, photography was merely "another of those new-fangled things," fated to perplex the modern world, but the extent to which it penetrated the

social, political, literary, commercial, and artistic realms gave it an immense and general influence, of a kind to which the Eidophusikon could never aspire. As one invention chased another, the public reeled under the impact of novelty, but it also saw a certain continuity, so aptly expressed in Fig. 1-1c, which relates photography to its older cousin-once-removed, lithography.

The first cartoon on a photographic theme was also arguably the most perceptive. The well-known December 1839 Parisian broadside by Théodore Maurisset, called *Fantaisies: La Daguerréotypomanie*, was addressed not to some photographic malpractice, but to photography

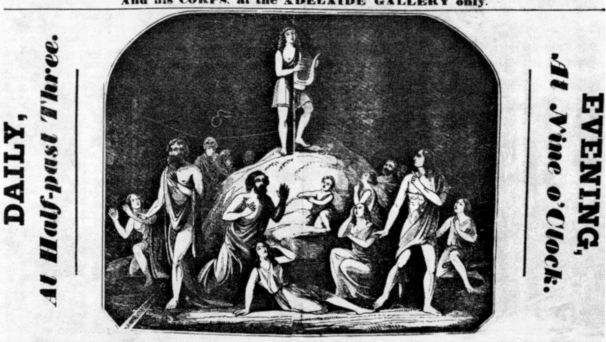

(a)

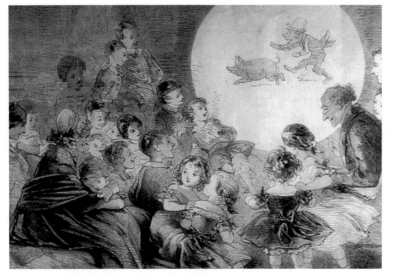

(b)

FIG. 1-1 (a)–(c). Tributes to pre-photographic entertainments and to photography's roots in lithography.

(a) Grands Tableaux Vivants at the Royal Adelaide Gallery, London, 1846. Professor Keller, from Berlin, was the impresario and stage director. Problems arose, and explanations were offered, to the effect that the performers were *not* nude, but wore dresses "fitting the person nearly as closely as the skin itself." Anon. (1846) and Altick (1978).

(b) "The Magic Lantern," a drawing by Phiz, from *The London Illustrated Times* of December 1858. Humphries (1989).

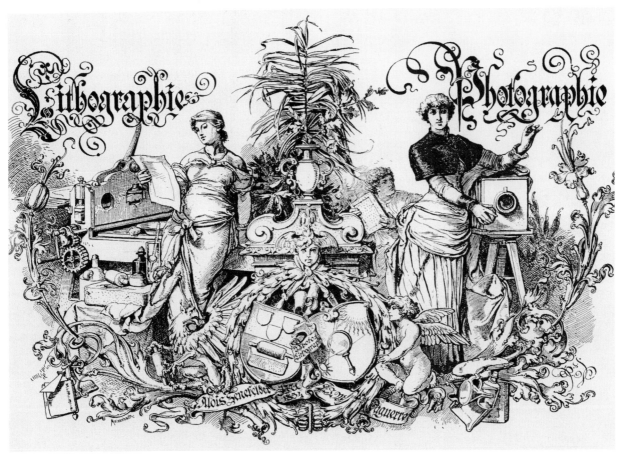

FIG. 1-1. (c) "Lithography and Photography"; continuity and change. German emblem of 1882, immortalizing the inventors of the two processes, respectively Alois Senefelder and Louis M. Daguerre. Gerlach (1882).

as such, and what distinguished it from later works was its prophetic character. In particular, the cartoon foreshadows the demise of the draftsman and engraver, likely to be deprived of their livelihood by the dangerous new rival. Those worthies, among whom Maurisset counted himself, are invited to take advantage of the gallows, conveniently provided right of center-stage (Fig. 1-2). Indeed, the subject of painters made unemployed by the new art gave rise to a whole sub-genre of photo-cartoons over the years (see Krauss 1978). Often these contrast the fate of painters who "joined the photographic bandwagon" by becoming photograph-ers or, at least, photo-colorists (Henisch 1996), with that of the few who remained true to their art. The former prospered, the latter lived in penury. Thus, Krauss reproduces the paired scenes shown in Fig. 1-3 "from a [German] family newspaper of 1865." In (a), the painter lives the life of a lord, having metaphorically transformed himself into a camera; on the floor is a big pile of advance bookings. In (b) he is depressed, after two years without a commission. Fig. 1-4 likewise comes from an unidentified source (Coke 1995), presumably English or American, and evidently (but not explicitly) related to Fig. 1-3. Both "sad" painters have loaves

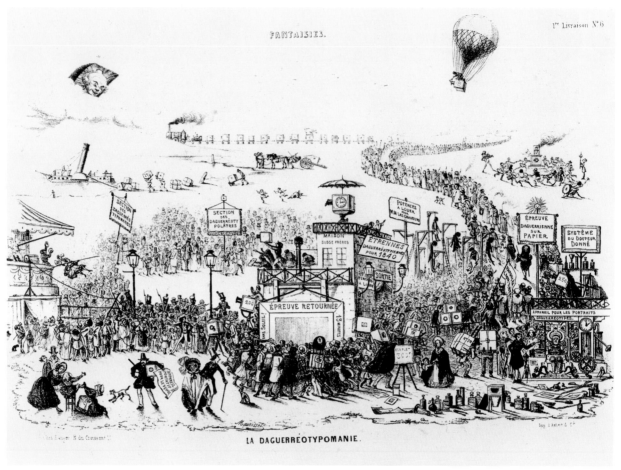

F<small>IG</small>. 1-2. La Daguerréotypomanie, earliest photo-cartoon, by Théodore Maurisset, December 1839. See Krauss (1978).

of bread by their side, hinting at a frugal diet; both dilapidated studios feature a top hat and an old boot. There are similar correspondences on the prosperous side, even though no metamorphosis of man into camera has taken place in Fig. 1-4. Both pictures feature champagne and grapes, as well as an unattended camera on a tripod. The furniture is similar and, above all, the sentiment is the same.

Maurisset's own drawing envisages even in those earliest of days the emergence of photojournalism, and of aerial photography, long before either occupation became technically feasible. It shows crowds enthralled by photography and, with an understanding of human nature, crowds already disenchanted by it; among many other prescient offerings, we have here also an example of an obstreperous child, the first of a long line, making life difficult for a strange and eager *homo photographicus*.

Though the genuine, classic daguerreotype is very much at the center of things, the cartoon mentions, at one place in its complex design, "épreuve Daguerrienne sur papier," as well as prints according to "Dr. Donné's system." Alfred Donné (1801–78) was already very active as a researcher in the optical arts at the time (Stenger 1938). In February of 1840, he was to

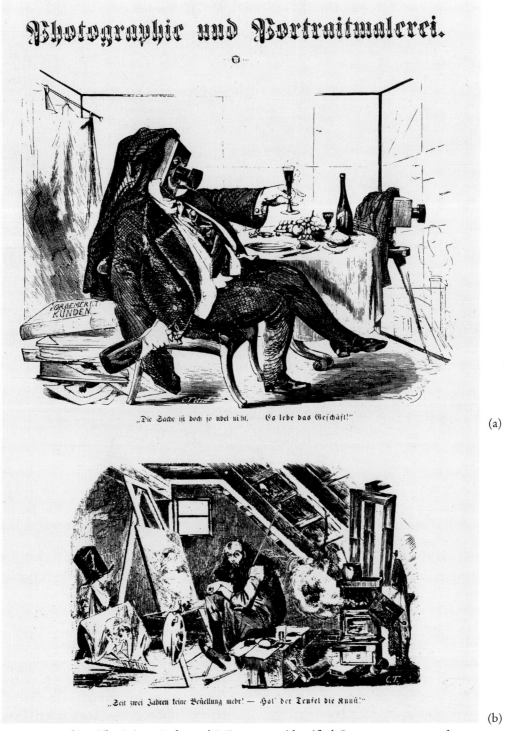

FIG. 1-3 (a)–(b). The Painter Reformed I. From an unidentified German newspaper of 1865. Krauss (1978).
(a) "The situation isn't so bad. Three cheers for business!"
(b) "No orders in the last two years—to the devil with Art!"

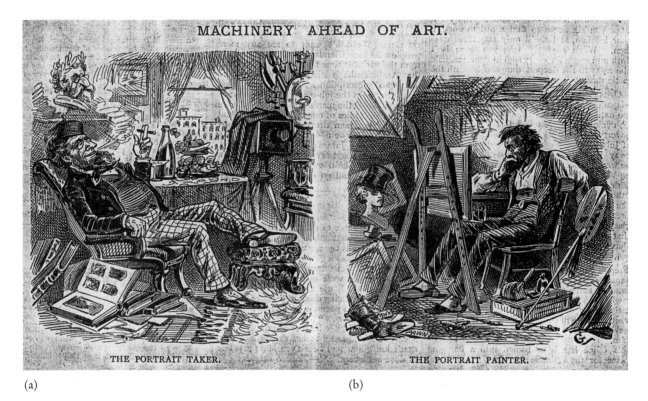

(a) (b)

FIG. 1-4 (a)–(b). The Painter Reformed II. From an unidentified 1860s source. Coke (1995).
 (a) The Portrait Taker.
 (b) The Portrait Painter.

submit to the Academy of Sciences a series of daguerreotypes taken through the solar microscope, in competition with his distinguished contemporary and principal rival, Benjamin Dancer of Manchester. Donné did, indeed, publish such pictures later, printed directly from deeply etched daguerreotypes and thus "on paper," but there is no suggestion that he invented any form of paper-based photography. See also Henisch 1994. The cartoon includes a mock advertisement for daguerreotype "plates made in 13 minutes [even] without sun."

The prescient significance of Maurisset's cartoon was recognized by Nadar's son Paul, who reproduced *Daguerréotypomanie* in his 1893 *Paris-Photographe* (p. 486), and by Eder, who gave it extensive coverage in 1905; see Eder (1945), Krauss (1978), and, for a very detailed and scholarly analysis of the work, Ewer (1995). Did Maurisset's cartoon depict a dream? Ewer asks. Maybe; if it did, the artist was blessed with total recall, a boon to his pre-Freudian analyst.

Nadar (Gaspard-Félix Tournachon) himself had almost certainly been inspired by the cartoon to undertake his own ballooning exploits from the late 1850s onward (Figs. 1-5 and 1-6), exploits that alerted the public to the varied uses of high-level observation. Nadar was, of course, a cartoonist in his own right, though ultimately not a highly successful one; see, however, Fig. 5-18. His interest in the art soon came to be displaced by photography itself. In 1866 he wrote: "I once practiced the métier of cartoonist . . . until the day when I felt I had no elbowroom,

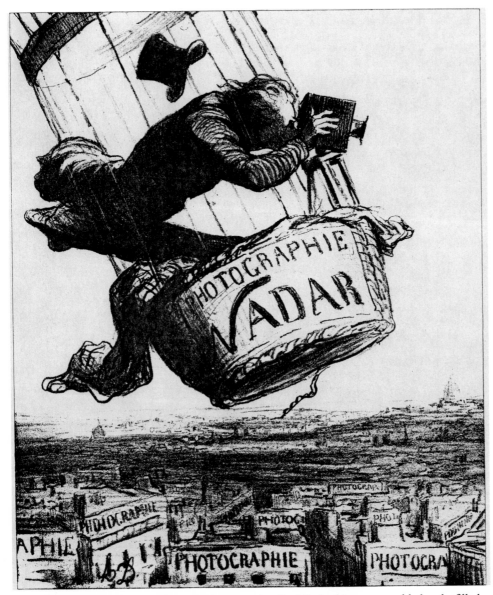

FIG. 1-5. "Nadar Elevates Photography to an Art," while looking at a world already filled with photographic advertising. Honoré Daumier's famous cartoon of May 1862, from *Le Boulevard*. "Art" here means "painting," all photography's pretensions notwithstanding.

and perseverance failed me . . ." (Nadar 1866). His best-known cartoons are not prophetic works in the style of Maurisset, but refer to photography's strained relationship with painting. Thus, Fig. 1-7a shows photography begging for even "the smallest place" in the 1857 Exposi-

tion des Beaux Arts, held in Paris. That place was denied (Fig. 1-7b), and it was not until 1859 that photography finally won admittance. Nadar did not predict this, but he did commemorate the triumph with another cartoon (Fig. 1-7c), which shows the camera and the palette about to

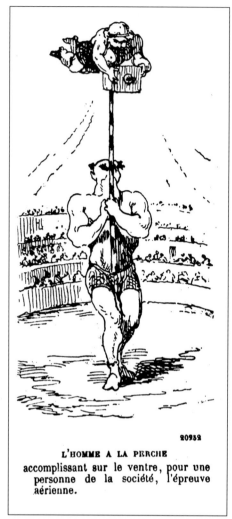

L'HOMME A LA PERCHE
accomplissant sur le ventre, pour une
personne de la société, l'épreuve
aérienne.

FIG. 1-6. "Man up the Pole on his Belly,
making an aerial photograph for an
important figure in Society," from the
Journal Amusant, No. 350, item 20252,
c. 1862. Courtesy of Van Deren Coke.

enter the exhibition arm-in-arm. Strained relations of a very different kind are touched upon in an earlier cartoon (Fig. 1-8), in which Nadar suggests that the courts might order the suppression of the daguerreotype, to prevent it from revealing embarrassing information about public figures. To be sure, Nadar meant it as a joke at the time, but though cameras as such are now

safe from judicial destruction, the fight over privacy and the public's right to know is still very much with us in our own day.

Maurisset's themes resonated as photography's role in society developed. Thus, at the top of Fig. 1-2, there is a whole train, consisting entirely of camera-carriages, and clearly intended to foreshadow the development of travel photography. There is also a riverboat laden with cameras, and a horse-drawn cart with photographic equipment. Early cameras were by no means light, and a great deal of supporting paraphernalia had to be carried with them. On August 30, 1839, the French satirical magazine *Charivari* ran an article on the joys of a camera trip into the countryside, with the perspiring photographer plodding along under the weight of the five boxes needed to carry the camera itself and all the essential equipment (Newhall 1971). By the year's end, some of this bulk had been reduced, and designs for travel cameras were beginning to appear. In Maurisset's cartoon (Fig. 1-2, foreground left), Baron Pierre-Armand Séguier can be seen setting off for foreign parts with his own invention tucked under one arm: the first daguerreotype bellows camera, which could be folded up and stored in a single box with the rest of the gear (Wade 1979). The size of that box, however, labeled in the cartoon "Appareil Portatif pour le Voyage," was enough to give second thoughts to all but the stoutest hearts a mile or so out from home base.

In the cartoon there are also chemicals galore (bottom right), though no one seems to be having any fun with them. Even a retail establishment is foreseen, specializing in studio equipment like head-clamps and leg-holds, modeled on medieval stocks, designed to keep the client motionless and the studio operator happy. Maurisset addresses himself, as the placards announce, alternatively to Daguerréo-typomanes and Daguerréo-typolâtres, that is to say, to daguerreomaniacs on the one hand, and daguerreo-enthusiasts on the other. He knew the difference.

(a)

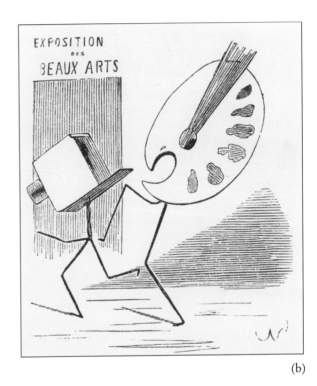

(b)

(c)

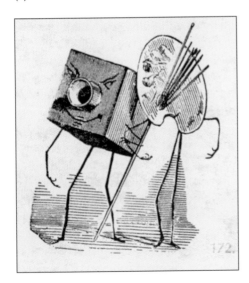

FIG. 1-7 (a)–(c). Photography and painting. Cartoons by Nadar, *Journal Amusant,* 1857 and 1859. Courtesy of Van Deren Coke.

(a) "Photography begging for just a little place in the Exhibition of Fine Arts," 1857.

(b) "The Ingratitude of Painting, Refusing [even] the Smallest Place in its Exhibition to Photography, to which it Owes so Much," 1857.

(c) Success at Last, 1859.

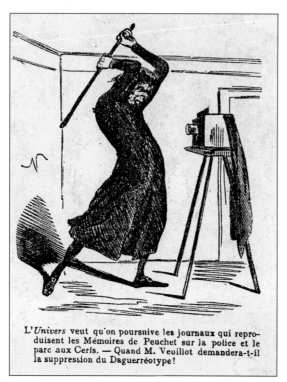

L'*Univers* veut qu'on poursuive les journaux qui repro-
duisent les Mémoires de Peuchet sur la police et le
parc aux Cerfs. — Quand M. Veuillot demandera-t-il
la suppression du Daguerréotype!

FIG. 1-8. Nadar's cartoon of 1851, from the *Journal
pour Rire,* hinting (but, of course, in jest), that
newspapers might be prosecuted, and the daguerreotype
camera suppressed, for publishing embarrassing
revelations about the police by Monsieur Peuchet. The
energetic avenger here shown is presumably the
Monsieur Veuillot referred to in the caption.

A later cartoon in the *Journal Amusant* re-
turned to the theme of displaced painters, and
while it did not send them to the gallows, it did
contemplate various new roles that the stars of
the current art-world might yet come to occupy;
see Fig. 1-9. Cartoonists often presented as
amusing fancies scenes which were far closer to
contemporary fact than they and most other
people realized. In 1865, for instance, the Count
Amédée de Noé of Paris, under the nom-de-
plume "Cham," published a brochure, *Nou-
veaux Habits! Nouveaux Galons!,* with a series
of cartoons in which he envisaged that units of
the French army might be formed for specifi-

cally photographic tasks, with Nadar as inspec-
tor-general (Fig. 1-10). Little did he realize that,
across the Channel, the British army had already
taken steps, ten years earlier, to establish a
photographic branch. Military photography did,
indeed, come to be an important, if artistically
dismal, application of the new art, and it led to
at least one constructive suggestion, likewise in
the *Journal Amusant* (No. 350), namely that
though war could not be abolished (since "peo-
ple are by nature bellicose") all conflicts in the
"Age of Collodium" should be settled by
photographic competitions, and transacted not
with cannons but with giant cameras. The world,
alas, did not listen.

Fig. 1-3 represents one kind of photo-humor,
in which the goal is to ridicule attitudes, but
there are other, very different and much less
conscious, modes, amusing not by direct intent,
but incidentally, as a wry marginal comment.
Both parts of Fig. 1-11 qualify under that head-
ing. The engraving shown in Fig. 1-11a was
made from a photograph which has, indeed, sur-
vived (Xanthakis 1988). It was made by a Greek
photographer in Athens during a visit by the
Prince of Wales in October 1875, and shows also
Queen Olga and King George I of Greece. The
engraver (whose services were needed because
photographs as such could not yet be photo-
mechanically reproduced at the time) assumed,
intentionally or otherwise, the role of a cartoon-
ist when he enlarged the scene and added a
photographer, complete with his camera, in an
odd perspective. No specific point is driven
home, but the stilted, artificial atmosphere of the
studio is very well conveyed. We do not know
whether the picture made the readers of the *Il-
lustrated London News* smile at the time, but
somehow, and though there is nothing here spe-
cifically designed to ridicule anyone or anything,
the stiffness and mock-formality of the scene
cannot fail to amuse the twentieth-century
viewer. Fig. 1-11b comes from about the same
time, but from France, and testifies to the fact
that a wedding photograph was truly a family
affair; nobody, but nobody, could be consigned

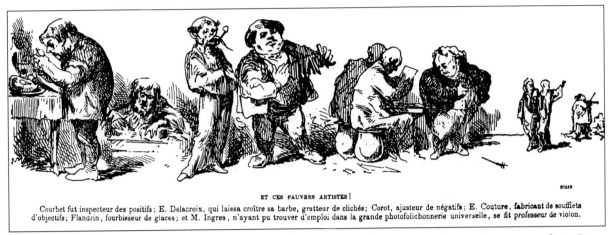

ET CES PAUVRES ARTISTES !

Courbet fut inspecteur des positifs ; E. Delacroix, qui laissa croître sa barbe, gratteur de clichés ; Corot, ajusteur de négatifs ; E. Couture, fabricant de soufflets d'objectifs ; Flandrin, fourbisseur de glaces ; et M. Ingres, n'ayant pu trouver d'emploi dans la grande photofolichonnerie universelle, se fit professeur de violon.

FIG. 1-9. "And These Poor Artists!" From the *Journal Amusant,* No. 350, item 20259, c. 1861. Courtesy of Van Deren Coke.

The destiny of great masters under the impact of photography: Courbet becomes an inspector of positives; Delacroix (who has grown a beard) a polisher of plates; Corot a retoucher of negatives; Couture a maker of bellows and objectives; Flandrin a cleaner of glass plates; and Ingres, who could not find employment in the photography game, a professor of the violin.

to the waitingroom, in all likelihood much to the photographer's chagrin.

Studio interiors were the subject of cartoonists' attentions in many other contexts. Fig. 1-12 is an example, made by Johann Baptist Isenring, a Swiss painter and one of the very first successful portrait daguerreotypists; see Henisch (1994), chap. 2; and Henisch (1996). The woodcut was not explicitly made for entertainment, but as a genuine advertisement for the artist's temporary studio in Stuttgart, Germany. And yet, there is a humorous dimension. In front of the client seated on the left, there is not just a single camera but a whole stack of cameras, the suggestion being that Isenring was able to take several (quasi-) simultaneous pictures (see also Hesse 1989). Whether Isenring actually did this is not recorded, nor is there any reference to the problem of opening several shutters at even roughly the same time. Other clients, behind the photographer, are awaiting their turn, and at the front right there are some obligatory emblematic references to traditional art. The printed text ex-

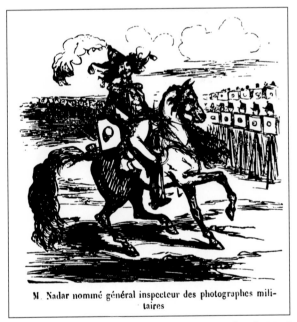

M. Nadar nommé général inspecteur des photographes militaires

FIG. 1-10. Cartoon by Cham (Count Amédée de Noé) of Paris, 1865, made apropos the suggestion that the French army might establish a photographic corps. Here Nadar is shown as a possible inspector-general. From *Nouveaux Habits! Nouveaux Galons!*

(a)

FIG. 1-11 (a)–(b). The Charm of the Studio I.
(a) Engraving after a photograph taken by Petros Moraitis, on the occasion of a visit to Athens of the Prince of Wales in October 1875. The Prince was on his way to India at the time. *Left:* Prince of Wales; *middle:* Queen Olga; *right:* King George I. From *The Illustrated London News,* November 16, 1875. The original photograph did not, of course, include the camera and operator on the right! Xanthakis (1988).
(b) Bride and bridegroom at the photographer. Woodcut, 1880, after a painting by M. Dagnan-Bouveret. Courtesy of Uwe Scheid. Scheid (1983).

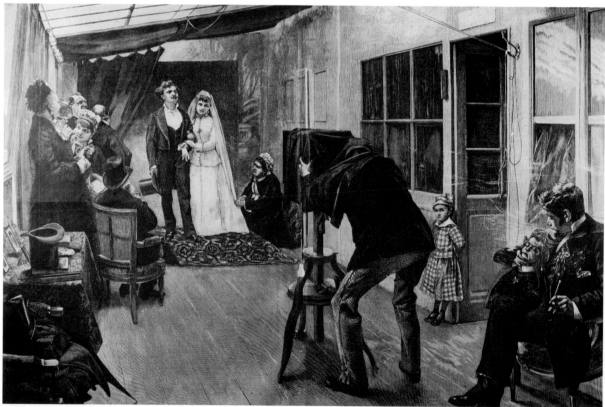

(b)

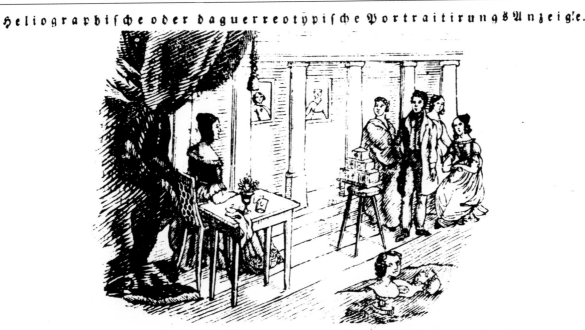

FIG. 1-12. The Charm of the Studio II.
 Advertisement for "Heliographic or Daguerreian Portraiture" by J. B. Isenring, the Swiss pioneer, 1841. See Hesse (1989) and Henisch (1996). Note the stack of cameras, designed to take "simultaneous" pictures of the client.

plains Isenring's purpose and mission. His set-up was disingenuous, and disarmingly simple, but only a few years later cameras were designed that did, indeed, permit (two) almost simultaneous exposures to be taken.

When it comes to photo-humor, *Punch* magazine is certainly an outstanding source. Judging only from the title, one might have had similar expectations for the 1859 *Phun-Fotograft, Kewreus Konseets Komically Illustrated*, by Kweer Feller, but those remain unfulfilled. After a promising title-page (Fig. 1-13a), it soon becomes clear that the term "Fotograft" is used metaphorically, for a "mirror of human foibles." In rather the same way a design by Cruikshank

(Fig. 1-13b) is the frontispiece of a grim social study of living conditions in the Scottish city of Glasgow. See also Chapter 7.

Some of the best-known examples of photographic humor have here been excluded, in order to avoid, or at any rate diminish, the reader's sense of *déjà vu*. To gain an impression of the enormous graphic and photographic variety that the field has to offer, readers will want to consult some of the existing anthologies, for example, Krauss (1978), Lebeck (1979), Kesting (1980), Scheid (1983), Sloan et al. (1993), Jay (1991 and 1994), each with its own mission. In the present work, familiarity with the principal facts of the history of photography and, in particular, with

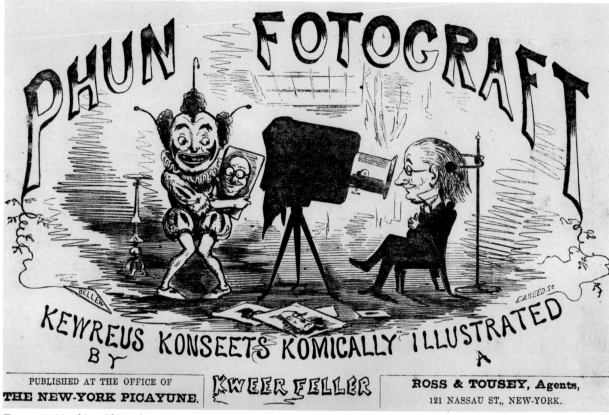

FIG. 1-13 (a)–(b). Photo-humor Frontispieces; Photographs as Metaphors.
 (a) Front cover of *Phun-Fotograft, Kewreus Konseets Komically Illustrated*, by Kweer Feller, 1859. Published at the Office of the *New York Picayune.* Stelts (1995). Courtesy of the Rare Books Room, Pattee Library, The Pennsylvania State University.

the sequence of major technical developments from the daguerreotype and calotype onward will be taken for granted; see Gernsheim (1969) or any of the standard works for help.

Just about everyone knows that photography began (for practical purposes) in 1839, that it was difficult, cumbersome, and expensive during its first four decades or so, that it became cheaper and enormously more convenient with the popularization of dry gelatine plates in the 1880s, and that it was virtually ubiquitous during the first few years of the twentieth century, as commercial photo-processing came to be firmly es-

tablished. While it is not necessary to be a photo-historian in order to appreciate photographic humor (which, indeed, was never intended for such an audience), it is true that the study of this brand of humor can serve as a means for deepening one's understanding of photography's impact on life and society, not to mention the impact of current fads and fashions on photography.

Among the mid-nineteenth-century photo-humorous ventures was the production, in England, of a truly unorthodox (sixth-plate) daguerreotype case; see Fig. 1-14; Krainik (1996)

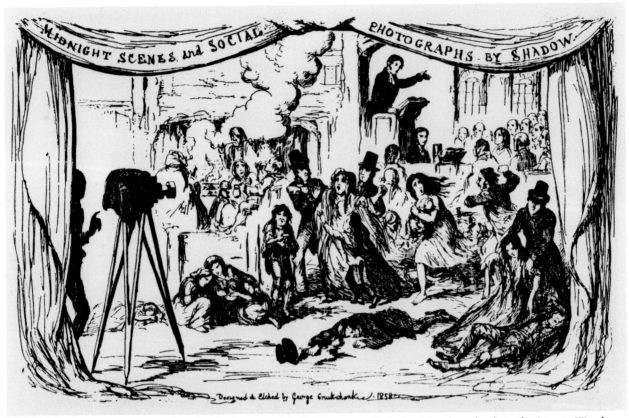

FIG. 1-13. (b) Frontispiece of *Midnight Scenes and Social Photographs, Being Sketches of Life in the Streets, Wynds and Dens of the City,* by Shadow, 1858. Thos. Murray & Sons, Glasgow. Designed by George Cruikshank. See also Anon. (1858).

and Moe (1996). Its front cover bears the golden imprint PORTRAIT OF THE GORILLA TAKEN FROM LIFE, a reference, no doubt, to "The Great Gorilla Controversy" raging in 1861. The existence of gorillas had only just been brought to the notice of the British public, by the publication that year of an exciting account of travel and exploration in Africa, including the "chace [*sic*] of the Gorilla, Crocodile, and other Animals." Written by an intrepid American lay-naturalist of French origin, Paul Du Chaillu (1831–1903), the book caused a sensation, as rival naturalists quarreled ferociously over the author's claims with an enjoyable lack of scholarly decorum; Blunt (1976). The newspapers were filled for months with riveting bulletins from the battlefront at every solemn academic meeting, the public loved the drama, and the gorilla became the topic of the year. The "Gorilla Daguerreotype Case" was an attempt, and a very successful one at that, to cash in on the popularity of the new theme. The joke, however, is double-edged; when the case is opened, it reveals not a daguerreotype but a simple mirror, inviting the viewer to self-analysis, and to new thoughts about the origin of species, not forgetting *The Origin of Species,* another subject very much in the news at the time, as Darwin's revolutionary book had appeared only two years earlier, in 1859.

As one would expect, humor as such has been

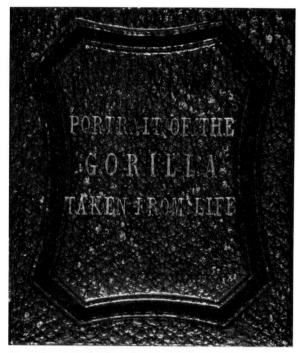

FIG. 1-14. Sixth-plate daguerreotype case, with gold-stamped imprint PORTRAIT OF THE GORILLA TAKEN FROM LIFE. The inside contains not a daguerreotype but a simple mirror. English, 1861. Courtesy of the Jinny Moe Collection (1996).

the subject of many learned dissertations, from its "philosophy" (e.g. Morreal 1987 and Koestler 1964), "theory" (MacHovec 1988), "anatomy" (Boston 1974), "psychology" (Sidis 1913), and "semantic mechanism" (Raskin 1984), to its "biopsychosocial and therapeutic perspectives" (Haig 1988), but while the cogency of such studies is not contested—and some are indeed admirable—the present authors place their faith in the power of the untutored smile, perhaps in the same spirit that led Joubert (1579) to maintain that laughter comes from the heart, not from the head.

Chapter 1 References and Notes

ALTICK, R. D. (1978). *The Shows of London*, Belknap Press of Harvard University Press, Cambridge, Mass., p. 345.

ANON. (1846). *Art Union*, Vol. 8, p. 73.

ANON. (1858). *Midnight Scenes and Social Photographs*, by Shadow. 1976 reprint, with an introduction by John F. McCaffrey, University of Glasgow Press, Frontispiece.

BLUNT, W. (1976). *The Ark in the Park; The Zoo in the Nineteenth Century*, Hamish Hamilton, in association with The Tryon Gallery, London, pp. 137–45.

BOSTON, R. (1974). *The Anatomy of Laughter*, Collins, London.

COKE, V. D. (1995). Personal communication, acknowledged with thanks.

EDER, J. M. (1945). *History of Photography* (trans. E.

Epstean), Columbia University Press, New York. 1978 reprint by Dover Publications, New York. Both volumes based on the author's original *Geschichte der Photographie* (1905).

EWER, G. W. (1995). "Théodore Maurisset's 'Fantaisies': La Daguerréotypomanie," *The Daguerreian Annual*, Pittsburgh, Pa., pp. 135–44.

GERLACH, M. (1882). *Allegorien und Embleme*, Gerlach & Wiedling, Vienna.

GERNSHEIM, H. and A. (1969). *The History of Photography*, McGraw-Hill Book Company, New York.

HAIG, R. A. (1988). *The Anatomy of Humor; Biopsychosocial and Therapeutic Perspectives*, Charles C. Thomas Publisher, Springfield, Ill.

HENISCH, H. K. and B. A. (1994). *The Photographic Experience, 1839–1914; Images and Attitudes*, The Pennsylvania State University Press, University Park, Pa., p. 267.

HENISCH, H. K. and B. A. (1996). *The Painted Photo-*

graph, 1839–1914; Origins, Techniques, Aspirations, The Pennsylvania State University Press, University Park, Pa., chaps. 2 and 6.

HESSE, W. (1989). *Ansichten aus Schwaben, 1839–1925,* Verlag Gebr. Metz, Tübingen, Germany.

HUMPHRIES, S. (1989). *Victorian Britain Through the Magic Lantern,* Sidgwick & Jackson, London, p. 16.

JAY, B. (1991). *Cyanide and Spirits; an Inside-out View of Early Photography,* Nazraeli Press, Munich.

JAY, B. (1994). *Some Rollicking Bull; Light Verse and Worse on Victorian Photography,* Nazraeli Press, Tucson (Ariz.) and Munich.

JOUBERT, L. (1579). *Treatise on Laughter,* translation (by G. de Rocher) published by the University of Alabama Press, Tuscaloosa, Ala., 1980.

KESTING, M. (1980). *Die Diktatur der Photographie; von der Nachahmung der Kunst bis zu ihrer Überwältigung,* R. Piper & Co. Verlag, Munich and Zürich.

KOESTLER, A. (1964). *The Act of Creation,* Macmillan, New York.

KRAINIK, C. and M. (1996). Personal communication, acknowledged with thanks.

KRAUSS, R. H. (1978). *Die Fotografie in der Karikatur* (Foreword by Bernd Lohse), Heering Verlag, Seebruck-am-Chiemsee, Germany, pp. 8, 11.

LEBECK, R. (1979). *Bitte recht freundlich,* Harenberg Kommunikationen, Dortmund, Germany.

MacHOVEC, F. J. (1988). *Humor; Theory, History, Applications,* Charles C. Thomas Publisher, Springfield, Ill.

MOE, Jinny (1996). Personal communication, acknowledged with thanks.

MORREAL, J. (ed.) (1987). *The Philosophy of Laughter*

and Humor, State University of New York Press, Albany, N.Y.

NADAR (Gaspard-Félix Tournachon). (1866). *Moniteur des eaux et des courses,* May 12. Quoted in *Nadar,* M. M. Hambourg *et al.,* Metropolitan Museum of Art, New York (1995), p. 66.

NEWHALL, B. (1971). *An Historical and Descriptive Account of the various Processes of the Daguerreotype and the Diorama by Daguerre,* a modern reprint with an introduction by Newhall, Winter House, New York, pp. 21–23.

RASKIN, V. (1984). *Semantic Mechanisms of Humor,* Dordrecht, Holland.

SCHEID, U. (1983). *Als Photographieren noch ein Abenteuer war; aus den Kindertagen der Photographie,* Harenberg Kommunikationen, Dortmund, Germany, p. 52.

SIDIS, B. (1913). *The Psychology of Laugher,* Appleton, New York.

SLOAN, M., MANLEY, R., and PARYS, M. V. (1993). *Dear Mr Ripley, a Compendium of Curiosities from the Believe It or Not! Archives,* Bullfinch Press / Little, Brown & Company, Boston.

STELTS, S. (1995). Personal communication, acknowledged with thanks.

STENGER, E. (1938). *Die Photographie in Kultur und Technik,* Verlag E. A. Seemann, Leipzig.

WADE, J. (1979). *A Short History of the Camera,* Fountain Press, Argus Books, Watford, Herts., U.K., p. 18.

XANTHAKIS, A. X. (1988). *History of Greek Photography, 1839–1960,* Hellenic Literary and Historical Archives Society, Athens, pp. 94–95.

2

INFERNAL CONTRAPTIONS

There is no doubt that of all aspects of the photographic presence, tools of the trade were the prime objects of ridicule. This was so partly because their function struck observers as intriguingly odd, and partly because they had an intimidating effect on hapless clients both in the studio and out. There was not only the camera—all-seeing, menacing, and enigmatic—but the formidable chair that served to keep clients in motionless order. The comparison with dental chairs was irresistible, all the more because the professions of dentist and photographer were often combined. Thus, for instance, Dr. W. J. Guild of Rolla, Missouri, advertised himself as

"Dentist and Photo-Artist" in the 1860s, and M. S. Eldridge of Providence, Rhode Island, promised his clients not only good likenesses, but "Chloroform, Ether, or Laughing Gas given when required" (Henisch 1994). Cartoonists made painful use of such examples. "Bitte recht freundlich," says a German studio operator to his chained client as he prepares to extract a tooth with a giant pair of tongs, while the camera looks on; see McCulloch (1981). The joke surfaced early in France (Fig. 2-1a), and variations on the much-loved theme found no difficulty in making their way around the world. Under the heading of *The British Tradesman*

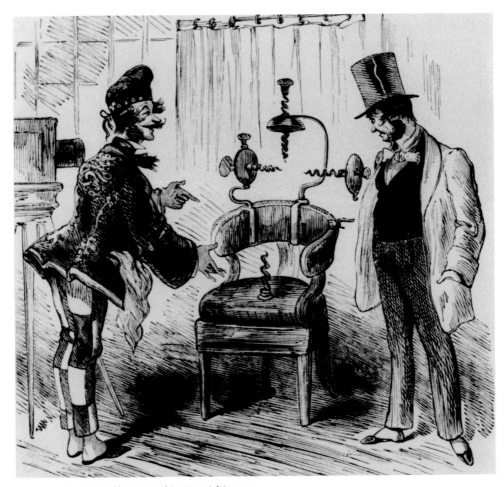

Fig. 2-1 (a)–(c). Photographic Furnishings.
 (a) "The Mechanical Armchair" in the photographic studio. Cartoon by Marcelin, *Journal pour Rire,* Paris, 1851; *Journal Amusant,* 1857. The original caption reads something like: "Please take pains [the trouble] to seat yourself." Krauss (1978). Courtesy of Rolf H. Krauss.

(Sullivan 1880), someone deftly appropriated an item (Fig. 2-1b) that was not native to the Sceptered Isle at all; the essential characters in the cartoon had first appeared in the April 1879 issue (p. 575) of the *St. Louis Practical Photographer,* under the title "Posing Quite an Art in Itself" (Fig. 2-1c). A brief text explains the winged thoughts in the air between master and client:

What? Don't think the machine quite suits you? Not a natural pose? Would rather sit eas-ily in an armchair, so? Oh, my dear sir, most preposterous! Wouldn't do at all. No ART in it. Oh dear, you'll excuse my laughing at the notion!

The grotesque appearance of various studio contraptions occupied not only humble opera-tors in the Midwest, but also the great and fa-mous in the East. Thus, an editorial in *The Phila-delphia Photographer* of 1867 (p. 82) describes an interview with Napoleon Sarony of New

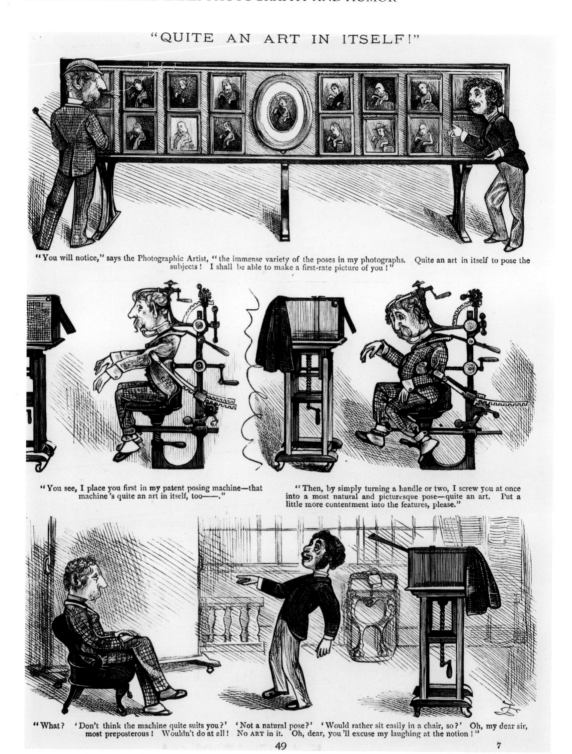

FIG. 2-1. (b) A page from *The British Tradesman and Other Sketches*, by J. Sullivan (1880). Engraving by Balziel Brothers.

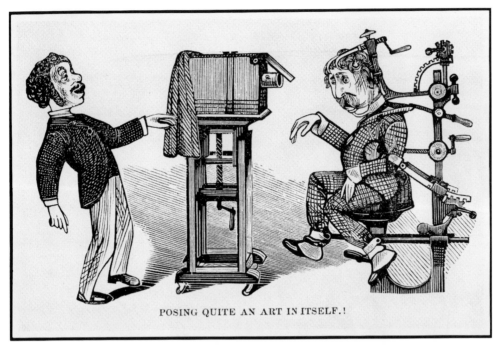

POSING QUITE AN ART IN ITSELF.!

FIG. 2-1. (c) Detail from the *St. Louis Practical Photographer,* April 1879, p. 515. Rare Books Room, Pattee Library, The Pennsylvania State University. Mann and Stelts (1990).

York, during which the budding master of theatrical studio portraiture demonstrated his "posing machine": "We were very comfortable, and could keep still an hour in its pleasant embrace. The sensation is almost indescribable. It must be experienced to be fully realized." The editor describes it, nevertheless, at considerable length and, though he thoroughly approved of the device, he found a passing reference to the Tortures of the Inquisition irresistible.

The formidable Towler (1864), author of *The Silver Sunbeam,* had already given it as his opinion that head rests were absolutely essential in studio practice. Only a few years later, H. P. Robinson (1869), on the other hand, expressed some doubts, pointing out that, for the best results, "the rest should be moved to the head, not the head to the rest." By 1899, Emerson allowed no such concessions: "Head rests must be entirely taboo. We have taken many portraits, some

with very long exposure, and no head rest was necessary. In nine cases out of ten, it simply ruins the portrait from an artistic point of view." For good measure, he goes on to say, "All artificial backgrounds should be banished, together with such stupid lumber as banisters, pedestals, and stiles; they are all inartistic in the extreme!" (Emerson 1899). Emerson refused to be charmed by studio artifice, but others were more indulgent. An almost endearing head-clamp can be found as an illustration in an 1850 letter written by John Parry (1812–65), an English actor and amateur caricaturist (Fig. 2-2), and even Mona Lisa continues to smile as she suffers the indignity of forcible restraint in Lucien Métivet's 1892 cartoon (Fig. 2-3a). In contrast, the dog in Color Plate 2-3b is immobilized by the sheer force of the photographer's personality.

Posing-chair and head-clamp were only two of the many baffling items in a studio; the cam-

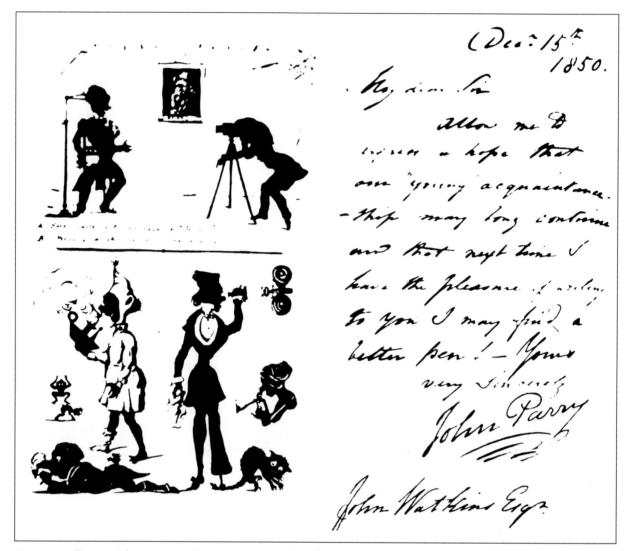

FIG. 2-2. Illustrated letter (December 15, 1850), sent by John Parry (1812–c. 1865), an English amateur caricaturist. From *The Illustrated Letter,* by Charles Hamilton (1987). Copyright Charles Hamilton; reproduced by permission of the author.

era itself was the most profound enigma, and if even some photographers did not fully fathom the process, their clients could scarcely be expected to. Thus, a *Punch* cartoon of December 19, 1863, shows a lady in the studio tying her skirt around her ankles, to make sure that it doesn't fall and reveal all when she appears upside down on the focusing plate (Fig. 2-4a).

Occasionally, the mocking of the camera, always considered a deserving cause in its own right, was made to serve a secondary purpose as, for instance, in the cartoon from New Zealand shown in Fig. 2-5a. There, not only is the camera, with its two optical ports, presented as an ambiguous object, but it is also suggested, so very gently, that a native Maori woman is much

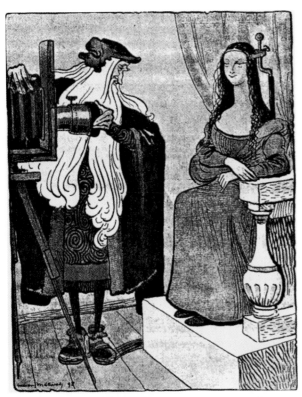

Fig. 2-3 (a). "Don't Move!" Gentle fun by Lucien Métivet, 1892, showing a modern Leonardo in the process of posing Mona Lisa in a head-clamp.

See also Color Plate 2-3 (b).

more likely to look into the wrong side than anyone else. New Zealand held no monopoly in this respect. The 1885 sketch contains the shadow of an ethnic sneer, but the basic joke was as old as photography itself, and was made with cheerful brutality at the expense of any fool in any country. A contemporary tale in New York's *Leslie's Magazine* told of a "prudish old maid" who was "poking around" where she had no business. When accidentally looking into the back of a studio camera, she found to her utter shock and dismay that things were presented upside down, the very fear in the mind of the English lady shown in Fig. 2-4a. Moreover, such "prudish old maids" were by no means alone in their reactions; after all, the devil himself, in a

German sketch, was disconcerted by the topsy-turvy world he saw on the focusing screen of a camera (Fig. 2-4b). The sheer wonderment of this optical inversion, though known for centuries, was the subject of an excited report in *Harper's Magazine* as late as 1869 (Anon. 1869). Years earlier, *Harper's New Monthly Magazine* had put a similar episode on record; see Fig. 2-5b. There, Mr. Peeper peeps, as he is expected to do, but why the man in charge is timing the process may seem puzzling; in fact he is doing so in the complacent belief that he is just taking the planned exposure, with his client still obediently posed in the chair. Indeed, there exists a commercial American stereo card of the 1880s (unidentified publisher), entitled "Studying the Mysteries of Photography," which was in all likelihood inspired by this cartoon. The joke found its way to faraway Brazil in 1866, where the same point was made in the *Semana Illustrada* of January 28 (Ferrez 1991). Color Plate 2-5c, from Austria, and Color Plate 2-5d from France, further testify not only to the wide popularity of the theme, but to its longevity.

Another ever-puzzling feature was the photographer's black cloth, for which there were several plausible explanations: for instance, that hiding under it was an act in a ceremonial, a secret rite, or else that concealed in this way the photographer was engaged in some nefarious activity, something to do with magic. The cloth particularly impressed children. Max Dauthendey (1925) recalls his father (a prominent mid-nineteenth-century professional photographer in Germany and Russia) telling him that children believed the cloth hid a ghost, and that when the photographer finally emerged from under its folds he was deemed to have scored a victory over the forces of evil. Alternatively, photographers were trying to catch sunlight in order to make it into gold; oh, how they would have tried! But the black cloth at times sent a different signal, one clearly recognizable by anyone already so disposed: draped over a camera, it resembled a painter's cloak. In an 1859 cartoon,

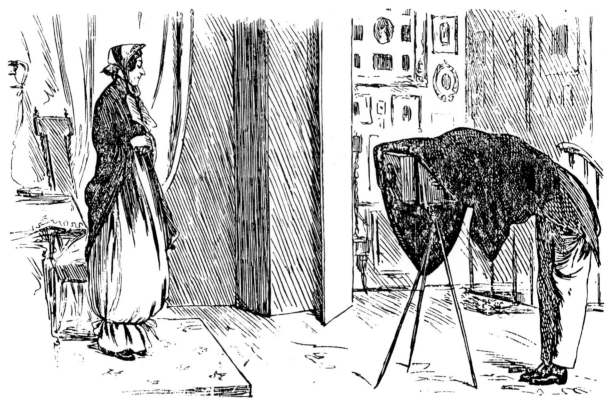

A PHOTOGRAPHIC INCIDENT.

Those who are familiar with the phenomena of the Camera Obscura will readily understand the precaution taken by Miss Tabitha Prue, on being focussed for her Carte de Visite.

(a)

(b)

FIG. 2-4 (a)–(b). The Dangers of Optical Inversion.
(a) "A Photographic Incident." Cartoon from *Punch* of December 19, 1863, p. 254.
(b) The very devil is frightened by the upside-down world he sees on the focusing plate. Unsigned watercolor, c. 1890. Scheid (1983). Courtesy of Uwe Scheid.

(a)

FIG. 2-5 (a)–(b). The Dangers of Optical Ambiguity.

(a) "Reciprocity," a watercolor sketch from New Zealand of the prominent photographer Alfred H. Burton and a Maori woman, 1885, by Edward Payton. Courtesy of Van Deren Coke.

(b) Illustration from "Foolish Folks—All-Fools' Day Sketches," *Harper's New Monthly Magazine,* April 1856. Palmquist (1980).

See also Color Plates 2-5 (c) and 2-5 (d).

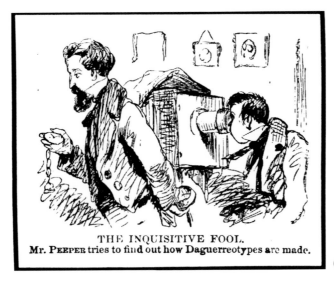

(b)

A BROTHER ARTIST.

FIG. 2-6. Artistic Fashions; a Brother Artist. From *Harper's New Monthly Magazine*, 1859.

Harper's New Monthly Magazine shows a camera on a tripod, "dressed" in this way, and confronting a great master in the flesh who, similarly attired, recognizes a brother artist in the traditional garb of those concerned with the higher realms of aesthetic experience (Fig. 2-6).

While the studio-camera was terrifying enough, even as an object, there was often a suspicion that it might actually come alive, in spirit if not in fact. Cuthbert Bede (1855), the famous clergyman-photocommentator, was well-acquainted with the anthropological view of the camera (Fig. 2-7 a and b), and with the charm of double meanings. Indeed, not only the camera was liable to enter the world of the living, but other photo-paraphernalia as well (Fig. 2-7c).

Just occasionally, animate and inanimate matter would combine to perplex not only the innocent bystander, but each other (Fig. 2-7d). And if the nineteenth-century camera could puzzle and threaten, it could also, on occasion, reap due punishment for its menace. William Devere, "Tramp Poet of the West," describes just such a case, in the context of what, with a lavish dose of charity, might be called an epic poem, entitled "Kinder Susp'shus." It concerns itself with an episode in which a photographer quite innocently visits a tavern and points his camera in the direction of other guests, worthy gentlemen who misunderstand the situation, with the disastrous consequences shown in Fig. 2-8 (a and b). The last stanza:

> We buried the pieces, all that we could see,
> Out thar in the gulch, by that old pi'non
> tree,
> With a card from his pocket,—its sticking
> thar yet—
> "Snap Kodak Artist, Gazootville Gazette."
> (Devere 1897; Mann 1994)

An earlier, less explosive variant on that theme comes from Brazil, a two-part caricature of Henrique Leiuss at work; Leiuss was a prominent figure in photographic circles, and founder of the Instituto Artistico in Rio de Janeiro. The first scene shows a trio of local types before the camera, prepared, or almost so, to be photographed; the second reveals them in full flight, frightened by the menacing lens and the ominous silence during the count (*Semana Illustrada*, No. 170, March 13, 1864, p. 1356).

The Wild West and Latin America may always have been a little trigger-happy, but the danger from the camera was just as great in staid and dignified London, and *Punch* reported in 1853: "Oh, Sir! Please, Sir! Don't for goodness' sake *fire*, Sir!" says an old lady (who, it is carefully explained, "is not used to new-fangled notions") when confronted by a photographer with his camera. Enough? Not at all; *Punch* cheerfully re-

turned to the theme seven years later, with a cartoon that shows a country-type being photographed. The photographer tells him to keep still, but the client tries hard to "evade the Focus": "Be Jabers, Man! Will I sit still to be shot at?!!" (Anon. 1948)

The openly brandished camera may have appeared menacing enough, but the almost hidden one seemed faintly ridiculous. Fig. 2-9a shows an example, a camera concealed, albeit not very effectively, in a top hat, with the photographer trying hard to act as an unobserved observer. This particular invention is credited to a Spanish photographer, Mara Mendoza, and dates from 1884. A similar device was patented by Luders of Görlitz in Germany. Naturally, such contraptions had a literary fallout, specifically in one issue of *Punch* in 1886 (February 27), in the form of a poem by H. Saville Clark:

> If they knew what I wear when I walk in
> the street,
> I should be quite a terror to people I meet;
> They would fly when they saw me, and
> ne'er stop to chat,
> For I carry a camera up in my hat.
>
> A Herr Luders of Görlitz has patented this,
> And I think the idea is by no means amiss;
> With a hole in my hat for the lens to peep
> through,
> And a dry plate behind, I take portrait or
> view.
>
> Should I meet, when I chance to be taking
> the air,
> With a lady who looks so surpassingly fair,
> If I wish to preserve her sweet face by the
> sun,
> Why I just pull a string, and the
> Photograph's done.
>
> I admire, say, a sea-scape, or else chance to
> look,
> With the eye of an artist, on picturesque
> nook;

(a)

(b)

Fig. 2-7 (a)–(d). "The Camera in Person."
 (a) (b) (c) from Cuthbert Bede's *Photographic Pleasures* (Bede 1855).

FRONT AND BACK VIEW OF A VERY CURIOUS ANIMAL THAT WAS SEEN GOING ABOUT LOOSE THE OTHER DAY. IT HAS BEEN NAMED BY DR. GUNTHER "ELEPHANS PHOTO-GRAPHICUS."

(d) "Elephans Photographicus." *Punch,* April 26, 1862.

THE VICES OF PHOTOGRAPHERS.

(c)

There are plates in my hat, if I poise it with
 skill,
That will take any beautiful view at my
 will.

If I'm stopped in the street—that may
 happen, you know—
By a robber whose manners are not *comme
 il faut,*
His identification should never be hard,
There's my neat little photograph in
 Scotland Yard.

So we'll all wear the hat made by science
 complete,
With a camera, lens, and a dry plate *en
 suite;*
And take views in the street with its bustle
 and traffic,
By the aid of this German's strange hat
 photographic.

Fig. 2-9b—an early Magritte?—shows the head-gear both on duty and at rest, a harmless bowler hat floating dreamily over the action. Clark (1886); see also Jay (1994). Clark's poem was an instant success, and was quickly reprinted in *The Photographic Times and American Photography Almanac* of April 30, 1886.

One record has survived, of an episode in which the photographic hat was actually used "in the field," so to speak, to the consternation of its unsuspecting victim (Campo 1887; Jay 1994):

When staying in a seaside resort in August 1886, I received a letter one day and, upon opening it, found to my amazement that it contained three photographs in which I had no difficulty in recognizing myself. But what photographs they were! Certainly not such as might be calculated to tickle my vanity. In the first photograph, I was shown at the very mo-

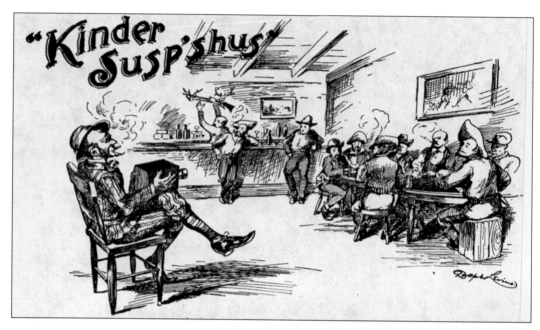

(a)

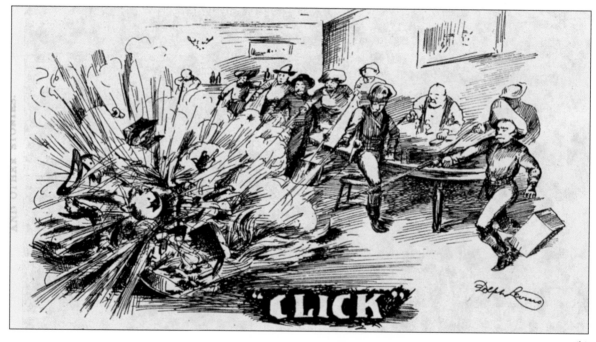

(b)

FIG. 2-8 (a)–(b). "Kinder Susp'shus," from *Jim Marshall's New Pianner and Other Western Stories,* by W. Devere (1897). Mann (1994).

(a)

(b)

Fig. 2-9 (a)–(b). The Photographic Hat.
 (a) 1884 model, after Stenger (1949) and
Docte (1888).
 (b) 1887 model from *De Natuur*, p. 172.
See also Jay (1994).

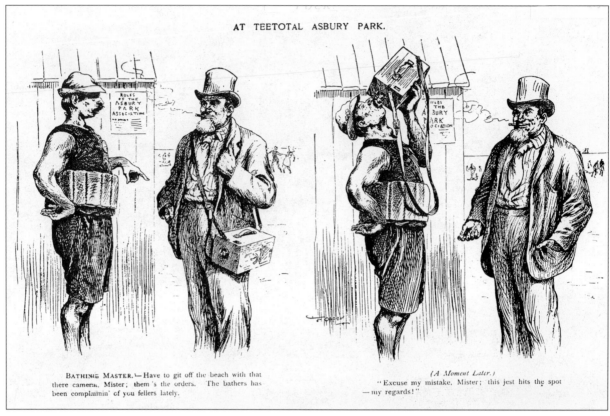

FIG. 2-10 (b). Hidden Agendas. "At Teetotal Asbury Park." Cartoon from *Puck's Library,* No. XLIX, p. 415, 1891. See also Color Plate 2-10 (a).

ment of entering the water, and my face reflected all too clearly the sensation of the first contact with the cold sea-water. Really, one would not approach a lady with such gestures on the shore.

The second picture had been taken while I was blowing out a mouthful of water which I had involuntarily gulped in, while my facial expression made it obvious that my taste buds had been stimulated in a far from pleasant way. In the third picture, I resembled a bedraggled poodle rather than a civilized man. I emerged from the sea, dripping wet.

It cannot be denied that the three exposures were a true reflection of what had happened two days before. On investigation, I found

that a good friend had availed himself of the opportunity of making several photographs of me while I was bathing, and had done so with the aid of a *photographic hat.*

And from the photographic hat, it was only a small step to the photographic belt or, indeed, the photographic girdle; see Braive (1966) and Color Plate 8-5. However, the latter invention was not, of course, a serious technical contender; it was part of a fancy-dress outfit. On the other hand, a French cartoon of 1910 depicts a camera, hidden in the handle of a walking stick, put to good use (Color Plate 2-10a). That cartoon, one of two on a ceramic plate, contrasts the clumsy old and static ways of early studios with the new

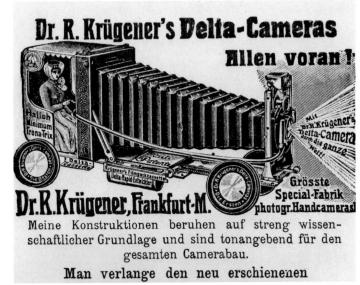

FIG. 2-11. Advertisement by Dr. R. Krügener's Company, Frankfurt-am-Main, 1906. The camera, together with the motorcar, in the forefront of modern technology. "My designs are based on scientific studies, and set the standards for camera construction everywhere." Scheid (1983). Courtesy of Uwe Scheid.

methods of the modern age, mobile, and full of flirtatious potential; see also Chapter 5 and, for details of Photographic Cane designs, an editorial essay in *The Photographist* (No. 96, Fall issue 1991). This describes a version published in the *Scientific American* of November 12, 1892.

By the first few years of the twentieth century, the camera was no longer an object of fixed shape, let alone size, but some of its characteristics were more common than others, and, as new inventions came along, new comparisons suggested themselves. Thus, it occurred to someone in 1906 that a camera, with its bellows extended, resembled nothing more than a motor car, the latest product of modern technology; see Fig. 2-11. One cartoon, by J. Ottmann, makes a reference to earlier and, indeed, pre-photographic times (Collins 1986). It shows a loving couple at the seashore, observed and monitored from afar by an eager and leering crowd hidden in a nearby camera obscura tower, and staring at its projection table. By the late nineteenth century, there was really no need to make use of such an observation post, because the portable camera

could assume any number of disguises. A cartoon-pair in a *Puck's Library* volume of c. 1890 showed the use of cameras mounted into shopping baskets and banjo cases for flirtatious explorations of the local scene; see also Krauss (1978). A camera could also serve as a container of liquid refreshments, the equivalent of a hip-flask, while managing to look totally respectable, as Fig. 2-10b shows.

While most cartoons dealt with the apparent absurdity of studio implements, a few reporter-artists also concerned themselves with the almost provocatively sumptuous elegance of some of the principal establishments (see Daval 1982). In England, *Punch* regarded the caricaturing of photography as one of its special responsibilities, and accompanied its graphic offerings with elaborate captions and texts that readers found adroit and scintillating, but which now remind us that the psychological gap separating the late twentieth century from the nineteenth is wider than we often care to admit. Much less well-known is the fact that many cartoons that appeared in *Punch* during the 1880s and 1890s,

whether aimed at photographic follies or not, were in fact *based* on photographs. They were made by Linley Sambourne, one of *Punch's* most popular cartoonists in the 1890s. He regularly made use of this technique, coaxing members of his family into posing for the camera, and then converting the photographic studies into lively sketches. Nicholson (1988) reproduces several side-by-side examples. For Sambourne, see also Figs. 6-16g and 7-1.

Nor did *Punch* or, indeed, other commentators, limit their analysis of the photographic scene to camera matters; they also covered and followed the processes that go on inside both the infernal contraption and its hapless operator. From the first, enthusiasts were tantalized by the dream of true color photography. The prize hovered just out of reach throughout the nineteenth century, and on October 5, 1904, an editorial writer in *Punch* felt constrained to take pity on the feverish experimenters, and offer some soothing words of comfort:

Never Despair. The secret of photographing in colour has again been discovered. We were getting afraid that this year was going to be an exceptional one.

Twenty years earlier, no less weighty a medium than the *New York Times* carried an article ("The Real Cause," February 23, 1884) on the disastrous effect of modern photographic methods on the human psyche. Thus,

It has not occurred to a single medical man that the first noticeable increase in the percentage of lunatics in this country and in England took place about a year after the introduction of dry-plate photography. Had this fact been noticed, the coincidence could hardly have failed to suggest its true explanation. No matter what "developer" the beginner may use he will be told to discard it and try another. It is estimated that the different combinations of chemicals which may be used as "developers" amount to 37,218 and the un-

happy man who begins to search for the very best "developer" is on the high road to insanity. . . . The intellect of the ordinary amateur reels under it, and he becomes a hopeless mental wreck. Our lunatic asylums are now crowded with men who rave of developers and toning baths. . . .

Every amateur who has tried dry-plate photography and preserved his reason will have no difficulty in attributing the recent growths of insanity to the introduction of dry-plates. We need search no further to find out why our lunatic asylums are crowded.

Not everybody raved about developers and toning baths, but at least one French artist (Fig. 2-12a) had, years before this American editorial, maintained that pyrogallic acid was an acceptable substitute for absinthe, when dispensed by a talented vendeuse, a grave mistake, whether considered from a culinary or a medical point of view. Another chemical, collodium (collodion), had a less favorable press (Fig. 2-12b). Chemicals were mysterious and fascinating in their way, but there is no doubt that, in comparison with other photographic paraphernalia, they lacked a certain visual excitement. And yet, a decorative function is just what was assigned to them in a Currier and Ives print of 1890, shown in Fig. 2-13. The cartoon otherwise echoes the widely accepted belief that owners in due course begin to look like their pets, and implies that a flash photograph might actually accelerate the process.

Equipment and chemicals apart, one of the aspects of photography that never ceased to amuse and amaze was that the picture came into being while the photographer was standing by, doing nothing by the sweat of his brow. In principle, the photographer could even doze off during the process. To the daguerreotypist, it seemed, "le talent vient en dormant." See Fig. 2-14, indeed one of the earliest of all photo-cartoons. The same sentiment is reflected in a German rhyme of 1840, quoted by Stenger (1938):

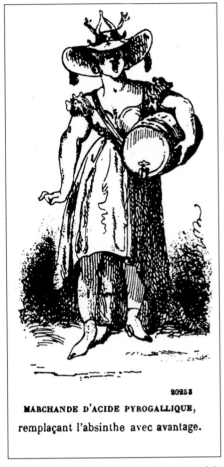

20253

MARCHANDE D'ACIDE PYROGALLIQUE,

remplaçant l'absinthe avec avantage.

(a)

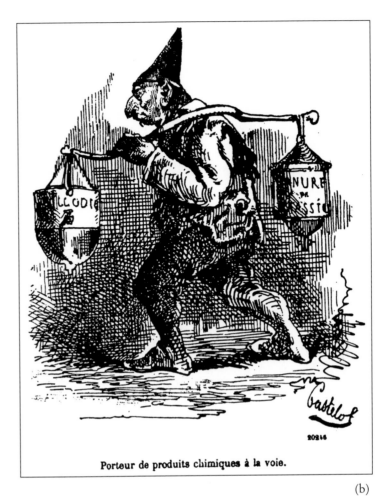

Porteur de produits chimiques à la voie.

(b)

FIG. 2-12 (a)–(b). The Romance of Photo-Chemicals. Courtesy of Van Deren Coke.

(a) A helpful camp-follower, offering pyrogallic acid as a (ludicrous) substitute for absinthe. From the *Journal Amusant*, No. 350, item 20253, c. 1861.

(b) A Post-photographic Sanitation Worker, removing collodion residues. Cartoon by Castelo from the *Journal Amusant*, No. 350, item 20256, c. 1861.

Und wenn vom Schlaf er dann erweckt,
Das Kunstwerk schon im Kasten steckt.

(And by the time he wakes up,
The work of art will be [completed]
 in the box.)

On just a few occasions, the camera was allowed to speak its own mind. C. S. Middlemiss, in about 1896, translated its feelings of self-conscious pride, and less than total faith in its master's competence:

The Lament of a Camera

I'm the choicest the makers can make,
 Of mahogany, leather and brass,
My lens the anastigmat
 Cut and polished from best Jena glass.

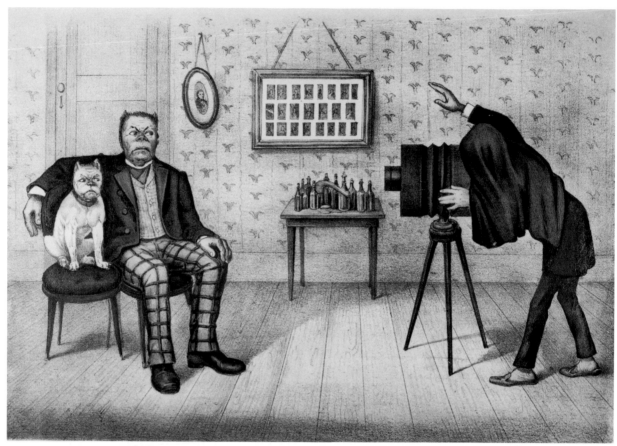

FIG. 2-13. A Man and His Dog; 1890 cartoon, by an unidentified artist, published by Currier and Ives. "A Dark Foreshading—on a Flash Picture"; the owner comes to look more and more like his pet, a process allegedly and alarmingly accelerated by the flash. Note the photo-chemicals used as decor. Courtesy of S. F. Spira (1988).

I'm as fresh as a girl in her teens,
 And my action as perfect and true,
How I long for remarkable scenes
 That will give me some pictures to do.

How I thrill when I come from my night
 In the padded and close leather case,
As I feel the wild pulses of light
 From inter-molecular space!

How I like the caress of their beams
 As they surge through me—yes, but
For glory of fame and its dream!—
 My owner's a bit of an ass.

To my beauty he lends not a thought—
 My beauty of fitness and line;
I'm a slave that his Highness has bought,
 Obedience and use to combine.

Were I free to have only my fling
 (Not a marionette working on wires)
With the sun and the moon I could sing
 And respond to celestial choirs.

I could bring up the art of the year
 By gem upon gem from my hand,
But alas! I am cramped in my sphere
 By a master who won't understand.

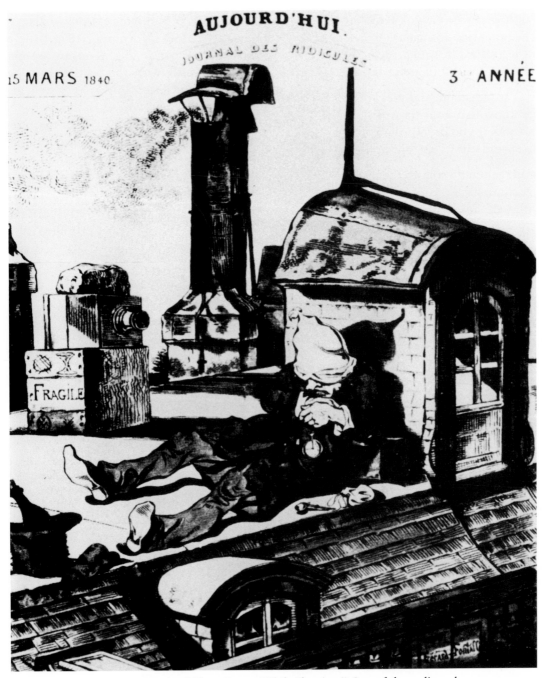

FIG. 2-14. "To Daguerreotypists Talent Comes While Sleeping." One of the earliest photo-cartoons, by Gérard Fontallard. March 15, 1840. *Journal des Ridicules,* Paris.

By an owner who cannot perceive
 The potencies dormant in me
For the greatest of fame to achieve
 And the greatest of artists to be.

This is so, amateurs, did you know it,
 Or know that your slave of the light
Has a soul if you'd only allow it
 To spread out its pinions in flight.

A soul that could soar to the peak
 Of all pinnacled fame in a day,
If you were not so terribly weak,
 If you were not such creatures of clay.

But instead, in my fetters I go,
 Driven on by stupidity crass—
All commonplace work that I do,
 For my owner's a bit of an ass.
(Thomas 1990; see also Chapters 5 and 8 below.)

In retrospect (Jay 1989), it is clear enough that neither *Punch* nor any of its rivals succeeded in illuminating the essence of photography as such. [—"What's the difference between photography and the whooping cough?"—"One makes facsimiles, the other makes sick families." From a Liverpool, U.K., daily newspaper of 1875, reprinted in the *British Journal of Photography* of March 19, 1875, p. 143.] Nor could such a thing have been expected, but writers and caricaturists the world over revealed a good deal about the response of a naive public to new inventions that intruded into every corner of daily life. Photography was certainly one of those, and the vagaries of human reactions, rather than the ground rules of aesthetic theory, have always been the proper targets for the humorist's art.

And if ordinary photography was widely misunderstood during the first half-century of its existence, the discovery (1895) of X-rays and X-ray photography by W. C. Roentgen in Ger-

many raised the misconceptions to dizzying new heights. Fig. 2-15, from an 1896 issue of *Life,* provides evidence that X-rays "see through" our jolly man with the scythe, and reveal his inner self: the Grim Reaper. Very well, an imaginative piece, but where is the X-ray source? How is it that a negative comes to be mounted as a cabinet card, and why is the sun (not a potent X-ray source) shown bright? We can ask such questions, but must in the end surrender ourselves to the charms of artistic license. Inevitably, Mr. Punch (*Punch,* Vol. 110, January–June 1896) had a look at X-ray portraiture, and didn't like what he saw:

. . .

We only crave to contemplate
 Each other's usual full-dress photo;
Your worse than "altogether" state
 Of portraiture we bar *in toto!*

The fondest swain would scarcely prize
 A picture of his lady's framework;
To gaze on this with yearning eyes
 Would probably be voted tame work!

No, keep them for your epitaph,
 These tombstone souvenirs unpleasant;
Or go away and photograph
 Mahatmas, spooks, and Mrs. B-s-nt!

The last enigmatic reference is to Mrs. Annie Besant, a well-known spiritualist of the day.

On the whole, inventors and inventions had "a good press" in the nineteenth century, but public approval was balanced by the conviction that old technology was better and more comfortable to live with than new. If there was a sense in which photography occupied a special position in the company of other incomprehensible inventions, it arose from the fact that it catered not only for human aspirations, but for that most enduring of foibles, human vanity.

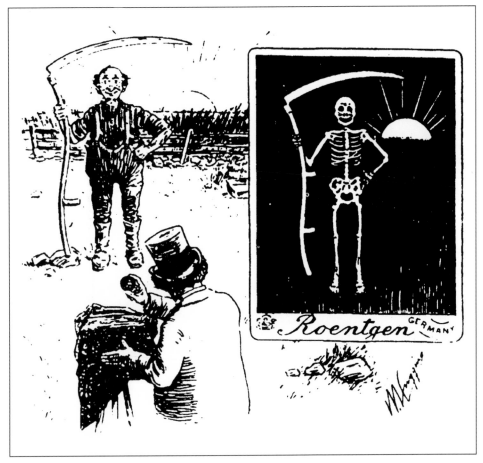

Fig. 2-15. Revealing the inner man by X-ray photography. N. Huggins, from an issue of *Life* (1896); see also Fig. 7-5 and *Photo-Antiquaria,* Vol. 22, No. 3, p. 32, 1995.

Chapter 2 References and Notes

ANON. (1869). "The Eye and the Camera," *Harper's New Monthly Magazine,* Vol. 39, pp. 478–82.

ANON. (1948). *Punch in Camera-Land,* W. J. Mackay & Co., London. Also Focal Press, New York, pp. 13, 31.

BEDE, C. (1855). *Photographic Pleasures, Popularly Portrayed with Pen and Pencil,* T. Mc'Lean, 26 Haymarket, London. 1973 reprint by the American Photographic Book Publishing Company, Inc., Garden City, N.Y., pp. 37, 73.

BRAIVE, M. F. (1966). *The Era of the Photograph; a Social History,* Thames & Hudson, London, p. 21.

CAMPO, O. (1887). "The Photographic Hat," *De Natuur,* Brussels, p. 172.

CLARK, H. S. (1886). "The Photographic Hat," *Punch,* February 27, p. 97.

COKE, V. D. (1995). Personal communication, acknowledged with thanks.

COLLINS, K. (1986). Personal communication, acknowledged with thanks.

DAUTHENDEY, M. (1925). *Der Geist meines Vaters,* Albert Langen / Georg Miller, Munich.

DAVAL, J.-L. (1982). *History of an Art; Photography,* Skira/Rizzoli, New York, p. 52.

DENSCHER, B. (1985). *Kunst und Kommerz, zur Geschichte der Wirtschaftsbewerbung in Österreich,* Österreichischer Bundes-Verlag, Vienna, p. 40.

DEVERE, W. (1897). *Jim Marshall's New Pianner and Other Western Stories,* M. Witmark & Sons, New York, Chicago, London, pp. 33–36.

DOCTE, Le A. (1888). *Manufacture Belge pour la Photographie,* catalog, p. 208.

EMERSON, P. H. (1899). *Naturalistic Photography for Students of Art,* Scovill & Adams, New York. 1973 reprint by Arno Press, New York, Book 2, pp. 66–67.

FERREZ, G. (1991). *Photography in Brazil, 1840–1900,* University of New Mexico Press, Albuquerque, N.M., p. 24.

GERLACH, M. (1882). *Allegorien und Embleme,* Gerlach & Wiedling, Vienna.

HAMILTON, C. (1987). *The Illustrated Letter; an Extraordinary Collection of Embellished Correspondence by Celebrated Artists and Writers,* Universe Books, New York, p. 117.

HENISCH, H. K. and B. A. (1994). *The Photographic Experience, 1839–1914; Images and Attitudes,* The Pennsylvania State University Press, University Park, Pa., p. 217.

JAY, B. (1989). "Comprehensive List of Prose, Verse and Caricature Relating to Photography in *Punch,* 1844–1910" (unpublished). Personal communication, acknowledged with thanks.

JAY, B. (ed.) (1994). *Some Rollicking Bull, Light Verse and Worse on Victorian Photography,* Nazraeli Press, Tucson (Ariz.) and Munich, pp. 80–82.

KRAUSS, R. H. (1978). *Die Fotografie in der Karikatur* (Foreword by Bernd Lohse), Heering Verlag, Seebruck-am-Chiemsee, Germany, pp. 14, 77.

MANN, C. (1994). Personal communication, acknowledged with thanks.

MANN, C., and STELTS, S. (1990). Personal communication, acknowledged with thanks.

McCULLOCH, L. W. (1981). *Card Photographs; A Guide to Their History and Value,* Schiffer Publishing Company, Exton, Pa., p. 159.

NICHOLSON, S. (1988). *A Victorian Household,* Barrie & Jenkins, London, pp. 16, 84.

PALMQUIST, P. E. (1980). "Photography, as seen by Caricaturists in Harper's New Monthly Magazine," *History of Photography,* Vol. 4, No. 4, pp. 325–28.

ROBINSON, H. P. (1869). *Pictorial Effect in Photography, Being Hints on Composition and Chiaroscuro for Photographers,* Piper & Carter and Marion & Co., London, pp. 97–98.

SCHEID, U. (1983). *Als Photographieren noch ein Abenteuer war; aus den Kindertagen der Photographie,* Harenberg Kommunikationen, Dortmund, Germany, pp. 42, 137, 143, 153, 157, 201.

SPIRA, S. F. (1988). Personal communication, acknowledged with thanks.

STENGER, E. (1938). *Die Photographie in Kultur und Technik,* Verlag E. A. Seemann, Leipzig.

STENGER, E. (1949). *Die Geschichte der Kleinbild-Kamera bis zur Leica,* Optische Werke Ernst Leitz, Wetzlar, Germany, p. 40.

SULLIVAN, J. (1880). *The British Tradesman and Other Sketches,* published by *Fun.* Engraving by Balziel Brothers.

THOMAS, G. (1990). "The Verses of C. S. Middlemiss," *The Photo-Historian,* No. 89, pp. 43–50.

TOWLER, J. (1864). *The Silver Sunbeam,* Joseph H. Ladd, New York. 1969 reprint by Morgan & Morgan, Hastings-on-Hudson, N.Y., p. 25.

3

WHAT IS TRUTH?

From the first, photographers were proud of the fact that their craft represented a pursuit of truth. Since truth was obviously a noble thing, how could the pursuer be anything but a noble creature? This notion had an immediate appeal among professionals, who needed moral support in their competition with painters. "The camera cannot lie" became the battle-cry, but the double-edged nature of that slogan soon proved to be embarrassing. If the camera did not lie, if it depicted "the truth, the whole truth, and nothing but the truth," how could photography claim to be an art? From such simple origins grew a sophisticated debate which, in some form or another, has survived to this day. So also have the illusions about photography and truth. Photographers still nourish them occasionally, and tend now to concede that the camera can manifestly lie, while maintaining that in their own hands it generally doesn't.

Lofty pretensions make tempting targets for humor; cartoonists had a happy time puncturing delusions of grandeur in photographer and client alike, and raising gales of heartless merriment over technical flaws in the incompetent, and practiced deceptions by the proficient.

When photographs were first seen by an eager public, they did, indeed, impress everyone by

the verisimilitude of their renderings, far beyond the capabilities of any painter, even though the colors of the universe were mysteriously missing, and their absence was mourned (Henisch 1996). "A good likeness" was what most clients wanted above all else, at any rate in theory. To name the goal was easy; to achieve it was quite another matter. Misgivings were soon voiced about the sense in which a studio photograph could ever be "true," considering the uncomfortable pose of the client, the unfamiliar setting that often seemed downright unfriendly, and the photographer's own injunction to keep rigidly still at all cost. And even though early photographers might aim at a good likeness, their objectives were frustrated at first by the insensitivity of the plates and later, indeed, by their sensitivity. The former drawback made it necessary for sitters to assume unnaturally stiff positions that could be held during the long exposures; the latter tended to produce trivial snapshots, where icons were called for.

The conflicting expectations of customers, and the often unexpected results of studio work, gave rise to a great deal of day-to-day frustration, but also to an endless stream of amusement. Furthermore, photographers took advantage of the fact that the temporary truth of the studio did not have to conform to the more lasting truths of actual life; they used artificial scenery and became masters of make-believe.

> He took her picture in a chair,
> With books and works of art around;
> The proof, she said, was more than fair,
> But then no atmosphere was found.
>
> He took her picture on a rock,
> A stream and rustic bridge behind.
> It gave her nerves a frightful shock
> Because there was no soughing wind.
>
> He took her picture in the sand,
> A nymph disporting by the shores,
> The scene, she cried, was nice and grand;
> It only lacked the ocean's roar.

And yet, the bard concludes, scenery, whether natural or artificial, is not necessarily the all-important ingredient:

> He took her picture by flashlight,
> Where smoke and smell will often linger.
> Her joy was boundless, out of sight;
> It showed the gem upon her finger!
> (Extract from "Her Picture," by
> Homer Fort [1900]; Ruby [1989])

There was also the question of whether either the studio photographer or the client, notwithstanding all protestations, really wanted "the truth and nothing but the truth" on their photographs, considering that reputations were involved, prestige, and last but not least, money. The protagonists, when confronted with the facts, often found the naked truth decidedly unpalatable. Figs. 3-1 a and b address themselves to that point, and to some of the delicate problems it can create, but there *were* occasions when both sides were satisfied with the outcome. One such is described in the following extract from an anonymous 1875 "poem," which is true to life, but somehow manages to avoid ostentatious symptoms of literary craftsmanship:

> Dear Kitty, by this you will see that I'm
> taken,
> But not up for murder, or fighting, or
> drink;
> It's up in a room on a glass that I'm taken,
> And faith 'tis a very good likeness, I think.
>
>
>
> The gentleman axed me to be pleased to
> keep steady;
> He clap't a could crutch to the back of my
> neck.
> I'm sure he thought I was intoxicated,
> For that was to keep my head steady, he
> said.
>
>

(a)

(b)

FIG. 3-1 (a)–(b). Facts of Life; Facts of the Studio.
(a) Cartoon from *Punch,* April 26, 1862.
(b) "Dangerous Compliment," German woodcut of about 1880. Scheid (1983). Courtesy of Uwe Scheid. SHE: "Don't you think I look a bit silly in this photograph?" HE: "Oh, I find it a brilliant likeness."

Then he took direct aim with his
blunderbuss at me.
I jump'd from the chair crying, "Murther!
you shan't
Take my life". "Don't be frightened", he
said, smiling at me;
"It is not your life, but your focus, I
want."

And then he completed his grand
operation
In less space of time than a minute could
pass.
He held in his hand my identification;
And sure enough there was myself on the
glass.

<div align="right">(Ruby 1989)</div>

"But it ain't necessarily so" and, as if to prove it, *The Photographic Times* of October 19, 1894, quotes a subtle piece from the *Pittsburgh Chronicle-Telegraph:*

A Great Recommendation

MISS DUKANE: I want to have some photographs taken. Where would you go?
MISS HUMLY: I'd go to Mr. Snapshot if I were you. He made some perfectly lovely pictures of me.
MISS DUKANE: Did he really? Well, if he is such a clever artist as that, I'll go there too.

<div align="right">(Weprich 1995)</div>

The Pittsburgh paper was taking a lead from "Mr." *Punch,* whose own version of January 1, 1887 ran:

Now which of these two photographs of you may *I* have, Dearest? The beautiful one, or the one as I know you?

The theme proved inexhaustible, and internationally popular.

WIFE: Don't you think I look rather silly on this photograph?

HUSBAND: Oh, I find it is a brilliant likeness.

<div align="right">(Fig. 3-1b)</div>

And there were other kinds of truth, of course, those better forgotten or, if not forgotten, best left unuttered, whether "reflectively" or otherwise:

FAIR CLIENT: I am always photographed from the same side, but I forget which!
SCOTCH PHOTOGRAPHER *(reflectively):* Well, it'll no be *this* side, I'm thinkin'. Maybe it's t'ither!

<div align="right">(*Punch,* November 22, 1890)</div>

Sensitive souls realized that "truth," with its aura of eternity, is a complex concept in an ever-changing world. In an attempt to deal with such problems, Percival Leigh (1862) anticipated Oscar Wilde by almost thirty years with what might be called the reverse side of *The Picture of Dorian Gray:*

To Charlotte, with Her Photograph

Depicted by the solar rays,
What loveliness this form displays!
The figure, what surpassing grace!
What radiant harmony the face!
Who such a likeness could have done?
No meaner artist than the sun.

You see yourself within this frame,
And, in a looking glass, the same.
The glass, though, must reflect your eyes,
Or straight the charming image flies:
But fixed you have your shadow here,
So that it cannot disappear.

This portrait as it is will last;
And, when some twice ten years have
passed,
Will truly show you what you were;
How elegant, how fresh and fair.
I wonder what the mirror will,
Compared with it, exhibit still.

Disconcertingly, cameras as well as mirrors can catch unwelcome changes. Miss Arabella says in a *Punch* cartoon of 1864: "They talk about improvements in photography. I don't see it. This picture of me isn't half as pretty as one I had taken twenty five years ago." Miss Arabella's recollection may have been mistaken; she could have been photographed in 1839, but it is rather unlikely.

Though most of the public was enchanted by the notion of ultimate and immutable truth recorded by the photograph, people with special insight not only recognized the limitations, but began to understand that, in one sense or another, every photograph is a lie. One who expressed misgivings was Mrs. Anna L. Snelling, wife of Henry H. Snelling, editor of *The Photographic Art Journal*, and author of an influential handbook (Snelling 1849). Palmquist (1989) comments: Anna Snelling "reminds us . . . of the impossibility of capturing the true spirit of life":

The Baby in Daguerreotype

What! put *her* in daguerreotype,
and victimize the pet!
Those ruby lips, so cherry-ripe,
On lifeless silver set!

The frisking, laughing, bouncing thing,
So full of life and glee—
A restless bird upon the wing—
A sunbeam on the sea!

Put shadows on that forehead fair—
 that look of quick surprise—
And give a dull unmeaning stare
 to those blue laughing eyes!

.

Give up the task—let childhood be
Nature's own blooming rose!
You cannot catch the spirit free,
Which only childhood knows.

Earth's shadows o'er that brow will pass
Then paint her at your will;
When time shall make her wish, alas!
She were a baby still.
(From *The Photographic Art Journal*,
Vol. 1, No. 2 [February 1851], p. 126)

Even without Great Thoughts about the passage of time, truth in the photographic studio proved to be an elusive prey, as Fig. 3-2a so vividly demonstrates. And just because it was known to be so, photographers took whatever pre-exposure measures they could to improve upon the truth. Those measures certainly included the provision of studio props and artificial backgrounds (Fig. 3-2b), or personal "templates" (Fig. 3-2c), or judicious editorial work on clients' faces. *Punch* of July 5, 1862, illustrates the point:

ARTIST! (PHOTOGRAPHIC): You've rather a Florid Complexion, Sir, but—*(producing a Flour Dredger to the old Gentleman's horror)* if you'll take a seat, we'll obviate that immediately.

To be sure, a flour dredger could be used to subdue post-alcoholic skin-tones, but there were other occasions when clients looked too pallid, rather than too florid. Fig. 3-2d shows one of the energetic attempts by a concerned helper to solve that particular problem, and bring a new and cheerful color to the face. We owe an early observation of "camera truths" to Edgar Degas, who produced a sketch after a carte-de-visite by Disdéri, a photograph in which the client had moved enough during the exposure to appear two-faced on the print; see McCauley (1985).

The renowned Wilhelm Busch lovingly conveyed the public's cynical but ambivalent reactions to the process (Fig. 3-3a; Kesting 1980). Busch's sentiments were to be poetically echoed in faraway Kansas, where George Downing, of

(a)

(b)

FIG. 3-2 (a)–(d). Camera Truths.

(a) "Too Swell for Anything," from the *Pittsburgh Post* of October 27, 1896. Weprich (1995).

(b) "In the Country, under Gaslight"; Himly's Studio, 1887. After Skopec (1963), Fig. 373.

(c)

(d)

Fig. 3-2 (c)–(d). (c) Truth Bent to Serve.
Method patented in New York by
A. Coolidge in 1884. Various templates of
this kind were offered for sale. After Skopec
(1963), Fig. 350.

(d) "The Magic of Color." Cartoon
illustration from *Twenty-three Years under
a Skylight, or Life and Experiences of a
Photographer.* Rodgers (1872).

(a)

und neue Zylinder.

Er arrangiert die Neuverlobten, und wohlgelungen
wäre die Gruppe, hätte nicht das männliche Objekt
der Kunst die rechte untere Extremität eigenmächtig
nach vorne geschoben.

(b)

FIG. 3-3 (a)–(c). Wilhelm Busch: "Honor the
Photographer; He Can't Help Himself."
 (a) From *Fliegende Blätter*, 1871. Kesting (1980).
 (b) From *Fliegende Blätter*, 1871. Coke (1995).
 (c) From *Fliegende Blätter*, 1871. Coke (1995).

Topeka, offered a solution to the problem of the
photographic facelift:

> The good times are coming, mother,
> Pretty photographs are all the go,
> So taller [tallow] my nose, dear mother,
> 'Twill reduce its size, you know.
> <div align="right">(Filippelli 1981)</div>

Wilhelm Busch (1832–1908), a talented
painter who, indeed, took a special interest in
photography, drew a whole series of cartoons
under the title "Ehre dem Photographen, denn
er kann nichts dafür," which, freely translated,
reads: "Honor (forgive) the photographer; he
can't help himself." Busch himself explained his
enigmatic slogan by adding: "How often we crit-
icize the photographer, and how unjustly. The
photographer is really a painter, because he
paints (faces)" So far so good, but he adds
an even more damaging afterthought: "Man is
the object; the camera does everything; the
photographer [then] sells the results."

Among Busch's favorite targets: distortions of
the sort that can arise from unfortunate camera
positions (Fig. 3-3b); two others were the tech-

Fertig!

"Hier ist die Platte!"

Fig. 3-3 (c)

yet, as Krauss (1978) points out, he was really the only major figure in this field in the German realm until 1896, when a new journal, *Der Simplizissimus*, offered fresh scope to other cartoon artists. In the United States, a corresponding role was filled by *Harper's New Monthly Magazine*. This, though a profoundly different type of publication, with a broad cultural mission, frequently published photographic cartoons, including some (e.g. in August 1856) very similar in sentiment, though not in style, to those of Wilhelm Busch (Palmquist 1980).

With great insight, a 1907 cartoon by Lucien Métivet (Mauner 1990) drew attention to the fact that the "truth" could be seriously compromised not simply by distorting pictures, but by altering the order in which they were presented to the viewer (Fig. 3-4a). And what if *two* truths were simultaneously presented? *Punch* of November 28, 1857, addresses just such a problem. The story concerns a case in which two stereo portraits were torn in half, with "a dead loss of three guineas," and then "wrongly" recombined, leading to the superposition (in an optical viewer) of a male and a female face, with dismal results. *Punch* actually shows "how the young husband and old Mrs. Jones would have looked, when, by the unitive effect of the stereoscope, their two physiognomies were rolled into one." In any event, and even without optical deception, truth has always been a complex concept. In Fig. 3-4b, an officer wants to be photographed in what he modestly describes as his "grandeur naturelle," but his concept of what is natural, and thus true, includes an ostentatious shako that he insists on wearing before the camera. And if a hat can symbolize status, so, certainly, can other much-loved props (Fig. 3-4c).

By and large, photographers contrived to produce studio images that were not substitute paintings, or snapshots, or sensitive characterizations, but rather archival records for the ever-open Museum of Human Life. One of the most powerful techniques was photomontage, which allowed photographic artists to make images that were realistic in one sense, but imaginative fantasy compositions in another. Fig. 3-5a

nique and ceremonial of posing clients. In one cartoon, Busch depicts a female customer who has evidently fallen asleep during the studio operator's interminable maneuvers, in another (Fig. 3-3c), he shows a gentleman client (Hanno von Hinkelsmark, no less) who collapses at the very moment of exposure. The idea that a client might actually fall asleep during the studio ordeal was widely popular; see, for example, Skopec (1963), fig. 251. Busch, we may safely conclude, was not an unreserved admirer of photographic art, and

Comme quoi les photographies successives d'un monsieur qui se fait débarrasser d'une abondante chevelure...

... peuvent fournir, à qui sait les disposer dans un ordre ingénieux, une excellente réclame pour une eau capillaire.

FIG. 3-4 (a)–(c). Studio Tricks; Illusion and Delusion.

(a) Cartoon by Lucien Métivet, published by the Librairie Félix Juven of Paris, 1907, as part of a series on "Les Maîtres Humoristes." The suggestion is that the order in which serial photographs are taken need not be the order in which they are finally presented to the viewer. Mauner (1990).

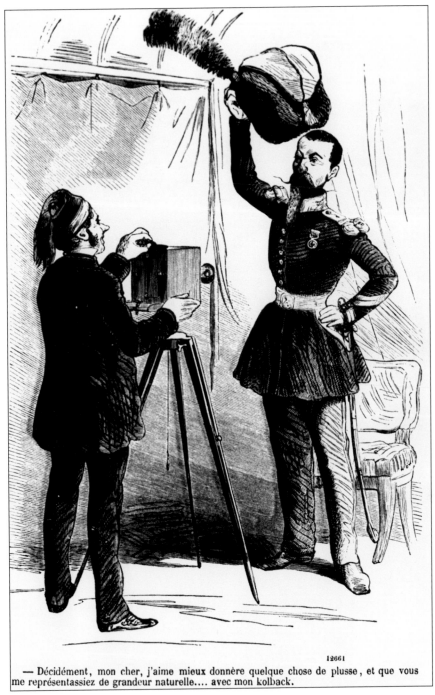

— Décidément, mon cher, j'aime mieux donnère quelque chose de plusse, et que vous me représentassiez de grandeur naturelle.... avec mon kolback.

FIG. 3-4. (b) Cartoon from the *Journal Amusant* of April 19, 1856. An officer wants to be photographed in what he modestly describes as his "grandeur naturelle." Coke (1995).

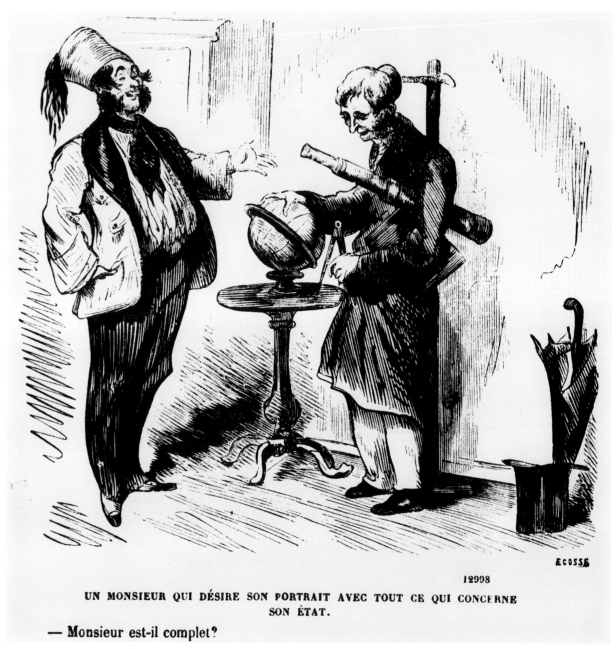

UN MONSIEUR QUI DÉSIRE SON PORTRAIT AVEC TOUT CE QUI CONCERNE
SON ÉTAT.

— Monsieur est-il complet?

FIG. 3-4. (c) Cartoon from "Fantaisies Photographiques" by Marcelin, *Journal Amusant*, c. 1860. Coke (1995).
Paraphernalia as status symbols.

shows a notable turn-of-the-century example, made undoubtedly in part as a bravado piece and in part to entertain (Kossoy 1978 and 1991). Enthusiasm for the method was truly international; Fig. 3-5b is from Russia, a dual self-portrait of c. 1897, and quite evidently intended as a photographic joke (Ashbee 1978). Valery Carrick, the Scottish-Russian photographer who made it, may well have been aware of earlier work by O. G. Rejlander of Wolverhampton in England, who undoubtedly counts as the father of the art (Jones 1973; Spencer 1985). His famous composite photograph "The Two Ways of Life" (being respectively Virtue and Vice) burst upon the scene in 1857 and opened exciting new territory for photographic art. One of his works, somewhat similar to the Carrick image, was made in 1871 and entitled "OGR the Artist introduces OGR the Volunteer." It shows Rejlander recruiting himself for the army. A great deal more subtle is Rejlander's c. 1860 montage "The Dream" (Fig. 3-6). It is at one level a joke about crinolines, and at another level a bachelor's nightmare, induced by the fear of being caught up in the cage of marriage.

Composite photographs, products of photomontage, were also celebrated in other contexts; thus, for instance, Francis Galton (in *Nature*, May 23, 1878) suggested that by superimposing portrait photographs of members of a group, a record of common characteristics could be achieved, "bringing into evidence all the traits on which there is agreement, and leaving but a ghost of a trace of individual peculiarities." Dr. Henry Pickering Bowditch (1840–1911), a distinguished professor of physiology at the Harvard Medical School, picked up this apparently fertile idea and produced, by photographic superposition, a composite photograph of a "typical" Boston doctor (Bowditch 1894; Wilsher 1981; Henisch 1994). "J.S.P." addressed himself to a far more desirable objective, allegedly achievable by the same means, namely the creation of an ideal portrait, the essence of female beauty. In a poem in *Puck* (1887, p. 132), he pours out his heart over the tempting possibilities of composite affection matched to composite image.

Composite Photography

Composite sunshine, sweetness
 superposed,
The sum of nine-and-forty girlish faces,
A thousand bits of loveliness disclosed—
A world of charms—a galaxy of graces!

The grand soul windows of a college
 queen
Are mirthful with Miss Madcap's merry
 twinkle,
A stately Edith's lofty brow serene
Has just a shadow of Miss Deepdigge's
 wrinkle.

Here saucy Betty's scornful nose atilt,
Defies grave Gertrude's tender, sad
 expression,
And languid Maud, who looks as she
 would wilt,
Is fortified by Abigail's aggression.

Oh, lucky alchemist of later years,
Whose task it is to blend these rarer
 simples—
Smooth tresses, laughing lips, and dainty
 ears,
Round, rosy cheeks and most bewitching
 dimples!

Dear girls, I well could love you every one,
But though a cynic, with a heart of leather,
Beholding this blest magic of the sun,
I'd love you—love you madly all together!
 J.S.P.
 (Collins 1986)

The fact that photomontage could also be used as a tool for political commentary was quickly grasped, as can be seen from an anonymous piece that appeared in a British journal about an Abraham Lincoln photograph:

A New York Photographer has published a portrait of President Lincoln, which is likely to prove acceptable to all parties. At first glance it appears to be a photograph of "Old Abe", taken when he had the small-pox a few

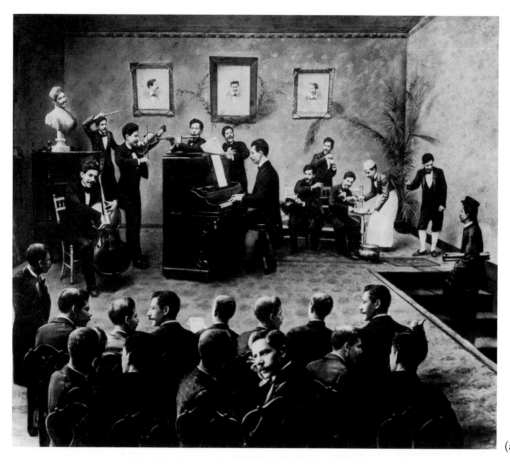

(a)

(b)

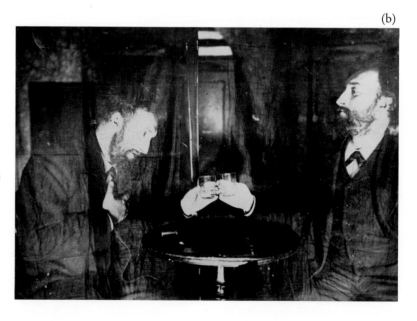

FIG. 3-5 (a)–(b). Photomontage in the
Hands of the Humorist I.

(a) "Os 30 Valérios," montage by
Valério Vieira. Turn of the century.
Kossoy (1978).

(b) Russian dual self-portrait montage
by Valery V. Carrick (1869–1942),
c. 1897. Valery Carrick was the son of
William Carrick, well-known Scottish
photographer in Russia, and recorder of
"Russian Types." Courtesy of Felicity
Ashbee.

FIG. 3-6. Photomontage in the Hands of the Humorist II. "The Dream" by O. G. Rejlander, c. 1860. The tiny figures on the crinoline threaten the somnolent bachelor with prospects of matrimony. Courtesy of George Eastman House. (No. 13984)

months ago; but on a closer examination the seeming pustules are found to be minute photographic likenesses of distinguished generals, statesmen, politicians, literary and scientific men, actors, actresses, etc. The likenesses, which are scattered all over the physiognomy of the President, number upwards of 400, and comprise men of all parties and professions, and are so exceedingly well executed as to be at once recognized. Although the individual likenesses are in most cases so excellent, yet, taken together, they constitute as ugly a picture of "Old Abe" as any of the others that have been published. (Anon. 1864)

See also Chapters 6 and 7 for other examples of the political photographic joke.

On the verbal front, the studio photographer's familiar command, "Don't move," or "Don't move now," was widely parodied in election campaigns as a mock exhortation for people to vote for conservative parties; see Braive (1966). At times, the exhortation could also be misunderstood and quite ludicrously misapplied (Fig. 3-7). Potent as it was, while it reigned, it was in due course replaced by another, and equally deceptive, exhortation, namely "Smile, please," or "Bitte recht freundlich" (Fig. 3-8a) in a German advertisement of

FIG. 3-7. "The Difficult Moment." Cartoon by Lucien Métivet, from *Le Rire*, April 1902. The cake, in mid-career, is exhorted to keep still during the exposure.

it's *only* for a *moment!*" The theme was pursued with endless variations. Thus: photographer to elderly lady: "Please make a friendly face." Son-in-law, waiting in the studio: "That, I'll want to see!" Alternatively (in *Gossip* [Washington], Vol. 1, No. 16, July 18, 1891), photographer to grim client: "Can't you assume a more pleasant expression than that? Just think of your best girl a few minutes." Young man, sadly: "It wouldn't do any good. She refused me about a week ago."

To a photographer, the exhortation made good sense, and since the verbal encouragement was not always effective, other steps could be taken to ensure the same results. Fig. 3-8b, for instance, shows a German client, glum at first, but smiling expectantly when shown objects of his dreams, projected by a lantern slide. Even the dog is moved by the prospect. Of course, opportunities for misunderstanding abound; there are special situations in which the photographer's encouragement to "Be Yourself" is not meant to be taken literally (Fig. 3-8c).

1894. The change reflected not at all a mellowing of the photographer's mood, but an increase in the speed of photographic media. Thus were icons made for eternity replaced by snapshots of (and often for) the moment. Sack (1979) has written engagingly about the resulting change in studio atmosphere, and the fun poked at each form of photographic practice, and has pointed out how utterly absurd it would have been for a traditional portrait painter to say "Smile please" to a client. Other exhortations could be tried. Thus, in an 1890 woodcut, showing a pair of newlyweds being photographed in front of the frozen Niagara Falls (Color Plate 3-8d), the photographer says, without any intended sarcasm, one may be sure, "Please look as far as possible as if you were in love"; Scheid (1983). A *Punch* (May 17, 1890, p. 237) variant: "Please look a little pleasant, Miss. I *know* it's hard, but

FIG. 3-8 (a)–(c). Pre-exposure Persuasion.
(a) "Bitte recht freundlich"; advertisement of the early snapshot era, Breslau, Germany, 1894. Lebeck (1979).

FIG. 3-8. (b) The power of the Magic Lantern. *Above:* glum client; *Below:* cheerful client, with his sights on happiness to come. From *Fliegende Blätter,* December 1891.

FIG. 3-8. (c) "The Inconvenient Consequences of Photographing a *malfacteur*, after the invitation 'Be Yourself!'" Wood-engraving by Cham (Count Amédée de Noé), *Charivari*, April 14, 1861. See also McCauley (1985).
See also Color Plate 3-8 (d).

The last word on the studio situation and its poignant dilemmas was delivered by the *St. Louis and Canadian Photographer* of June 1900:

The Modern Photograph

The lady and the photographer.

THE LADY: I desire a sitting.

THE PHOTOGRAPHER: Yes, madam. Any particular style?

THE LADY: The style that will bring the best results, of course.

THE PHOTOGRAPHER: Full face, quarter face, profile?

THE LADY: All of them. Then I can pick the best.

THE PHOTOGRAPHER: Very well, madam; will you sit now?

THE LADY: Mercy, no; I am not prepared for it. I'm having a special dress made. And, of course, I must materially alter my complexion. Then I want my hair powdered on this side and darkened on that.

THE PHOTOGRAPHER: Yes, madam.

THE LADY: And you can smooth out all these wrinkles, and clear away this mole, and lift the corners of my mouth, can't you?

THE PHOTOGRAPHER: We can do all that in the retouching, madam.

THE LADY: So I supposed. And you notice that one of my ears is a little lopsided and will have to be straightened. And the curve of my nose must be softened, and the crease in my double chin obliterated.

THE PHOTOGRAPHER: Yes, madam.

THE LADY: Of course, I want my eyebrows darkened, and my eyelashes lengthened, and a sort of peachbloom finish given to the entire face.

THE PHOTOGRAPHER: And may I ask, madam, how—with all this—you expect to get an accurate likeness?

THE LADY (*haughtily*): That's your business, sir.

THE PHOTOGRAPHER (*asserting himself [they rarely do]*): Well, madam, I really don't see that there will be any necessity for a sitting at all.

THE LADY: What do you mean by that?

THE PHOTOGRAPHER, (*with emphasized sarcasm*): I mean that I have a young and pretty woman in attendance here who can sit in your place with just as satisfactory results.

Whereupon the lady sniffs and flounces out.

(Weprich 1995)

Even more than the photographing of humdrum clients, portraiture of the High-and-Mighty has always been a delicate business. On the face of things, photographers were always managers of the scene, but there were occasions when they saw themselves less as successful generals and more as downtrodden conscripts. (Fig. 3-9; see also Color Plate 5-17 and Fig. 5-19)

Of course, most of the interactions between photography and politics were not humorous at all, but even serious situations sometimes had a frivolous outcome. One such has been described

by English (1981), in the course of an extensive study of political photography in France during the 1871–1914 period. On November 23, 1889, *Le Figaro* published a highly controversial photo-interview of General Boulanger, conducted by Paul Nadar (son of Félix). The General was also a political figure, and the article contained eighteen photographs of him in various poses, while he was answering questions put to him by a journalist. Photo-interviews were a novelty, and a startling experience for a public used to the stiff studio portrait. The entire practice was soon attacked by the rival press on a variety of grounds. Among other things, the informality of the process was regarded as undignified, and attempts to ridicule Boulanger were quickly made by a competing journal (Fig. 3-10a), using a standard tool in the cartoonist's armory, imaginative exaggeration. The emphasis here is not on the camera, but on the attitudes, with the implication that in the informal atmosphere of a photo-interview, the General might as well make himself thoroughly and, indeed, domestically comfortable. It was also charged that the photo-interview was merely a vulgar device used by *Le Figaro* to boost its circulation. The issue remained alive for a surprisingly long time; even two years later, *Le Grelot* published a cartoon (Fig. 3-10b) that referred back to the famous interview, and supplied the ultimate pose, in which the General would shoot himself in the head, rather than "in the foot," as had previously been alleged.

From the beginning, albeit not in daguerreotype circles, photographers and their public were intrigued by the word "negative," and its inherent ambiguity. Figs. 3-11 a and b explore its possibilities in the respective styles of their periods, and testify to the remarkable durability of the theme, indeed, into modern times. On October 12, 1876, *Punch* pontificated: "Logicians tell us that two Negatives make an Affirmative. Will somebody say how many Negatives make a Photographer?" Enough? No, 16 years later, *Punch* was still at it (*Punch's Almanack* for 1892,

FIG. 3-9. Photographing the High and Mighty; Management of the Photographer by His Clients. Cartoon by V. Rotkirch of Lithuania, 1854, referring to an episode in which the photographer was asked to daguerreotype the Company of Princes, only to run into assorted troubles with his clients, too high in rank to be marshaled and disciplined. Courtesy of Vilnius University Library. See also Juodakis (1977).

Vol. 102), though with a slightly different twist, in the context of "Mr. Punch's Handbook of Definitions, for the use of young writers": "Though a man who always says 'No' cannot be considered a good fellow, yet a photograph may be described as a proof of *cameraderie* [*sic*], based on nothing but negatives."

Harper's New Monthly Magazine (Vol. 13, No. 76, 1856, p. 845) took the linguistic dilemma very seriously, and published a sage and ponderous comment:

The word *negative,* which the photographer applies to the first image which he obtains of

(a)

(b)

Fig. 3-10 (a)–(b). Comments on a famous photo-interview (itself a novelty) with General Boulanger, conducted by Paul Nadar, November 23, 1889.

(a) "Don't Move," composite cartoon by C. Gilbert-Martin from *Le Don Quichotte*, November 30, 1889.

(b) "The Last Pose," by Pepin, from *Le Grelot*, October 11, 1891.

(a)

FIG. 3-11 (a)–(b). Linguistic Confusion.

(a) From *Punch*, September 25, 1886. ARTIST *(in despair):* "Cruel Girl! For years I have tried to photograph your image in my 'eart—and all I get is a 'negative.'"

(b) French cartoon, 1950s, signed A. Duboiy, published by Les Jarres D'Or of 3 Rue D'Artois, Paris, in a "limited edition" of a mere 6,000 copies, "numbered 1 to 6000"! Courtesy of S. F. Spira.

— Alors? C'est toujours négatif?...

(b)

the subject, whatever it may be, that he is to photograph is rather a misnomer, inasmuch as the properties which characterize it, though striking and peculiar, do not seem very clearly to involve any idea of negation. If it had been called the *reverse,* instead of the negative, its name would have been perhaps more suggestive of its character. But the name negative is established, and must stand.

Worries about photographic truth could be used in a similar way, and in political contexts: Thus, *Punch* of July 17, 1865, commented: "It is remarkable that in view of the General Election, no eminent Photographer has put himself forward with a proposal to represent [*sic*] the people." In due course, "photographic truth" came to be caricatured not only by being questioned, but by being accepted. Fig. 3-12 is an example, aimed at Nadar, drawing attention not only to the unrelenting realism of the photographer's artistic preoccupation, but also to the trivia upon which photography lavishes the same loving attention that is traditionally reserved for important matters. In 1877, *The Photographic Times* made its own distinctive contribution to the dual debates about "Photography and Truth" on the one hand, and "Photography and Art" on the other (Fig. 3-13; Weprich 1995). The accompanying text describes an artist's progress, the development of his sensibilities:

1. In the infancy of photography, he became an enthusiastic amateur. His soul was ablaze with the artistic flame, and his mind was filled with dreams of vast panoramic views of Pre-Raphaelite distinctness. So he hired him a 60 × 82, and betook himself to the top of a mighty mountain. And he exposed.

2. He developed, and was hugely delighted with the result, for it was monstrous sharp and clear. "I can tell the hour by yonder clock twelve miles off," he chortled: "This is a Great Work" (capitals, please, Mr. Printer), "This is indeed Art."

FIG. 3-12. "Nadar, a Realist Painter," lovingly attending to trivia. From the *Journal Amusant,* January 1857, No. 55.

3. But as the years passed, and the pegtops came in, he grew dissatisfied with his Great Work. "Nay," he murmured, "it cannot be art because it is distinct and clear. Fuzziness is Art: Sharpness is commonplace. Alack!" So he turned the negative round, and printed it through the glass. And when he saw the results he wept for joy because it was so fuzzy. "This then is true Art," he exclaimed, "for none can tell what it is."

4. But as the years passed, and he looked at his Great Work in cold blood, it did not appear such a Great Work at all. "Art is immensity and Armitage," he mourned. "Art is all dominant and imposing. It must be enlarged and mounted upon a great white card." So he did this, and was satisfied.

5. But as the years passed, and he once again looked at his Great Work in more cold blood, he was filled with bitterness. "This

FIG. 3-13. The Artist's Progress.
 (1) An enthusiastic amateur.
 (2) In pursuit of photographic precision.
 (3) Conversion to the fuzzy-graph.
 (4) Conqueror of the wall.
 (5) Celebrating the meaningless fragment.
 Moral: "What true Art is, no one knoweth."
 From *The Photographic Times,* February 1877, p. 105. Weprich (1995).

largeness is not Art," he sorrowed, "Art is a jewel in a swine's snout, small, but of great value and beauty." So he smote the white mount with a pair of scissors, and cut down the Great Work till it was no longer a Great Work, physically speaking. And he framed it close up in a mahogany frame, and he was enraptured. "This, then, it appears," said he, "is True Art: I have got it at last." But as the years passed, etc., etc., etc.

MORAL: What True Art is, no one knoweth, for it altereth annually, like the time tables. For the Art which suited the Age of the Crinoline is not the Art which suiteth the Eon of the New Woman.

In a much earlier issue of *Punch* (October 6, 1860), there is a reference to the rivalry between photography and painting, and the social pretensions that accompany the photographer's professional status. The cartoon (by Du Maurier) shows a studio photographer (actually a Du Maurier self-portrait) in conversation with a smoking patron (a sketch portrait of Whistler, the painter).

PHOTOGRAPHER: No smoking here, Sir!

PATRON: Oh, a thousand pardons! I was not aware that

PHOTOGRAPHER *(interrupting with dignified severity):* Please remember, Gentlemen, that this is not a common Hartist's [Artist's] Studio!

Then, in parentheses, the caption goes on to say: "The Patron and his friends who *are* Common

Ever after, when depressed, drinks a bottle of Dr. Dipps, and Shoots his own Daguerreotype.

FIG. 3-14. Final sketch from a cartoon series entitled "Noodle's Attempts at Suicide"; the ultimate art-critical self-assessment. *Harper's New Monthly Magazine,* February 1859. Palmquist (1980).

Artists feel shut up by the aristocratic distinction, which had not yet occurred to them"; Weprich (1995). The cartoon was reprinted in *The Photographic Times* of January 1897 (p. 44) and thereby, albeit a little late, introduced to members of a new audience, who were expected to view it from their own perspective. It was pointed out that, incidentally, this was Du Maurier's very first published drawing.

In extreme cases, "truth" in a photograph, supposedly desired by all and sundry, though hardly ever without reservations, could turn out to be so unacceptable as to lead a studio client not only to indignation, but to suicide by proxy (Fig. 3-14), the ultimate art-critical response.

Chapter 3 Notes and References

ANON. (1864). *The British Journal of Photography,* August 26, p. 321.

ASHBEE, F. (1978). Personal communication, acknowledged with thanks.

BOWDITCH, H. P. (1894). "Are Composite Photographs Typical Pictures?", *McClure's Magazine,* September, p. 331.

BRAIVE, M. F. (1966). *The Era of the Photograph; a Social History,* Thames & Hudson, London, p. 18.

COKE, V. D. (1995). Personal communication, acknowledged with thanks.

COLLINS, K. (1986). Personal communication, acknowledged with thanks.

ENGLISH, D. E. (1981). *Political Uses of Photography in the Third French Republic, 1871–1914,* UMI Research Press, Ann Arbor, Mich., pp. 120–38.

FILIPPELLI, R. (1981). "Greenback Shutterbug," *History of Photography,* Vol. 5, No. 3, p. 263.

FORT, H. (1900). "Her Picture," *Recreations,* Vol. 14, December, reprinted from an earlier issue of the *New York Herald.*

HENISCH, H. K. and B. A. (1994). *The Photographic Experience, 1839–1914; Images and Attitudes,* The Pennsylvania State University Press, University Park, Pa., pp. 46–47.

HENISCH, H. K. and B. A. (1996). *The Painted Photograph, 1839–1914; Origins, Techniques, Aspirations,* The Pennsylvania State University Press, University Park, Pa.

JONES, E. Y. (1973). *Father of Art Photography: O. G. Rejlander, 1813–1875,* David & Charles, Newton Abbott, U.K.

JUODAKIS, V. (1977). "Early Photography in Eastern Europe; Lithuania," *History of Photography,* Vol. 1, No. 3, pp. 235–47, Fig. 1.

KESTING, M. (1980). *Die Diktatur der Photographie; von der Nachahmung der Kunst bis zu ihrer Überwältigung,* R. Piper & Co. Verlag, Munich and Zürich.

KOSSOY, B. (1978). "Os 30 Valérios," *History of Photography,* Vol. 2, No. 2, p. 22.

KOSSOY, B. (1991). Personal communication, acknowledged with thanks.

KRAUSS, R. H. (1978). *Die Fotografie in der Karikatur* (Foreword by Bernd Lohse), Heering Verlag, Seebruck-am-Chiemsee, Germany, p. 46.

LEBECK, R. (1979). *Bitte recht freundlich,* Harenberg Kommunikationen, Dortmund, Germany.

LEIGH, P. (1862). "To Charlotte with Her Photograph," *Punch,* April 26.

MAUNER, G. (1990). "Mysteries of Publicity," *History of Photography,* Vol. 14, No. 4, p. 308.

McCAULEY, E. A. (1985). *A. A. E. Disdéri and the Carte de Visite Portrait Photograph,* Yale University Press, New Haven (Conn.) and London, pp. 49, 155, 156.

PALMQUIST, P. E. (1980). "Photography, as seen by Caricaturists in Harper's New Monthly Magazine," *History of Photography,* Vol. 4, No. 4, pp. 325–28.

PALMQUIST, P. E. (ed.) (1989). *Camera Fiends and Kodak Girls; 50 Selections By and About Women in Photography, 1840–1930,* Midmarch Arts Press, New York, pp. 13–14.

RODGERS, H. J. (1872). *Twenty-three Years Under a Skylight, or Life and Experiences of a Photographer,* H. J. Rodgers, Hartford, Conn. (1973 reprint by Arno Press, New York).

RUBY, J. (1989). Personal communication, acknowledged with thanks.

SACK, M. (1979). "Glückliche Augenblicke," afterword in Lebeck (1979), pp. 165–71.

SCHEID, U. (1983). *Als Photographieren noch ein Abenteuer war; aus den Kindertagen der Photographie,* Harenberg Kommunikationen, Dortmund, Germany, pp. 61, 131.

SKOPEC, R. (1963). *The History of Photography in Pictures, from the Earliest Times to Today,* Orbis, Prague, Figs. 251, 350, 373.

SNELLING, H. H. (1849). *The History and Practice of the Art of Photography,* 1970 reprint by Morgan & Morgan, Hastings-on-Hudson, N.Y.

SPENCER, S. (1985). *O. G. Rejlander; Photography as Art,* UMI Research Press, Ann Arbor, Mich.

WEPRICH, T. M. (1995). Personal communication, acknowledged with thanks.

WILSHER. A. (1981). "Look Here, Upon This Picture, and on This," *History of Photography,* Vol. 5, No. 3, p. 209.

4

MERRY MARKETING, STUDIO SEDUCTION

No nineteenth-century photographers worth their salt would have yielded an inch of the claim that photography was an art, and entitled to the same respect ordinarily accorded to painting. However, because even an artist had to eat, photographic art and photographic business soon came to be closely linked with one another. The business side was, to be sure, utterly serious, but it was grasped from the first that comedy could be used to catch a customer, and there are many light-hearted touches on record, sometimes actually intended to be entertaining, sometimes not. For the occasional element of humor, there were essentially four vehicles: the decora-

tive device, the cartoon, the photograph, and the cartoon derived from a photograph.

Eyecatching publicity, whether regarded as humorous by the public or not, was often found on the *versos* of cartes-de-visite and cabinet cards. In most cases, perhaps wisely, the names of the designers are nowhere to be found. Fig. 4-1a may not have been intended as a joke, and certainly the much later newspaper notice in Fig. 4-1b was not, but neither can now be seen without a smile. Fig. 4-1a depicts the photographer staking his claim to a place on Mount Parnassus, and in the Groves of Academe, as a close associate of painting (symbolized by the easel), music

(a)

FIG. 4-1 (a)–(b). Aspects of the Public Image.

(a) Cabinet-card verso of the 1880s, with a design that symbolizes the close relationship (in intent, if not always in fact) between photography and painting. Note the owl, for wisdom, at the top left.

(b) Advertisement for ICA Focusing Spectacles, 1922; the garb of *homo photographicus.* The invention somehow failed to gain real popularity. Cornwall (1976).

(b)

FIG. 4-2. Carte-de-visite verso of the 1870s. Note the internationally popular sunburst symbol. It refers to the old notion of photography as "sun painting."

deal in the course of time, and many an emblem accepted as serious in Victorian days now seems full of whimsy and incongruity, raising a smile that it was perhaps not intended to evoke. Alas, the converse is also true; examples abound of nineteenth-century humor that leave the twentieth-century audience puzzled, cold, and just occasionally jarred.

The endearing absurdities perceived by modern eyes in allegorical owls and sunbursts can also be found in the use of *putti* as busy little helpers in the well-regulated studio or darkroom. Painters had long delighted in filling the corners of their work with these creatures, each playing with the tools of his trade, the sculptor's mallet or the musician's lute, and photographers borrowed the charming convention. Fig. 4-3a is a good example, an amiable group cultivating the arts, with photography prominently included (Mauner 1981). And yet, the photographer (a child, rather than a genuine *putto*, since he lacks wings) is here paying tribute to the traditional muses, in close association, but without being actually one of them; he takes a picture of his gifted cousins. As Mauner points out, at the date this little vignette appeared (1866) it was already a compliment for photography to be included at all among the arts, rather than among new technologies, which are featured elsewhere on a fullpage design in the *Atlas National,* of which this illustration shows a detail. The later Fig. 4-3b "has everything," including a painted portrait. The winged client-*putto* on the right is evidently preparing for a delicate balancing act, to be duly captured on camera by the photographer-*putto* on the left, while the painter-*putto* paints. Other photo-*putti* are shown in Figs. 4-3 c and d.

Fig. 4-3e shows photo-*putti* very differently employed, in a trade emblem designed before cherubs were unionized and made conscious of their civil rights (Palmquist 1990). At some stage, around the turn of the century, the playful photo-*putto* turned into a businesslike photognome (Fig. 4-3f), gnomes being the German counterparts to the popular American Kodak

(symbolized by the lyre), and all-purpose wisdom (represented by the owl and the mortar board). The three enigmatic heads on the pot are still open to iconographic interpretation.

Since photographs were regarded as "sun paintings" for several decades after their invention, room had to be found for the all-important heavenly body in photographic emblems; Fig. 4-2 shows an 1870s example in which the camera, the palette, and the sun are in particularly close association. The sun was a symbol, rather than a joke, but sensibilities have changed a great

Brownies (Lothrop 1973). Mythical creatures of all sorts had been useful collaborators for some time. Thus, Henry Taunt used the "Old Father Thames" character (actually a river god, rather than a common or garden gnome) as part of his own logo in the 1880s and 1890s, because his firm specialized in photographic studies of the Thames Valley (Fig. 4-3g; Read 1989).

Just occasionally one finds a special design genre, involving *putti* bystanders and a veritable salvo of cartes-de-visite, discharged by the camera (Figs. 4-3 h and i). In Fig. 4-3j, the actors in the scene are little people, cast in roles more often filled by *putti*-players; see Darrah (1981). In Fig. 4-3k, one of the most famous of the genre, Marcelin compares the *putto* who paints with the *putto* who photographs. Painter-*putto*'s efforts result in a gracious, romantic portrait; Photo-*putto*'s in a grim, disheartening mugshot. However, Photo-*putto* does have a residual sensitivity to beauty, and while he is about it, he actually takes a photograph (let us hope a kind one) of his picturesque colleague.

From time to time one comes across gentle humor of a more subtle variety as shown, for instance, in Fig. 4-4a. All the usual elements are there, the palette, the brushes, the painter's easel, the sunburst and, of course, the camera, but there is more. The photographer himself, sitting in a conventional studio chair of the nineteenth century, dressed (for reasons best known to his tailor, and to his family, the Knickerbockers of Old New York) in eighteenth-century clothes, is about to light himself a pipe. Printed within the sunburst is the cosmic response to this act, a motto reading: "ET FACTA EST LUX" ("and there was light"). See also Henisch (1994). In Fig. 4-4a, the sun inspires the artist; in Fig. 4-4b it illuminates the scene; in Fig. 4-4c it works its magic on a glass negative; in Fig. 4-4d it plays the part of an overworked, underpaid assistant collecting contributions for the best possible cause: cleaning up sunspots. The overworked sun proved to be a popular theme. Scheid (1983) shows a much fatigued heavenly body complain-

FIG. 4-3 (a)–(k). *Putti* at Work and Play.
(a) Detail from the title page of the *Atlas National,* by V. Levasseur, Paris, 1866, published by Pelissier Editeur. Design by Eugène Duchez. Mauner (1981).

ing: "Woe, how I have to labor from morning to night, no peace for even a quarter of an hour is granted to me by photographers."

If the sun was a benefactor, it also had its critics, and could be blamed for occasionally dismal results. Johann Nestroy, in his 1847 work, "Der Schützling," expands with relish on that theme, and says (in dialect):

> Doch wird's d'Sonn weit bring'n in der
> Kunst?
> Ich sag' nein!
> "G'schwind und billig" ist kein
> Wahlspruch,
> Wenn man Künstler will sein.

(Is the sun going to get far in the realm of art? I say: no! "Quick and cheap" is no motto [for anyone] who wants to be an artist.)

Nestroy adds that the sun, all its virtues aside, has much on its conscience.

Along similar but strictly nonpoetic lines,

Fig. 4-3. (b) Carte-de-visite verso of the 1870s.

Fig. 4-3. (c) Cabinet-card verso of the 1880s.

FIG. 4-3. (d) Early-twentieth-century Kodak advertisement.

FIG. 4-3. (e) Cherub Chain Gang. Trade emblem, undated, but obviously made before cherubs were properly unionized and conscious of their civil rights. Palmquist (1990). Courtesy of Peter E. Palmquist.

FIG. 4-3. (f) Advertisement for the German Gnom Hand Camera, 1900.

Koppen (1987) quotes an 1846 letter sent by Alexander von Ungern-Sternberg to the famous Swedish chemist Berzelius, in which he says:

> They have made the sun into a portrait painter! Oh, what an unfortunate idea. How well does she paint? It could be that a splendid sun turns out to be a thoroughly dismal painter.

Bad enough, but the French writer Camille Recht, quoted by Stenger (1938), went a step further in his condemnation. He knew his school Latin and, with an eye on the sun, said: "Puritans have called photography an invention of the devil; they would have done better to call it an invention of Lucifer."

Another German writer, Oskar Pletsch, also found in Stenger, referred in 1862 to the sun's reluctant role, saying about a studio client:

> Er kann sein Bild bezahlen,
> Drum muß die Sonne malen,
> Doch schüttelt sie das Haupt und spricht:
> "Ich tu's, doch gerne tu ich's nicht".

He [the client] pays for his picture, and that's why the sun has got to paint. She [the sun] shakes her head and says: "I'll do it, but not gladly."

There was just no way in which *Punch* could be kept out of the sun-worshiper's tangled

Father Thames sitting to Henry W. Taunt for his Photograph.

Henry W. Taunt's

ARTISTIC PHOTOGRAPHS OF

THAMES SCENERY,

EMBRACE EVERY POINT OF INTEREST,

From Thames Head to the Nore.

THIS SERIES NOW NUMBERS OVER FOUR THOUSAND VIEWS.

Extract from letter:—

"Your photographs are by far the finest published of our dear Old Father Thames."

CATALOGUES GRATIS AND POST FREE.

SELECTIONS SENT ON APPROVAL.

HENRY W. TAUNT & CO., OXFORD.

FIG. 4-3. (g) Broadside and logo (c. 1880) used by Henry W. Taunt, Oxford, prolific photographer of the Thames from the late 1850s onward. Read (1989).

FIG. 4-3. (h) Card-salvo advertising logo of
L. E. Jackman, Springfield, Vermont, c. 1872.
Darrah (1981).

(i) Card-salvo advertising logo of Carl Forell,
Galesburg, Illinois, c. 1873. Darrah (1981).

(j) Studio-in-a-lucky-horseshoe motif. Arthur
A. Glines, Newton, Massachusetts, 1881.
Darrah (1981).

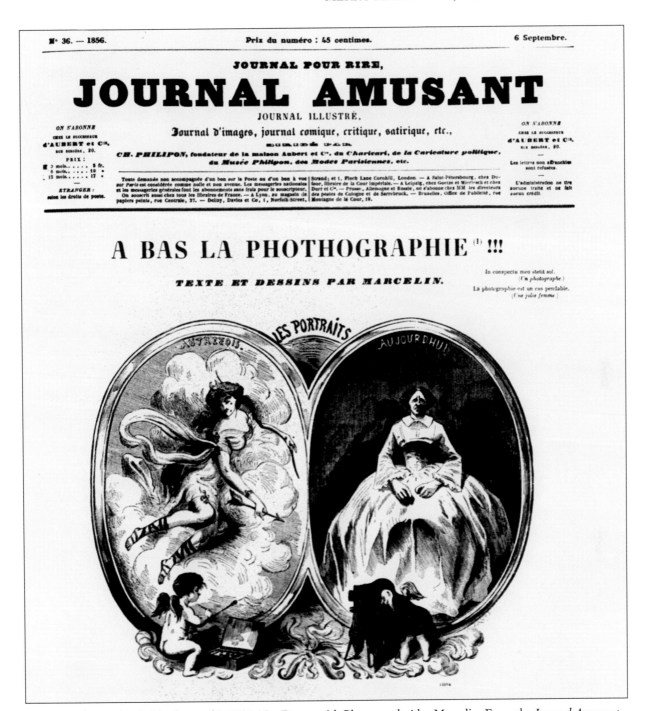

FIG. 4-3. (k) "A bas la Phothographie!!!" [*sic*]—Down with Photography! by Marcelin. From the *Journal Amusant*, September 6, 1856. Marcelin here compares the *putto* who paints with the *putto* who photographs. Stelts (1990).

(b) Advertising emblem used by the Finnish photographer Albert Edelfelt, 1895–96. Hirn (1977).

FIG. 4-4 (a)–(g). The Ubiquitous Sunburst.

(a) Fredrick's Pun. Advertising design used by Fredrick's Knickerbocker Family Portrait Gallery of Broadway, New York, 1881. All the familiar elements are present: sunburst, easel, camera, posing chair, and the palette with brushes. In addition, the great master is here depicted in eighteenth-century costume, in the act of lighting himself a pipe under the comprehensive motto "ET FACTA EST LUX."

(c) The sun's way with a negative. From Skopec (1963).

FIG. 4-4. (d) Caricature relating to the activities of photographer and art-publisher G. Schauer, Berlin. From *Kladeradatsch*, 1860. Neite (1977).

(e) The Ultimate Sunburst; title page of *Photographic Pleasures*, by Cuthbert Bede (1855).

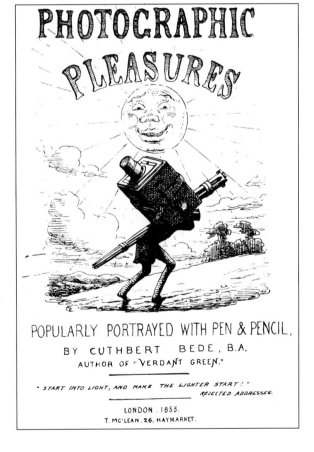

FIG. 4-4. (f) "Fine child for his age! Mons. Daguerre introduces his pet (sun) to Mr. Bull (the British public)." From *Photographic Pleasures,* Bede (1855).

relations with photography. On May 28, 1870, it published its own compassionate contribution:

On Photography to Phoebus

PHOEBUS APOLLO, King of Light benignant,
In glory seated, 'mid the solar blaze,
Lord of the Fine Arts, dost thou not,
 indignant,
Behold how mortal men profane thy rays?

O Phoebus, 'tis enough to drive thee
 furious
That we sun-pictures make of scoundrels
 thieves,

Whilst thine half-brother, eloquent
 Mercurius,
Nephew of Atlas, their Protector, grieves.

.

Vile notorieties, snobs, scenes of folly,
Displayed to gaping multitudes we see,
Dead brigands; objects yet more
 melancholy,
Live blackguards in show windows drawn
 by thee!

And, indeed, the concerns of the journal were not limited to social aesthetics: an open reader's letter in the February 15, 1868, issue, addressed

YOU can have beautiful PHOTOGRAPHIC LIKENESSES taken by the Daguerreotype process, in the most perfect style of the Art, embracing all the colours and beauties of nature; and perfect satisfaction given, or no charge, at *No. 6, Wellington Buildings*, King Street, for 12s. 6d.

☞ Ladies and Gentlemen are respectfully invited to call and examine Specimens.

.*. German Acchromatic Cameras, Chemicals, Plates and Cases furnished, and instruction given in the Art, on reasonable terms. Operating hours from 9, A. M., until 4, P. M., without regard to weather.

E. BURRITT.

Toronto, April 23, 1846. 570-m

Fig. 4-4. (g) Advertisement for E. Burritt, showing the sun painting a portrait of the world. From *The British Colonist*, April 28, 1846, Public Archives of Canada No. PA-118718.

to the Prime Minister, Mr. Disraeli, proposes a tax on photographs (following the precedent set in America a few years earlier, during the Civil War), and adds: "This will be taxing the Sun. He won't mind. He was very hurt about the Window Tax, which shut out his light, but that is all done away and forgotten. I, his moral representative, answer for him."

One of the early photographic sunbursts and, in a sense, the classic one, appears on the famous title page (Fig. 4-4e) of Cuthbert Bede's *Photographic Pleasures* (1855). Here the sun is in the driver's seat, beaming down heartlessly on his slave, the overburdened photographer. In the book itself, the roles are reversed, when Bede sketches a charming scene in which the sun has

become a child, so that Monsieur Daguerre can present his "Sun" to a client, none other than Mr. Bull, the embodiment of the British public (Fig. 4-4f).

In German lands, innocent fun could be made with the word *Sonnenstich* which, on the one hand, means sunstroke (and, by implication, an attack of madness) and, on the other, sun engraving, that is to say precisely the kind of work the sun was doing for photographers (Mauner 1979). A cartoon that showed the sun stroking the head of a cameraman with just a trace of malice appeared in an 1884 exhibition catalog, published in Vienna. In Fig. 4-4g, a very early Canadian advertisement depicts a confident but incompetent sun in the process of painting the world's portrait. With obvious reference to the photographer as the human embodiment of this heavenly power, a *Punch* notice of 1888 (June 30) calls an early practitioner "Mr. Sonnenschein," and describes him as being "in camera" while he is engaged under the black cloth, with the sun looking on.

In the noble cause of business, photographers occasionally designed advertising material that even poked gentle fun at their own profession. Fig. 4-5 shows four notable examples of that genre from different parts of the world, Down Under, Brazil, Spain, and, in a very different mode, America. For extensive anthologies of photographic advertising, see Gilbert (1970) and Cornwall (1976).

The photographic business thrived from the start by advertising itself to a wide public, partly by word-of-mouth, partly on the versos of photographs already made (as above), and partly through drawings and text in newspapers, before the days when photographs themselves could be photomechanically reproduced. All this was very well, but strong-arm tactics were needed from time to time, and many a city studio, always situated on the top floor to catch the best light, employed auxiliary staff at street level, essentially "hookers" (in the pure, original sense of the term), whose job it was to entice passersby upstairs to have their pictures taken. Fig.

4-6a shows a whole team of those in action, and making every attempt to persuade the prey that they were really doing it a favor. Here Mr. Punch seems to be mildly amused by the practice, but a little more than three years later his tone has noticeably darkened (Fig. 4-6b); see also Lansdell (1985). There is also a Cockney variant on the theme, in which a photo-hooker on the street in front of the studio shouts to a man with a horse and cart, saying: "Now, Sir! Ave yer Cart de visit done?" (*Punch*, June 29, 1861), a punning reference, of course, to the carte-de-visite. *Punch* did not, indeed, confine its protests to the cartoon medium, or to poetry; an article in the October 31, 1863, issue (p. 178) is full of righteous indignation in stark prose:

Photography with a New Face

The Photographic touters use persuasion now in addition to force, with the view of entrapping customers. They compliment the ladies, who imprudently pass their doors, on their good looks, and declare there never was a better occasion for having their portraits taken. It was not long ago, one of those pushing blackguards seized hold of an elderly lady by the arm, and accosted her rapturously thus: —"Hallo, Ma'arm, how beautiful you are looking today! On my word, as sure as I am looking at you, I never seed you look handsomer! Now's the time to have your portrait taken! Lose the chance, Ma'arm, and it may never occur again. Come along, my dear, and have your beauty immortalized for ever! It's only sixpence, Ma'arm. Come along! Angel like you isn't caught every day". So saying, the brute kept pulling at the poor antiquated "angel's" shawl, and would have succeeded in dragging her forcibly into his inveigling den, if a stray policeman had not accidentally made his appearance round the corner. Photographers are notorious for their dark deeds, but we think it is high time, a stop was put to their "taking off" people in this vigorous style.

If studios could be client traps, they could also offer joy and comfort, and occasional props to self-esteem; a little verse in *Puck's Library,* No. XLIX, under the heading of "Fads and Fancies," 1891, touches on this softer side:

To have my picture taken swift I hied
To a photographer's, who deftly tried
 Positions numerous, and to a jot
 Adjusted every hair, nor yet forgot
To call me beautiful—or as much implied.

An eye-catching advertisement was guaranteed whenever practitioners of an entirely different trade came to adopt photography as their second professional string. There are many examples of such enterprising optimists (Henisch 1994), hairdressers and dentists (Fig. 4-7) being the most frequently encountered, in large part because both already possessed the right kind of demoralizing chair. See also Chapter 2, and McCulloch (1981). "Hairdresser and Photographic Artist" became a perfectly respectable shingle, but *Punch* magazine was much too alert to allow the incongruity to pass. In some happy banter of February 4, 1857, the journal commented on it:

Two Artists Rolled into One. This strikes us as a curious combination of businesses. Are the two operations carried on at the same time? Does a gentleman sit down in the tonsorial chair to have his stubble removed and his physiognomy struck off by the same *coup-de-main?* Does the self-satisfied *Figaro,* as he wipes his customer's chin, exclaim in a high tone of tradesman-like exultation: "There you are, Sir, clean shaved—and your portrait taken to a hair, Sir—all in less than two minutes!"

The writer then makes an unsubtle punning reference to one of London's earliest and most prominent studio photographers:

However, the rare power of an artist, who takes off your head in one minute and cuts

your hair the next, is certainly deserving of record in our historical columns, and we do not know of any photographic genius who would be able to *coiffer* a person equally in both lines of business, unless it is BEARD.

For a witty pictorial comment on the two arts of hairdressing and photography, see Fig. 3-4a. Not only were the chairs used by photographers, hairdressers, and dentists remarkably similar, but so also were the reactions of their respective clients. A weary notice appeared in the *Photographic Times and American Photographer* of October 6, 1886:

WANTED. —A party who can sit for their portrait without incidentally comparing the operation to one very often performed in dentists' apartments.

The editor then comments:

The existence of this long-felt want thus clearly stated, instantly suggests the query: Did anybody ever express a preference for a *photographic* "operation" when about to take part in the other?

Photographers could rise to their own brand of sarcasm and, since the issue was evidently inexhaustible, the same journal reported on December 24, 1886:

A Remarkable Man

PHOTOGRAPHER *(to sitter):* That gentleman who preceded you is the most remarkable man I ever saw.
SITTER: In what way?
PHOTOGRAPHER: He didn't tell me that he would rather have a tooth pulled than have his picture taken.

(Weprich 1995)

On that perennial dental theme, the same journal had already published another piece, on February 27, 1885 (p. 101), relating to the practice of J. F. Ryder of Cleveland, and his chief

FIG. 4-5. (a)–(d). Ensnaring the Customer.

(a) Advertising Down Under. From *The Bulletin* (Australia), September 26, 1885. Davies and Stanbury (1985).

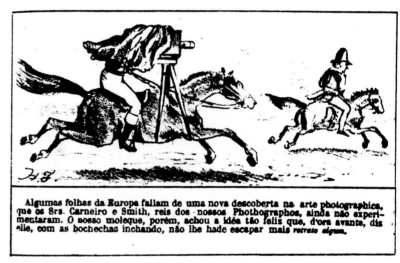

(b) Advertising in Brazil. Design used by Carneiro and Smith. From the *Semana Illustrada* of November 2, 1862. From now on, the photographer says, no portrait will escape him. Carneiro described himself as the "King of Photographers." Ferrez (1991).

camera operator, Mr. Charles A. Park. It was Mr. Park's practice to place a placard near his camera, with the inscription: "Do not fail to ask if the camera is insured. Hesitate not to say that you would sooner have your tooth pulled than to sit for a photograph"; Weprich (1995). The journal then signifies compassion for the "wearied operator . . . [who] has to meet two or three hundred sitters per day, each one of which [*sic*] greets him with the *standard jokes.*"

Dentists and hairdressers were not the only double-dippers into the photographic bonanza, as Bull and Denfield (1970) point out. Monsieur F. Gayrel of Capetown, South Africa, approached his studio practice from a very different background (Fig. 4-8) and advertised the fact with a Napoleonic headgear that might have done valiant service for some studio masquerade. It was not, presumably, worn during business hours unless, perhaps, used as a stylish substitute for the conventional black cloth.

Another view of the studio, this time mercifully without the dreaded chair (though still with one dental detail!), and seen through the jaundiced eye of its operator, can be gleaned from an unsigned article that appeared in the *Juniata Democrat and Register* of August 6, 1890, under the heading "Giddy Girls," quoted from an earlier publication in the *Boston Globe* (Ruby 1985):

> They came in the late afternoon, all talking at once. "We want our tintypes taken." "Yes, all together." "In a group." "Any particular style you like?" "Oh, we want something picturesque." "Yes, we want it artistic—an outdoor scene, you know."
>
> The photographer quickly wheels up a mountain view for background, waltzes a wooden looking "rock" into the foreground, props up a rustic fence at one side and throws down a grass-suggesting mat before it. While he is composing this medley from the inexhaustible beauties of nature the girls discourse on the subject at hand.

CRIC Y CAM
FOTÓGRAFOS CÁNDIDOS.
(sans retouche)

FIG. 4-5. (c) Advertising in Spain. Design used by Cric & Cam of Madrid, offering "candid photography without retouching" in the 1870s. Fontanella (1981).

> "Belle, you sit on the rock and I will stand beside you; Grace can lean on the fence, and, May, you sit on the floor. We ought to have a book to be looking at. Ah, here's an album; that will do. Dora, which side of my face would be the best to have taken?" "The outside," says Dora promptly. "I wish we had a parasol," says Grace.
>
> "Be quick as you can", interrupts the photographer, realizing how precious is every moment of the fast fading light. Dora bestows upon him a look which says, "with intent to annihilate": "We pay you by the job, not by the hour. Do not presume to hurry us."
>
> At last they locate themselves according to the dictates of their own sweet and wayward fancies. "Ah, my," exclaims Belle from the rock, "what an awful uncomfortable thing this is to sit on". "Put your hand on my shoulder, Grace."

FIG. 4-5. (d) Advertising in Minnesota. Explosive design by E. Billings, 1860s. Morgan (1948).

(a)

(b)

FIG. 4-6 (a)–(b). Happy Photo-Hookers.
(a) Male team. From *Punch* of May 2, 1857.
(b) Feline team. From *Punch* of September 29, 1860.

Finally all seems in readiness, when just as the photographer is about to remove the cap to expose the plate, May suddenly exclaims from the floor: "Hold on a minute. Grace you ought not to be standing; you are too tall. Change places with me."

Then ensues a general scrambling and rearranging, Belle improving the opportunity to try for a softer spot on the rock. "Am I looking at the right place?" May anxiously inquires of the photographer, as if the sun would fail to do its desired work if her head was [*sic*] not turned at just the most becoming angle. "Yes," replies the much harassed personage addressed, heroically choking back unholy utterances. "Sit perfectly still now."

He removes the cap and a brief and blessed silence ensues. When he replaces the cap for a moment the chorus breaks out: "Oh, my goodness . . . dear me . . . I never . . . why, I was just . . ." "Keep just as you are," says the photographer authoritatively, unexpectedly removing the cap again and thus effectively shutting off the deluge of remarks.

The poor light necessarily made the exposure unusually long, and when at last it was over a volley of deep and revengeful groans comes from the girls as the photographer disappears with his plate.

Then their tongues are loosened. "My, I feel all tied up in a bow knot." "Goodness, but I am tired standing so long." "I never knew anyone to be so long taking a tintype." "Oh, I feel as if I had just had a tooth pulled—so thankful it is over." . . .

"I don't think he is very agreeable anyway. All he thinks of is to get it over with." "Oh, here he comes with the pictures."

Now they gather around the man with the pictures, all talking excitedly. "Oh, oh, just

FIG. 4-7. Double Dipping I. A dental-photograph parlor of the 1860s. McCulloch (1981); Henisch (1994).

look at me." "Just see the way my eyes look." "My head is held too high, and I asked you. . . ." "Oh see how my dress looks," etc., till at last they relinquish the artistic treasures long enough to have them put in envelopes.

Then they pay for them and go out, leaving the long-suffering photographer free to relieve his overwrought nerves in any form of speech he thinks will be most soothing to his feelings and expressive of his sentiments.

Needless to say, and irrespective of the owner's professional background, any studio's principal clients were people, but few operators were prestigious enough to be able to refuse commissions for photographing treasured objects and pets. Once again, *Punch* rose to the occasion and gave its nod to dog-portraiture with an interminable conversation piece (January 27, 1894) called "Fluff Sits for His Photograph." In the course of a three-page account of the session, a stage is reached in which Fluff, having been brought to the studio by "Elderly Lady," barks: "Look here, I've had about enough of this tomfoolery. Let's go"—and readers must have thought: Bravo, Fluff, not a minute too soon!

Nor indeed was Fluff the only canine client with a photographic profile and a strong personality; among many others, there was Caesar, "a fine Newfoundland dog of great intelligence" and the subject of a special article ("How the Dog Got His Likeness Taken") in the *Juniata Sentinel Republican* of October 7, 1874 (Ruby 1986). Caesar had misbehaved himself grievously in a photographic studio, had been severely reprimanded, and had been told to leave. "Hereupon Caesar slunk away with a crestfallen look. . . . But next day . . . Caesar came home with a box tied around his neck." The box "contained a fine daguerreotype of himself." It appears that Caesar, full of remorse, had gone back to the studio on his own, and had persuaded the operator to photograph him, by the simple trick of posing before his camera. Once the picture had been taken, "Caesar rose and stretched himself, with the satisfaction of one who had wiped out a disgrace by making reparation. . . . We are glad to be able to record this story in our pages as a tribute to his memory," a sentiment with which the present authors are in complete accord.

For any client, the visit to a photographic studio remained a special event well into the 1930s, and its mementos were treasured *inter alia* because they somehow combined the joy of the moment with the promise of permanence, if only on paper. Photographers, of necessity, had to impose their will on patrons, to draw each session to a sensible conclusion within a reasonable time, but they also knew how to sheathe the iron fist in a velvet glove (Fig. 4-9a). The fact that "flattery gets you somewhere" was recognized almost from the beginning of studio practice. It is charmingly recorded in an 1865 cartoon from *Charivari* (Fig. 4-9b). "How many prints will you want of your photograph, a dozen?" "I would like to give them to all my friends." "Well, then I think a dozen won't be nearly enough." Indeed, flattery had its uses even in the post-exposure phase. Thus, the *Pittsburgh Morning Post* of July 7, 1895, reports on "A Narrow Escape": Mrs. Newlywed— "Is it possible that your watch is in pawn again? I'm shocked". Mr. Newlywed— "Oh, no, darling, I'm having

your photograph put in it." (Weprich 1995)

Punch suggested in 1860 (January 14, p. 14), that photography's role as a "family broker" of immense scope and influence might well be extended by its entry into the marriage market. The writer foresees the advent of a new family paper, the *Photographic Advertiser,* happily unaware that the preposterous fantasy of 1860 was to come remarkably close to the reality of a late-twentieth-century dating service:

A New Family Paper

'Ark!— No More Balls, Evening Parties, or any other Expense. —The *Photographic Advertiser,* shortly to be published, offers peculiar advantages to parents naturally anxious to dispose of their grown-up Daughters in Marriage, precluding all necessity of mixing in extravagant society, and all the cost and trouble involved in going to, and giving in return, *soirées, réunions,* dancing and musical parties, &c. Each advertisement of a young lady will consist of an accurate description of her personal advantages, accompanied by a sun-portrait, by which the exactness of the text will be capable of being tested, and which will obviate any danger which may be apprehended by country gentlemen of "buying a pig in the poke," or even of being induced to deal for the fair creature whose charms may be unsuited to their peculiar taste. The *Photographic Advertiser* offers its columns to the bereaved widow, as well as to the spinster, regardless of years; the mature conviction of its proprietors being, that no time in life, and no antecedent ties, are adequate to forbid the loving heart of woman from endeavouring to cling, like a tendril, to any eligible object of the stronger sex, that may happen to be brought within its reach: an approximation to effect which is the express object of the *Photographic Advertiser.* To gentlemen, the *Photographic Advertiser* is likewise open, and those

School of Arms.

MONSIEUR F. GAYREL, Professor of Fencing, lately arrived in this Colony, intends opening a School of Arms, where he will teach the use of the Sword, in the most modern style, by which it is rendered much more formidable than the lance, or any other weapon of this class. This will be taught thoroughly in thirty lessons.

He will also give instruction in *gun and pistol firing* to be acquired with great perfection in *eight lessons.*

Monsr. G. has also to announce that he takes Likenesses with the Daguerreotype, at very *moderate prices,* and with great faithfulness.

No. 5, Zieke-street.

☞ Lessons will be given at the Dwellings of those who may prefer it.

FIG. 4-8. Double Dipping II. Advertisement for a photo-and-fencing parlor. Monsieur F. Gayrel's "School of Arms," in Cape Town, South Africa. September 1852. Bull and Denfield (1970).

happily gifted with regular features, luxuriant whiskers, a prepossessing expression, and symmetrical proportions, will be enabled, by its means, to negotiate all these endowments with the utmost facility and at the very lowest terms. Gentlemen less fortunate in ordinary estimation, will find in the *Photographic Advertiser* a medium for the exhibition of those peculiarities of Physiognomy or configuration, which are not without their admirers in a world wide enough for us all, not excepting those who weigh eighteen or twenty stone. The nose which has never attained to, or which transgresses, the proportion, or which deviates, in what shape soever, from the outline of beauty; the eyes which are peculiar in their convergence or in the specialty of their

GRANDMA TAKES THE BABY TO THE PHOTOGRAPHER'S.

FIG. 4-9 (a)–(b). Studio Courtesy; Studio Flattery.
 (a) "Grandma Takes the Baby to the Photographer's." American cartoon of 1904, made for Life Publishing Company. Farmer (1990).

colour; the mouth which differs widely, or by opposite dimensions, from APOLLO's bow, will be presented by the *Photographic Advertiser* in the most attractive light to those individuals of the other sex to whose predilections they have been adapted by the plastic and pictorial hand of Nature. For further particulars inquire at the Office, 85 Fleet Street, E.C.; where attendance will constantly be given to receive any amount of subscriptions.

Notwithstanding the occasional preoccupation with the softer side of life, studios, particularly for children, remained menacing places, in which grown-up men, never the most rational of creatures, hid below black cloths and stared into puzzle boxes with giant glass eyes in front. Mama was a treasured standby on such occasions, even when cunningly hidden behind a piece of furniture (Fig. 4-10) or, better yet, disguised as furniture itself (Fig. 4-11). Root (1864) recognized the problem of client control, which was not actually confined to photographing the young:

The would-be eminent heliographer must especially have patience, as few places more urgently require it than the operating room. For,

Fɪɢ. 4-9. (b) "How many prints will you want of your photograph, a dozen?" "I was thinking of giving them to all my friends." "Well, then I think a dozen won't be nearly enough." *Charivari*, 1865.

FIG. 4-10. "Photographing Under Difficulties," picture by Charles V. Brown, *Harper's Bazaar*, May 27, 1882, p. 329.

from the nature of his art, a single day may bring under his hand a host of persons, comprising almost every type of organization; the ignorant and stolid, the flippant and conceited, the fastidious, the difficult &c. To deal with all these, even so as to avoid giving moral offense, often taxes the patience to an extent that might make him almost envy even the patriarch Job himself.

The problem of how to survive young clients in the studio setting was the subject of a lengthy exposition by Taylor (1867), indeed, the Rev. A. A. E. Taylor, who seems to have added studio practice to his pastoral duties. His article "Taking Baby" appeared in *The Philadelphia Photographer*. Taylor begins promisingly by saying:

"A baby is a very nice thing to have about the house, but," as he cautiously adds, "a studio is not a house, and still less a home."

Among the tactics developed for coping with young customers was the use of such devices to attract their interest as "Watch the Birdie" flashcards. At least one prominent photographer, Geo. G. Rockwood of 839 Broadway, New York, in 1874, went to the trouble of publishing an instruction booklet for the benefit of his professional fellow sufferers: *Rockwood's Photographic Art-illery Manual and Infantry Tactics* (Zucker 1971). Each one-page chapter is illustrated by a drawing, of which a selection, and the cover, are shown in Fig. 4-12a. Rockwood claims to have mastered the art, but the text is actually preoccupied with the prospect of

failure, and the last two drawings are titled "Re-treat" and "Defeat." Even so, the booklet contains some useful advice, conveyed with a light-hearted touch.

Rockwood was a battle-scarred survivor who wrote from the combat zone, but another artist, W. Bromley, managed to create a make-believe studio in which all the actors were on their best behavior (Bara 1992). His painting, "The Photographer," was published as an engraving in *The Illustrated London News* of May 28, 1864 (Fig. 4-12b), and the accompanying review could not have been more forgiving to the charming young critters, nor ultimately more constructive:

All the natural movements of children are unconstrained, and therefore full of grace; and when combined in groupings they are picturesque. But when children take to mimic their seniors, as they are so fond of doing—thereby showing that they belong to the great family of "imitative animals" which, according to some of the old naturalists, includes first man and secondly monkeys—children are particularly amusing. Look, for instance, at the little boys in our picture. How laughably they copy the mysterious proceedings and apparatus of a photographer! They have placed the music-stool on a chair, and, with the aid of books and a roll of music, have constructed something which bears a general resemblance, in form, to a camera and stand. This being prepared, they have evidently *posed* the group to be photographed; and one boy, in mimicry of the "photographic artist", puts his head under a shawl and looks through the music tube in order to adjust the focus; while the other boy crawls away on all fours, that he may not distract the attention of the sitters or in any way disturb the operation. The group to be photographed meanwhile enact their part very creditably. The girl, as befits her years, enters into the spirit of the performance, though she is disposed to betray with a smile her private

FIG. 4-11. The Art of Disguise. American cabinet card of the 1890s. Baby on mother's lap, mother disguised as an armchair. Made by Saylor's New York Gallery of Reading, Pennsylvania.

opinion that it is all a farce. The little boy in her lap, however, discovers that apprehensiveness of something terrible and extraordinary going to happen which may be detected in the expression of older folk when that formidable instrument of torture, the camera—before which the heroic Garibaldi quailed—is aimed at them for the first time. There is another brother, who is just old enough to feel only a little timidity, revealed by his shrinking attitude and shy expression. As regards the composition of this group, it is arranged more

Fig. 4-12 (a)–(b). The Generation Gap.
(a) Extracts from *Rockwood's Photographic Art-illery Manual and Infantry Tactics,* 1874. Zucker (1971).

agreeably than we see similar subjects treated in the ordinary run of photographs; for it is in the "posing" of his unfortunate "patients" that the full-grown photographer generally absorb.

The conventions of nineteenth-century studio photography, with their frozen poses and fixed stares, were dictated, of course, not only by contemporary ideas of appropriate behavior and gesture, but by the size of the camera and the slowness of the plates. To that extent, they were inherent in the process, but it is also true that they lingered for many years beyond the time when they were truly needed. These styles rep-

FIG. 4-12. (b) "The Photographer," by W. Bromley. Engraving made from a painting. *The Illustrated London News,* May 28, 1864, p. 516. Courtesy of Jana L. Bara (1992).

resented fertile material, which humorists did not hesitate to exploit. An example is Wing's (1915) *The Fotygraft Album,* which combines "fotygrafts" (actually reproduced as charcoal-and-wash sketches) with earthy comments (Fig. 4-13). Each portrait is accompanied by a descriptive mock-characterization of the sitter. The book was popular, and subsequently appeared in many other editions. Blank pages with imprinted frames were bound into it, for readers to insert their own family pictures, and their own pithy comments.

Somehow, exotic settings have always served as a disarming excuse for the exercise of patronizing humor. Thus, *The Philadelphia Photo-*

grapher of September 1896 (pp. 320–21), very much a trade publication, offers the following story for the enjoyment of its readers, sent in by a contributor (named only as E.K.H.) who was evidently an American professional, far from home, and with time on his hands.

One day, when operating in a city in Brazil, a countryman came in, and wanted a picture of himself. When told the price, "two milreis," he said: "As I don't want a full-length picture, only a half length, can't you do it for one milreis?" This we declined; but he continued to importune until my partner conceived the idea of having some fun with the fellow by a

(a) (b)

FIG. 4-13 (a)–(d). Pages from *The Fotygraft Album,* Wing (1915). Charcoal and wash imitations of studio photographs, each with descriptive text; extracts below.

(a) "That's Sophrony Ann Gowdey, kind of a distant cousin of ma's. She's gifted weth th' secont sight."

(b) "That's Perfessor Tweedie. Ain't he a hairy feller? Onct him 'n Frank Mendenhall was a-doin' Brutus and Cassius wrapped up in sheets in Liberty Hall and when Prof says 'Here is muh dagger and here muh naked breast', pa hollers out, 'Git a shave, Prof!' Well, sir, it purty nigh busted up th' show."

play on the term half-length; so he said: "Give me your millreis, and I will take you a half-length"; and thereupon arranged him standing, and took a card melainotype from his waist band *down.*

The look of stupid amazement with which he at first glanced at the picture of his not very elegant boots and unmentionables, and the spluttering anger in which he sought to ex-

plain that it was from the middle *up,* not *down,* that he wanted, kept the room in a roar for about half an hour, until he finally cooled off, and accepted our view of the contract, a half-length, *which half* not designated, and we chose what we thought the most favorable view of him; but, if he preferred the *other half,* he could have it by paying *another* "millreis," which he finally did, and left in tolerable good

FIG. 4-13. (c) "That's my cousin, Willie Sparks. Don't he look awful meek?" But, we learn, he "got a temper."

FIG. 4-13. (d) "Uncle Adoniram Burgstresser. Tightfisted farmer and hardshell preacher."

humor, but calling us "diablos Americanos."

That particular diablo was actually lucky. *Punch* (January 12, 1861) tells a very different story of a studio pay dispute, about a client with the promising name of Clown:

Another scene [supposedly in a play] is laid in a photographic studio, where Clown gets his so-called likeness taken, and as it is not a bit like him he declares, by pantomime, that he will not pay for it. The "artist", as he calls himself, threatens by dumb show that he will send for a policeman, whereat Clown appears alarmed, intimates that the artist may make

another trial, and be paid for both. Artist hides his head in his camera obscura, and no sooner has he done so than Clown gives him a "bonneter" and bolts out of the studio, while Pantaloon who has been pouching all the "portraits" in the place, hoists them on a gibbet, and proclaims they are "HIGH ART".

The photographer's shingle proclaims:

Here is an artist who is willing
To take Clown's portrait for a shilling

but one can guess that he is beginning to have doubts; a shilling is one thing, a "bonneter" is

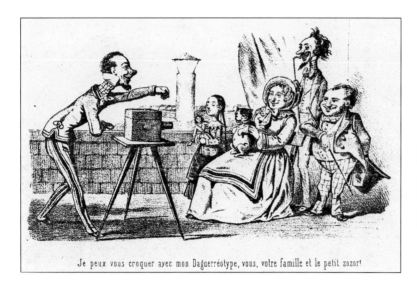

Je peux vous croquer avec mon Daguerréotype, vous, votre famille et le petit zozor!

FIG. 4-14 (a). Photo-salesmanship. "With my daguerreotype camera I can take you, your family, and even little Zozor," all for the price of a single exposure. Scheid (1983). Courtesy of Uwe Scheid. French lithograph, c. 1850. See also Color Plate 4-14 (b).

another. (In mid-nineteenth-century slang, "to bonnet" was to crush a man's hat down over his eyes.)

The subject of pricing is also touched on by a much earlier, French cartoon (Fig. 4-14a) in which the photographer claims that he can depict not only all the members of a family group for the price of one, but also the dog, without extra charge—a rash promise, because those lovable creatures had a nasty habit of moving during the exposure and, as studio clients, tended to be even less responsive than children were to the photographer's threats and promises. The studio of Fig. 4-14a appears to be one of the early rooftop variety, popular and much needed at a time when photographic plates and efficient artificial light sources were as yet unavailable (Henisch 1994). Color Plate 4-14b likewise presents a studio with a view, albeit a very different one, designed to satisfy a taste for the Great Outdoors in the comfort of an indoor setting. Here the photographer encourages an unpromising subject to look as if he were *just about* to yodel. In contrast, Fig. 4-15 shows a scene outside the country shack of an itinerant operator, "only 8 days in this place," and all the more a source of excitement to the locals, whether intending to take advantage of this offer or not. No one, ex-

cept the horse, is unmoved by the excitement of the posters and the glamour of the dashing artist.

Photographers operating from more settled headquarters were often prepared to redeem the monochrome dullness of their products by offering to overpaint them in color. The practice was widely popular (see Henisch 1996), but art lovers tended to despise it on grounds of irredeemable vulgarity. Somehow it was felt that a person of taste would always prefer a straight print, or else a traditional painted portrait, to the meretricious charms of a manipulated photograph. When *Punch*, in 1878, ran a series on the exploits of Mr. and Mrs. Jack Spratt, as they attempted to gate-crash high society, Mrs. Spratt was described as so eager for publicity, and so beautiful, that "the photographers blessed her very name," and her pictures, "Full Length! Lifesize!! Coloured!!! Front-view! Back-view!! Side-View!!!" were put on sale at every carnival (Fig. 4-16). However, *Punch*'s strictures notwithstanding, popular taste prevailed in the end; at any rate, the painted photograph, desired or despised, is still very much with us.

It was Ernest Lacan (1856) who first soberly suggested that photography be enlisted in the "war on crime" (as it was not yet called). He felt there was a prospect of reducing recidivism in

FIG. 4-15. The Itinerant Photographer. Wood engraving by E. Sues, 1873. Courtesy of Uwe Scheid.

FIG. 4-16. "The Rise and Fall of the Jack Spratts, a Tale of Modern Art and Fashion." *Punch*, October 12, 1878, p. 159.

that way. His objectives were entirely public-spirited, and his message addressed to the authorities, but professional photographers themselves very soon discovered a new line of lucrative practice on behalf of the police: the photography of criminals, at any rate after their apprehension (Henisch 1994). To a degree, police photographs followed the practices and mannerisms of ordinary studio photography; even the official Newgate prison photographer, not to mention the official Newgate prisoner, favored the much-loved top hat as an accessory (Fig. 4-17).

The idea of such a link between camera and criminal was in circulation for some time before it became a part of day-to-day reality. Under the heading "The Collartype; or Sun Pictures of Scoundrels," an April 30, 1853, issue of *Punch* had already carried a lighthearted poem about the indignant reactions to the whole process that might come from its potential "clients." The piece contains a passing reference to *Punch*'s rival, *The Illustrated London News,* and is full of moving concern for the integrity of photography on the one hand, and wanton misapplications of sunlight on the other:

The Collartype

A VULGAR print has just come out
To aid the low detective scout;
Appealing chiefly to the eye:
The *Illustrated Hue and Cry.*

The object of this journal base
Is to facilitate the chase
Of gentlemen, for whom the air
Is warmer than their health can bear.

To coarse descriptions not confined,
Which are most personal in kind,
Your portraits also it appends
Or superadds to them, my friends.

This periodical—excuse
The literary slang I use,

Strange in our fashionable haunt—
Is issued to "supply a want".

That is, in short, should you or I,
From legal persecution fly,
'Twill circulate the stations round,
That we, the Wanted, may be found.

And—can you fancy any one
So void of taste?—the very Sun
Its soulless publishers degrade
The common Constable to aid!

Grave as the fact is, one might laugh
Almost, to see the photograph
So ignominiously applied,
To serve as the Policeman's guide.

The likeness most correct you'd deem.
Indeed, 'tis rather too extreme;
The least obliquity it shows
Of eyes converging to the nose;

The faintest lines our feelings trace
On our characteristic face;
The cast that to the visage cleaves
Of those called harshly, Rogues and
 Thieves.

Oh, Sects! for mastery that fight,
And do obscure a deal of light,
Would you could intercept the rays
Whose pencil thus the Prog betrays!

(By a gentleman of the
Predatory Profession)

For more on the "Collartype," see Fig. 2-7 a and b.

Fig. 4-18, an engraving taken from Woodbury's *Encyclopedic Dictionary of Photography* (1896), shows a surprisingly cheerful scene inside another dismal realm, not a prison, but an institution for the mentally ill. Woodbury himself took it from an 1893 issue of the *Scientific American* (Wolf 1990; Woodbury 1896), which connects it with chronophotographic

FIG. 4-17. Top Hat on Location. From "Sketches in Newgate [prison]," *The Illustrated London News,* February 22, 1873. See also Henisch (1994).

FIG. 4-18. Engraving from an essay by A. Londé, which appeared in an issue of *Scientific American* of December 30, 1893, illustrating chronophotography at the Salpêtrière mental asylum, outside Paris. Wolf (1990).

FIG. 4-19 (a)–(b). The Sitter's Revenge.
(a) Bishop Thomson Has His Portrait Taken. From *Punch,* November 9, 1861, p. 185.

experimentation in a French asylum. Some technical equipment can be seen, but cool, dispassionate, and painstaking "research" is not actually a notion prominently conveyed by the image. Its original purpose remains unclear, but we can enjoy it now as an example of the heroic posturing before the camera that was popular in studios throughout the world and that gave studio photography itself some of its characteristic flavor.

Suspects and inmates, presumably, knew what they liked, but they were, to say the least, in something less than a commanding position during the procedure. In sharp contrast, Dr. Thomson, Bishop of Gloucester, was able to take matters into his own hand (Fig. 4-19a), and exercise masterful control, not perhaps over the photograph, but certainly over the photographer.

Sitters, even bishops, liked to think of themselves as victims, but to the photographer they were tormentors, never still and never satisfied. Very soon after the beginning of studio photography in France, Grandville (1842) wrote a fable called "Topaz the Portrait Painter," in which the photographer hero is a monkey, and all the birds and beasts of the jungle are his clients. Not one felt a proper gratitude when he saw his portrait: "Pelicans thought their beaks too long. Cockatoos complained of the shortness of theirs. Goats said their beards had been tampered with. . . . Squirrels wanted action" (Fig. 4-19b). The murmur of complaint can still be heard today.

Fig. 4-19. (b) "Topaz's Critical Customers." Cartoon by J.-J. Grandville, from *Les Animaux*, Paris, 1842.

Chapter 4 References and Notes

BARA, J. (1992). Personal communication, acknowledged with thanks.

BEDE, C. (1855). *Photographic Pleasures, Popularly Portrayed with Pen and Pencil*, T. Mc'Lean, 26 Haymarket, London. 1973 reprint by the American Photographic Book Publishing Company, Inc., Garden City, N.Y., title page and p. 19.

BULL, M., and DENFIELD, J. (1970). *Secure the Shadow; the Story of Cape Photography from Its Beginnings to the End of 1870*, Terence McNally, Cape Town, p. 53.

CORNWALL, J. E. (1976). *Photographische Anzeigen von 1886–1943*, J. E. Cornwall, Oberhausen, Germany.

DARRAH, W. C. (1981). *Cartes-de-Visite in Nineteenth Century Photography*, W. C. Darrah, Publisher, Gettysburg, Pa., p. 182.

DAVIES, A., and STANBURY, P. (1985). *The Mechanical Eye in Australia; Photography, 1841–1900*, Oxford University Press, New York and Cambridge, p. 227.

FARMER, B. (1990). Personal communication, acknowledged with thanks.

FERREZ, G. (1991). *Photography in Brazil, 1840–1900*, University of New Mexico Press, Albuquerque, N.M., p. 22.

FONTANELLA, L. (1981). *La historia de la Fotografía en España*, Ediciones El Viso, Madrid, p. 166.

GILBERT, G. (1970). *Photographic Advertising from A-to-Z*, Yesterday's Cameras, New York.

GRANDVILLE, J.-J. (1842). "Topaz the Portrait Painter," in *Public and Private Lives of the Animals* (trans. J. Thomson), Sampson Low, London, 1877, pp. 169–70.

HENISCH, H. K. and B. A. (1994). *The Photographic Experience, 1839–1914; Images and Attitudes*, The Pennsylvania State University Press, University Park, Pa., chaps. 7, 9, and 10.

HENISCH, H. K. and B. A. (1996). *The Painted Photograph, 1839–1914; Origins, Techniques, Aspirations*, The Pennsylvania State University Press, University Park, Pa.

HIRN, S. (1977). "Early Photography in Eastern Europe; Finland," *History of Photography*, Vol. 1, No. 2, p. 135, *et seq.*

KOPPEN, E. (1987). *Literatur und Photographie; über Geschichte und Thematik einer Medienentdeckung*, J. B. Metzler, Stuttgart, Germany.

LACAN, E. (1856). *Esquisses Photographiques à propos de l'Exposition Universelle et de la Guerre d'Orient*, Grassart, Paris. 1979 reprint by Arno Press, New York, p. 39.

LANSDELL, A. (1985). *Fashion à la Carte, 1860–1900*, Shire Publications Ltd., Princes Risborough, U.K., p. 11.

LOTHROP, E. S., Jr. (1973). *A Century of Cameras*, Morgan & Morgan, Dobbs Ferry, N.Y.

MAUNER, G. (1981). "The Putto with the Camera; Photography as a Fine Art," *History of Photography*, Vol. 5, No. 3, pp. 185–98.

MAUNER, G. (1979). "Coup de soleil Viennois," *History of Photography*, Vol. 3, No. 1, p. 99.

McCULLOCH, L. W. (1981). *Card Photographs; a Guide to Their History and Value*, Schiffer Publishing, Exton, Pa., p. 161.

MORGAN, W. D. (1948). *Photo-Cartoons; a Book of Wit, Humor, and Photo-Drollery*, Morgan & Morgan, Scarsdale, N.Y., p. 18.

NEITE, W. (1977). "G. Schauer, Photograph und Kunst-Verleger in Berlin, 1851–1864," *History of Photography*, Vol. 1, No. 4, pp. 291–96.

PALMQUIST, P. E. (1990). Personal communication, acknowledged with thanks.

READ, S. (ed.) (1989). *The Thames of Henry Taunt*, Alan Sutton, Bristol, U.K.

ROOT, M. A. (1864). *The Camera and the Pencil, or Heliographic Art*, M. A. Root, Philadelphia, Pa. Facsimile reprint 1971 by Helios, Pawlet, Vt., chap. 3, p. 38.

RUBY, J. (1985). "Giddy Girls," *History of Photography*, Vol. 9, No. 3, p. 261. From the *Juniata Democrat and Register*, August 6, 1890.

RUBY, J. (1986). "How the Dog Got His Likeness Taken," *History of Photography*, Vol. 10, No. 1, p. 81.

SCHEID, U. (1983). *Als Photographieren noch ein Abenteuer war; aus den Kindertagen der Photographie*, Harenberg Kommunikationen, Dortmund, Germany, pp. 48, 77, 132, 229.

SKOPEC, R. (1963). *The History of Photography in Pictures, from Earliest Times to Today*, Orbis, Prague, Fig. 263.

STELTS, S. (1990). "A bas la Phothographie!!!" [*sic*], *Shadow and Substance* (K. Collins, ed.), Amorphous Institute Press, Bloomfield Hills, Mich., pp. 225–28.

STENGER, E. (1938). *Die Photographie in Kultur und Technik*, Verlag E. A. Seemann, Leipzig, p. 214.

TAYLOR, Rev. A. A. (1867). "Taking Baby," *Philadelphia Photographer*, Vol. 2, No. 3, pp. 249–68.

WEPRICH, T. M. (1995). Personal communication, acknowledged with thanks.

WING, F. (1915). *The Fotygraft Album,* Reilly & Britton Company, Chicago, Ill.

WOLF, E. (1990). Personal communication, acknowledged with thanks.

WOODBURY, W. (1896). *Encyclopedic Dictionary of Photography,* Scovill & Adams, New York.

ZUCKER, H. S. (re-publisher) (1971). *Rockwood's Photographic Art-illery Manual and Infantry Tactics,* 1874–75, facsimile, with new introduction. New York.

5

UBIQUITOUS AMATEURS

Flirtatious Fringe, Joys of Travel, Photo-Pests

The public's voracious appetite for portraits provided ample copy for the humorist as, one by one, the all-too-familiar hopes, fears, delusions, and vanities were held up for laughter. The surface details of the comedy, of course, were new, but the kernel of each joke was old. Human nature does not change very much, and similar reactions to a study in oils or a sculpture in marble could have been mocked by satirists in any century. Photography provoked a stream of entries for the timeless anthology of folly, but opened only one new category. As the camera's images rapidly became cheap, and available to all, a completely fresh figure appeared for the indulgent amusement of middle-class viewers: the workingman as patron, and critic, of the arts.

The theme caused much merriment, along the lines of a cartoon published in *Punch* on July 27, 1867, under the title "Encouragement of the Arts." Two magnificently uniformed footmen keep their appointment in an elegant studio, and one "curled and powdered darling" is saying to the long-suffering photographer: "You'd better take pains with these 'ere carte de visites, as they will be a good deal shown." The other chimes in with kindly encouragement: "Yes—pertiklerly in the Hupper Suckles [upper circles]—get you customers, you know."

Jokes about flirtation are quite as ancient as those about vanity, and here again cartoonists used photographic motifs to put a fresh coat of paint on well-worn tales of tedious husbands, coquettish wives, and dashing lovers (Color Plate 5-1a). But photography also offered one or two original twists to the age-old comedy. The new art was actively practiced by women as well as men; everybody loved the magic, the happy dabbling, the irresistibly mysterious vocabulary. Shared enthusiasm led to intimacy, and neither side was slow to sense the rich possibilities for flirtation offered by black cloths and dark rooms, picturesque ruins and photographic picnics. In one story, a daughter is swept off to the altar by a tutor who has been teaching her the rudiments of photography, and her father is left to sigh: "Fool that I was, to think that all was collodion and innocence, instead of being design and camera obscura!" (Seiberling 1986)

Cartoonists pounced with purrs of pleasure on an entirely new figure of fun, the lady amateur, stalking the hapless prey with love in her eye and a lens in her hand. Miss Fanny Bouncer, one of Cuthbert Bede's characters in *The Adventures of Mr. Verdant Green,* was a prime example. She

> was both good-humoured and clever, and, besides being mistress of the usual young-lady accomplishments, was a clever proficient in the fascinating art of photography, and had brought her camera and chemicals, and had not only calotyped Mr. Verdant Green, but had made no end of duplicates of him, in a manner that was suggestive of the deepest admiration and affection. (Bede 1853–54)

Fig. 5-1b shows Miss Bouncer at work. There is, alas, no record of her success, no evidence of her status in the annals of art-photographic reportage, but it is known from other sources (Fig. 5-1c) that the best intentions occasionally went awry. Oddly enough, despite its inexhaustible charm, the theme of photographic flirtation was never exploited in the arts with notable ingenu-

ity, and it is in actual reminiscences that some more original sidelights are cast upon the subject. Alexandre Dumas (1866) bristled when prodded and poked into position by male photographers, but loved to be patted into place by a delightful lady operator in Vienna:

> As your charming photographeress cannot explain by word what she wishes, she takes your hands, and places them where she wishes them to be; she takes your head, and places it where she wishes it to be turned. Now, I do not know that there is anything disagreeable in feeling your head placed in position by two pretty hands. Then a time before, instead of saying, like the photographer: "Look at my shoulder!" she says, "Look at me!" and she does not need to add, "You will smile"; the smile comes upon the lip by itself when one looks at a pretty woman.

H. G. Wells (1893), an exuberantly successful lover himself, dwells fondly on the strangely seductive image of a retoucher at work:

> "When I have my photograph taken," said my uncle, "I always like to think of the retoucher. I idealize her; I fancy her with the sweetest eyes I have ever seen, and an expression infinitely soft and tender. And she looks closely into my face, and her little pencil goes gently and lovingly over my features. Tickle, tickle. In that way, George, I get a really very nice expression indeed."

Photography introduced new vexations as well as new pleasures to the social scene. As cameras became more portable and less demanding, amateurs took to the open road in large numbers. Cartoonists followed their escape from the studio and darkroom, and found them in the countryside, clustered like mushrooms in beauty-spots, their lenses trained on picturesque views, and on picturesque girls who just happened to be passing by. If Miss Bouncer was a keen amateur, so assuredly were the far more predatory gentlemen lurking in the rushes in

(b)

FIG. 5-1 (b) and (c). Amateur at Large II.
(b) "Miss Fanny Bouncer in Hot Pursuit of Mr. Verdant Green," Bede (1853–54).
(c) Anon.'s Disappointment; a Familiar Experience. Cartoon from *Puck's Library* of August 1891, p. 23.
See also Color Plate 5-1 (a).

(c)

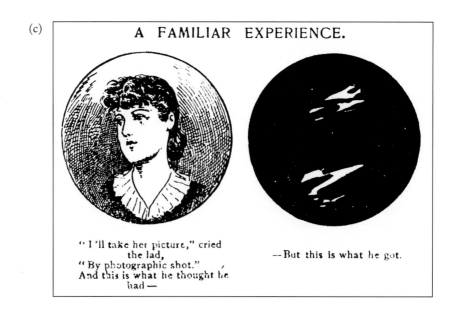

Edmond de Beaumont's 1859 cartoon (Fig. 5-2a), or behind a rock on the Valentine postcard (Fig. 5-2b) made in England almost half a century later, different in style, but fired by similar objectives. There was never anything, of course, to prevent the *client* from playing the flirtatious role. Thus, *The American Amateur Photographer* (October 1892, p. 453) shows a scene in which an enthusiast is poised with his camera, in front of a lady who is prepared to have her picture taken: "How long er—how long ought the exposure to take?" he asks diffidently. Lady client, who is a visitor in town, answers: "I don't know the custom here, but in our city it lasts the entire evening."

Fig. 5-2c depicts an event all the more dramatic because a whole horde of amateurs is involved. In the course of a steamboat outing on the Thames for more than fifty members of the Amateur Photographic Society of London, the party has disembarked for picture-taking and a picnic lunch. That gives Edwin an opportunity to take Angelina aside, and he has just popped *the* question when he finds himself caught in the act, surrounded by a group of totally unwanted photo-parasites. In this case, the nuisances are all men, but there were any number of cartoons showing the New Woman, not to be outdone, threatening the peace with her camera, and annoying people with her intrusive curiosity (Fig. 5-2d). The victims in each case may have been indignant, but it was left to a Scottish artist, W. Ralston, to demonstrate how the scoundrel with his "Kodak" would have been dealt with in the Highlands (Fig. 5-3a). A generation earlier, Cuthbert Bede (1855) had already conveyed essentially the same sentiment, as promoted in deepest England (Fig. 5-3b), while Mother Nature (Fig. 5-3c) could always devise her own ways of nipping any nuisance in the bud.

This mild joke about the bull and the photographer was to find its echo both in literature and in life. Charles Kingsley, himself an enthusiastic amateur, liked it so much that he made explicit reference to it in his 1857 novel, *Two Years*

Ago (see Chapter 8), while in 1873 a maddened buffalo did actually charge the cameraman of a surveying party in Colorado, and tossed his tripod high into the air. (Stark 1982; see also Lebeck 1979)

The correct reaction to the camera fiend was one of disdain, if not disgust, but even in the most hidebound society, the lure of the photograph was strong enough to make established attitudes crumble. Fig. 5-3d shows an "unspeakable" huntsman of 1875 in conventional pursuit of the uneatable prey, but in obvious hope of catching his fox in more ways than one; he gallops along with a camera tucked under his arm.

If persistence was one of the outstanding characteristics of the photo-amateur, so was practical ingenuity. Fig. 5-3e shows an illustration published at the time of the World's Columbian Exhibition of 1893, held in Chicago. ". . . The public was allowed to use only small, hand-held cameras, and tripods were strictly forbidden. This is how one clever fairgoer used his head and a bicycle/camera clamp to get round that little obstacle" (*The Photographist*, No. 91, Fall 1995). His kindred spirit in faraway Greece (Fig. 5-3f) needed no such subterfuge for his own approach to desirable images.

In the studio, clients still retained a certain amount of dignity and control but, before the lens of the ubiquitous amateur, they found themselves stripped of all rights. One of the most forceful condemnations of that impertinent intrusion came from *The Amateur Photographer* of September 25, 1885 (p. 388), a comment, no doubt of serious intent, made droll by the subsequent passage of time. The journal was then in its first year, and the article in question was reprinted from an earlier, unidentified American source. The essay is also quoted in Jay (1994), accompanied by a cartoon showing a nineteenth-century amateur in the process of carefully photographing a drowning man. It is poignant to think that the drawing was intended as a joke; nobody could have guessed that such

(a)

Fig. 5-2 (a)–(d). Stalking the Prey.
(a) "Oh, Klarissa, look at this big machine. One would think that a huge eye is looking at us." Cartoon ascribed to Edmond de Beaumont. From *Charivari*, July 27, 1859. Courtesy of Uwe Scheid.
(b) English litho-postcard of c. 1905, by Valentine; see also Lebeck (1979).

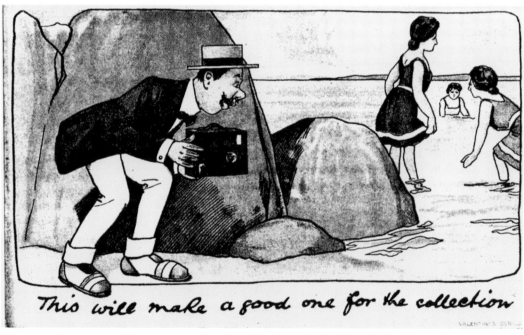

(b)

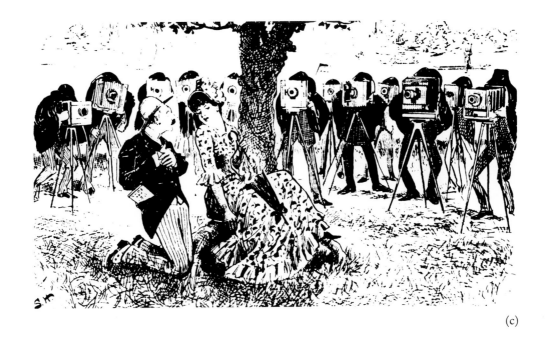

(c)

FIG. 5-2. (c) "What an Exposure." From *The Amateur Photographer*, U.K., September 23, 1887. Club outing and picnic near Cookham on the Thames.
 (d) "Eine photographische Aufnahme" by St. v. Mucharski, c. 1895. Scheid (1983). Courtesy of Uwe Scheid.

(d)

(a)

(b)

FIG. 5-3 (a)–(f). Measures and Countermeasures.
 (a) "The Kodak up North; a Highland Fling," 1905. See also Lebeck (1979).
 (b) "A Simple Mode of 'Levelling' a Camera." Bede (1855).

a response would become expected journalistic practice in our own, more enlightened times:

The Obtrusive Amateur

The daguerreotyper of thirty years ago was as unobtrusive in his professional behavior as an undertaker or a dentist. A man was thought in those days to have the same exclusive right to his personal experience as to his toothbrush. A lady would no more be photographed than kissed without permission. It is different now. A man cannot kick a dog, or smash in a blind beggar's hat, or help a lady over a barbed wire fence, without incurring the hazard of having the conditions of the instant perpetuated for all time. You take the lady's hand to steady her as she jumps, there is a snap behind you, and before you can turn, your likeness has been raped. As you stoop to pick up a rock he has you again, and scuds away with his spindle-legged machine and mendacious plates under his arm. The plates lie; that is the worst of them. In the case in point, you hold the lady's hand perhaps ten seconds. Politeness is not satisfied with less. But the ruffianly dry plate, catching the fleeting expression of the instant, makes you look as if you had been that way all morning, and liked it, and hoped it would be a long day.

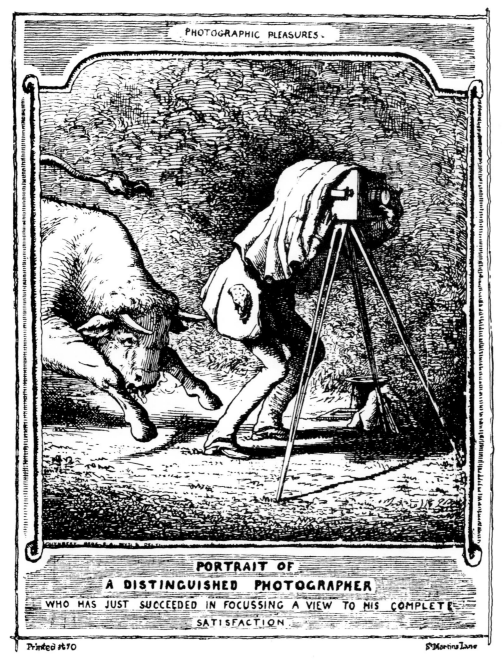

FIG. 5-3. (c) "Portrait of a Distinguished Photographer." Bede (1855). First published in *Punch*, May 1853.

FIG. 5-3. (d) "Hunting-Photography." Woodcut by G. Krickel, c. 1875. Scheid (1983). Courtesy of Uwe Scheid.

FIG. 5-3. (e) Ingenious Jones—American Brand. Amateur at the World's Columbian Exhibition of 1893, Chicago. The use of tripods was strictly forbidden, but "where there's a will . . .". See also *The Photographist*, No. 91, Fall 1995.

FIG. 5-3. (f) Greek advertisement of the 1890s. "You all become photographers, for only 35 Drachmas; what a miraculous bargain" (Stavros 1995). From Xanthakis (1988).

There is but one remedy for the amateur photographer. Put a brick through his camera whenever you suspect he has taken you unawares. And if there is any doubt, give the benefit of it to the brick, and not to the camera.

The rights of private property, personal liberty and personal security—birthrights, all of them, of American citizens—are distinctly inconsistent with the unlicensed use of the instantaneous process.

Next to the photographic pest, the roving amateur was a favorite target of cartoonists, always intrusive, always misunderstanding, always misunderstood, naive to a fault, and never on target, except in Fig. 5-4, where he actually becomes one. Throughout the ages, visitors from foreign parts have been regarded by the locals as inherently demented, but true-born natives too began to lose their grip on sanity once technical developments had made it possible in the late nineteenth century for just about everyone to catch the photographic bug. Even John Bull himself, the quintessential Englishman, became infected (Fig. 5-5a; Ruby 1990).

Occasionally, there was more method in the madness than at first meets the eye. Thus, *Punch,* on May 15, 1901, shows a keen English gentleman, in the country with his camera, preparing to photograph a woman, "the Oldest Inhabitant of the village"; Fig. 5-5b. He has been "fiddling about" with his finder, etc., for the last ten minutes, asking her to stand here, and to stand there. Oldest Inhabitant has no idea what is actually going on; eventually she has had enough of it, and says: "I can't hear what you be a-playin', Sir, being hard o'hearin'; but thank 'e kindly, Sir, all the same!" In 1901, when this cartoon appeared, amateur photographers were swarming over the English countryside, intent on recording every picturesque costume and custom of a vanishing way of life. Their model and inspiration was Sir Benjamin Stone (1838–1914), a Member of Parliament and an indefatigable photographer, who had founded the National Photographic Record Association for just this purpose in 1897. Within ten years, the efforts of the volunteer members of this society had produced more than 4,000 prints for the British Museum's archives, and had inspired independent local surveys all over the country. Stone's vision and enterprise are comparable to those of Sir Cecil Sharp in the collection of English folksongs during the same period.

On the other side of the Atlantic, a cartoon character (in a *Puck* issue of 1891), besieged by photo-pests in a park, asks plaintively: "How long shall the Amateur Fiend be allowed to run at large without restraint?" *Puck* does not answer, but merely echoes: "How long, O Lord, how long?" Likewise in *Puck* of that year, readers were treated to a poem by Chas. F. Lummis, which contains the forgettable lines:

> It may be that I am defective
> In humor; but I'd like to hammer a
> Youth that's abroad with a detective camera.

There survives another short piece, evidently composed both as a response to the first Kodak camera with its enticing advertising slogan "You press the button, and we do the rest" and as a cri-de-coeur against the amateur menace.

<div align="center">

The Camera Fiend

You're a flagrant public nuisance,
 You crazy camera crank,
And the person who'd suppress you
 Most warmly would we thank.
Continue to "press the button",
 And it yet will be your fate
To have some angry victim
 Smash your box upon your pate.

</div>

It dates, presumably, from the turn of the century; authorship, alas, unidentified (Rodgers 1995).

Molested members of the public were not the only ones to object to the ubiquitous amateur;

ACCOMMODATING—1.

(a)

ACCOMMODATING—2.

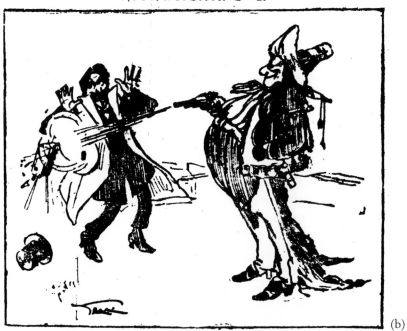

(b)

Fig. 5-4 (a)–(b). French Tourist in the Wild West. *Pittsburgh Post*, February 21, 1897. (Weprich 1995).
(a) "Ah, would misseur mind giving me von leetle shot?"
(b) Buffalo Pete—"Certainly not, take two." Bang! Bang!

(a)

Fig. 5-5 (a)–(b). Photography and Nostalgia.

(a) John Bull, Photographer. The quintessential Englishman, posing as a tourist, and photographing Bolton Abbey on this turn-of-the-century color litho-postcard, printed in Saxony. Ruby (1990).

(b) Rural Record. *Punch,* May 15, 1901.

(b)

among the principal antagonists of that new tribe were photographers who were either professional, or serious, very serious indeed. They saw the Johnny-come-latelies as incompetent destroyers of established standards and, of course, as usurpers of professional privilege. John J. Woolnought (1896) addressed himself with feeling to that issue, and made his point in the form of a dramatic "poem" (with elastic rhythms and exotic punctuation) purporting to report a club meeting on the occasion of the initiation of a new member. Woolnought (see Robertson 1989) first describes the setting:

> A burlesque with a motive.
> Dedicated to whomsoever the cap fits.
> Place: Initiation chamber at club-
> house, with members assembled.
> Time: Night.

Advancing to the table (solemnly referred to in the poem as the altar) in the center of the chamber, the President then proceeds to extract the necessary promises, asking the candidate to distance himself from all those who take photography lightly, from those who take the easy path, and from those, horror of horrors, who use a fixed-focus camera or, worse, a tiny aperture that guarantees sharpness all over.

> MEMBERS: Prepare, prepare,
> He's going to swear!
> PRESIDENT: Now open wide your every sense's portal,
> This ordeal through, you'll rank with
> us—immortal!
> On bended knee, with upraised hand,
> Swear you'll ne'er join any band
> Whose outings in photography
> Are leavened with a little spree;
> A merry school who hie away
> Only on a sunny day!
> When nature gasping seeks the shade,
> They make a photographic raid.
> If they feel a spot of rain,

> In a panic board the train.
> Who know no other joy so great
> As having "fired off" every plate.
> If you would to us belong,
> Swear you'll shun this giddy throng.
> NOVICE: Right glad I swear.
> MEMBERS: Gladly he swears!
> Pitter, patter,
> Round we clatter,
> Swiftly circling round we go;
> It makes a more impressive show!

The candidate has duly sworn, and is reminded of his obligations, nay, warned of fearful consequences if his spirit should ever weaken. However, all is well in the end:

> PRESIDENT: A summer landscape's passing
> fair,
> But every amateur's been there.
> If you would gain an entrance here,
> You'll have to seek a wider sphere;
> If you would win undying fame,
> You'll have to hunt for higher game.
> Grasp Dame Nature's every mood,
> Humbly mild, and grandly rude;
>
>
>
> When the air is razor-keen,
> When the snow o'ertops the fence,
> From the fireside get you hence!
> These are subjects worth a brace
> Of milk-and-water commonplace.
> Swear you only *will* appease,
> Your picture thirst with scenes like these.
> NOVICE: I swear; and mean to strain each
> nerve
> Your approbation to deserve.
> MEMBERS: An answer worthy of a king!
> So once again round moves the ring
> Pitter patter, etc.
> PRESIDENT: Swear you'll never take delight
> In prowling round—a sorry sight
> With box of tricks (the focus fixed),
> Inanely snapping left and right.
> Hold that right hand high in the air

And most distinctly say "I swear".
NOVICE: I swear.
MEMBERS: He swears!
　　If to that vow he keeps not true
　　He'll surely rue, he'll surely rue;
　　For we can swear distinctly too!

Then comes a homily on darkroom discipline, and diatribe against the indiscriminate use of sharp focus:

PRESIDENT: Solemnly you're asked to swear,
　　When to these rooms you repair,
　　Cause no hoarse and vengeful howl
　　Through wiping dishes on the towel.
　　Make a point to put away
　　Every measure, every tray,
　　Every visit that you pay.
　　Swear!
NOVICE: I swear.
MEMBERS: Pitter, patter, etc.
PRESIDENT: If there's a weakness we deplore,
　　It's using stop f.64.
　　That mass of sharpness everywhere
　　Is really more than we can bear.
　　Every plate that you possess,
　　"Back" it—never mind the mess.
　　Let your prints discard all trace
　　Of a burnished brazen face.
　　When the promised picture's done,
　　When the battle's lost or won,
　　When it's in its little frame,
　　Oh! be careful how you name;
　　Don't fall back on some threadbare phrase
　　Like that old chestnut "Summer days";
　　For if you do, then bear in mind
　　You'll reprimanded be—and fined.

The threats continue:

MEMBERS: Yes, you'll heavily be fined
　　If you spring that on us—mind!
PRESIDENT: If your ardor's fire should fail,
　　If our cause you e'er assail,

　　Turn a traitor in our sight,
　　Suffer then our ban's black blight!
MEMBERS: Oh! it's worse than sudden death
　　To feel our ban's black, blighting breath!

Enough? No, it gets worse.

PRESIDENT: Specks and stains your efforts cloy,
　　Fog and frill your hopes destroy;
　　.
　　Prints when in the "fixing laid"
　　Instantaneously fade.
　　.
　　Till you—so bitter is the cup
　　Despairing throw your hobby up.
　　.
　　Fondly I hope you'll never feel
　　The crushing of this iron heel.
NOVICE: I hope so too;
　　Indeed I do!

And then, at last, the President gets down to brass tacks.

PRESIDENT: There's just one matter to dispose,
　　Before we draw this to a close.
　　You'll have admission full and free,
　　Proud possessor of the key,
　　When you've paid the entrance fee.
　　Let us hear,
　　Blythe and clear,
　　Have you brought the needful here?
NOVICE: I have.
MEMBERS (rapturously): He has!
　　Pitter, patter, etc.
PRESIDENT: This ceremony's ended; 'tis now in order
　　Into an inner room forthwith to wend,
　　To toast our latest brother.
　　Where clinking glass
　　And cheerful cry of "Give your orders, gents,"
　　Will help us pass the short remaining time
　　'Twixt now and smiling morn.
　　Let us away!

FIG. 5-6. Front page of *The Amateur Photographer*, Vol. 1, April 1885. Ruby (1991).

Amateurs were, of course, perfectly capable of fighting back on their own ground, and established journals to cater for their needs, and to boost their essential artistic respectability (Fig. 5-6). On the other hand, it was only to be expected that the amateur movement would occasionally spawn private as well as public problems. Lillian M. Ratcliffe (1903) described one of those:

The Novice

Don't go near the mantle, darling,
　Papa's plates are there to dry;
Fie! you've nearly spilled the hypo,
　Take more care as you go by.

No, you cannot speak to Papa,
　He is in the dark-room now;
Fuming, fretting, at his pastime,
　Like a farmer at the plough.

Hush! I think I hear him coming,
　What is that I heard him say?
"Darn it, I have spoiled that landscape!"
　Dear, you'd best run out to play.

And quite apart from the problem of domestic diplomacy in the face of photographic passion, there remained the issues of incompetence on the one hand, and health hazards on the other, not forgetting insomnia and insufferable sitters.

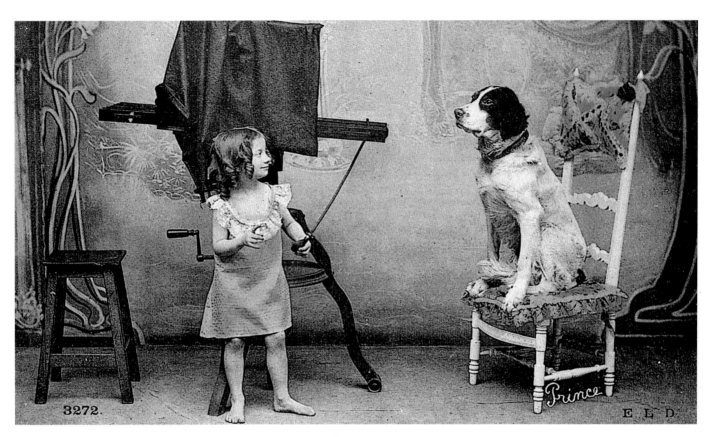

Color Plate 2-3 (b). "Attention! Ne bougeons plus!" French postcard of 1906. Print by Prince, L.E.D. Courtesy of U. Scheid. Scheid (1983). See also Fig. 2-3a.

COLOR PLATE 2-5 (c). The Dangers of
Optical Ambiguity.

 Advertisement issued by C. Reichert,
Optical Instrument Workshop, of Vienna,
1880s. Denscher (1985); see also Gerlach
(1882). See also Fig. 2-5 (a–b) and Color Plate
2-5 (d).

COLOR PLATE 2-5 (d). The Dangers of Optical
Ambiguity.

 French postcard, 1906. Scheid (1983). Courtesy
of Uwe Scheid. See also Fig. 2-5 (a–b) and Color
Plate 2-5 (c).

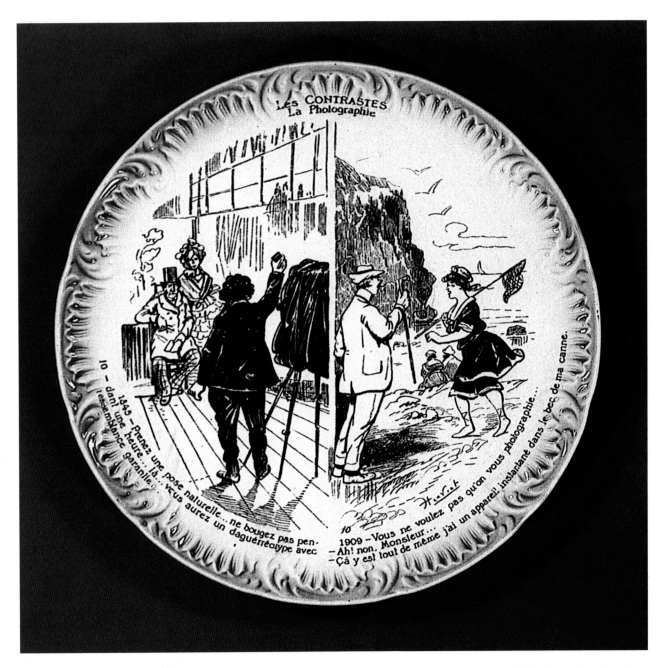

COLOR PLATE 2-10 (a). Hidden Agendas. French decorative ceramic plate of 1910, contrasting old-fashioned and modern photography. Imprint on back: "Digoin & Sarreguemines." Scheid (1983). Courtesy of Uwe Scheid.

Left: 1845, "Don't move during the 1-hour exposure, to ensure that you get a good likeness on your daguerreotype."

Right: 1909, "Don't you want to be photographed?" "No, Sir!" "No matter, I have here in the handle of my walking stick a camera that takes pictures instantaneously [thus, no need to pose]."

See also Fig. 2-10 (b).

COLOR PLATE 3-8 (d). Pre-exposure Persuasion. "Please look as much as possible as if you were in love"; newlyweds at Niagara Falls. Colored woodcut cartoon, c. 1890. Scheid (1983). Courtesy of Uwe Scheid. See also Fig. 3-8 (a–c).

COLOR PLATE 4-14 (b). Tall order: "Please look as if you were just about to yodel." Cartoon by Meggendorfer, c. 1900. Scheid (1983). Courtesy of U. Scheid. See also Fig. 4-14 (a).

COLOR PLATE 5-1 (a). Amateur at Large I. (a) Eternal Triangle. Colored lithograph by Charles Vernier, c. 1843. Scheid (1983). Courtesy of Uwe Scheid.

HUSBAND: "I am trying to see but can't find anything."

VISITING COUSIN: "Just keep on trying, it will all come."

See also Fig. 5-1 (b–c).

COLOR PLATE 5-10. "Jeu de Billard." Lithograph, after a drawing by Georges Meunier, 1899. Scheid (1983). Courtesy of Uwe Scheid.

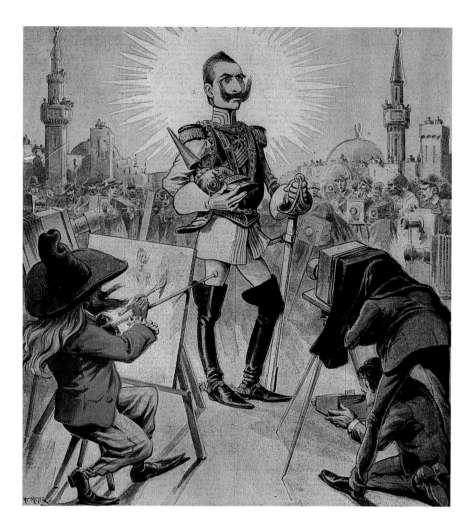

COLOR PLATE 5-17. Emperor Exposed. "The German Kaiser on his Travels"; painters and photographers in competition, with photographers evidently winning. Lithograph by H. Meyer. *Le Petit Journal,* November 6, 1898. Scheid (1983). Courtesy of Uwe Scheid.

COLOR PLATE 6-3 (f). All the World's a Stage.

Drollery. Advertising card of the Parisian Department Store "Au Bon Marché." Chromolithograph, c. 1900. Courtesy of U. Scheid (1983). See also Fig. 6-3 (a–e) and especially 6-3 (b).

COLOR PLATE 8-3 (b). Critters and Their Clients II. "With the Compliments of W. R. Shayes" of Oswego, New York, "Largest, Finest, and Best Equipped Photograph Parlors in Northern New York," c. 1900. See also Fig. 8-3 (a).

COLOR PLATE 8-5. Godey's Fashions for October. Litho-engraving by unknown artist, 9¼ × 11½ inches. 1866. American.

Miss Popkins prefers Photography

Color Plate 8-6 (b). The Incredible Crinoline II. "Miss Popkins Prefers Photography." Album page with a photographic theme, c. 1860. Watercolor and appliqué print, a charming example of a Victorian hobby, the creation of composite prints in color. New printing processes made tempting ingredients readily available. See also Fig. 8-6 (a).

FIG. 5-7. "Enough of Latin! Students of the Sorbonne are learning the tricks of the grand art of calcophotogribouillomania." From the *Journal Amusant,* No. 350, item 20257, c. 1861. Courtesy of Van Deren Coke.

PLUS DE LATIN.

Écoliers allant en Sorbonne pour apprendre les trucs du grand art de la calcophotogribouillomanie.

Percy Greenbank (1897) addressed himself to all four:

A Photographer's Nightmare

An amateur busy—don't ask me "who is
 he?"
 For *I* can't supply information—
Resided away from society's sway,
 Quite absorbed in his black occupation.
One day he fell ill, as one frequently will,
 Who in chemicals carelessly wallows,
And, lying in bed, underwent, it is said,
 An experience something as follows;

He had to take dozens of hideous cousins
 Who showed imbecility utter,
In Stygian gloom and a tiny back room
 With a quick, instantaneous shutter;
His plates were not backed—all the dark
 slides were cracked,
 And admitted a good deal of *white* light,
And weary and hot he developed the lot
 By the aid of a flickering night-light.

The weather was grilling, the plates kept
 on frilling,
 In manner extremely offensive,

And afterward dried in a state which he
 tried
 To improve by retouching extensive;
He printed the best, and, though not
 prepossessed
 With the practice of processes mixing,
In one dish alone he'd to wash and to
 tone,
 Which was also employed for the fixing.

With intellect swimming he next started
 trimming,
 Contriving the edges to mangle,
From horrible strife with a very blunt
 knife
 And a square that was not a rectangle,
But as he squegeed with all possible speed
 On some mounts that persisted in curling,
He suddenly fell out of bed with a yell,
 And awoke with his brain wildly whirling.

Among the unusual concerns about the amateur movement was one, voiced astonishingly early in the day by the *Journal Amusant,* hinting that the preoccupation of students with matters photographic might lower academic standards (Fig. 5-7). It will just have to be admitted to its

Fig. 5-8 (a)–(b). Ingenious Jones at Work. Cartoons from *Punch,* October 24, 1868.
(a) "Happy Thought." "Ingenious Jones sits for his portrait to a peripatetic photographer and, cunningly, places himself exactly between the apparatus and the unconscious Oriana, whom he worships at a respectful distance, and whose likeness he would like to possess."

shame that photography did little to encourage the study of Latin. However, if the amateur movement gave no impetus to classical pursuits, it did make substantial contributions to scientific ones, and spurred on human inventiveness in a thousand unexpected ways. Fig. 5-8, from *Punch* of October 24, 1868, shows a favorite photo-cartoon character, Ingenious Jones, cunningly exploiting light's rectilinear propagation. In Fig. 5-8a he has his photograph taken, in a position dictated by his own amorous ambitions, and Fig. 5-8b shows the result. Fig. 5-9 depicts ingenuity of a different kind, one with a potential utility far beyond the photographic domain.

Despite the worldwide condemnations of the photographic pest, there were always, everywhere, those who loved the camera's caress, and liked nothing better than to pose for the roving amateur, whether his interests were in the realm

FIG. 5-8. (b) "Ingenious Jones's Happy Thought's Result."

FIG. 5-9 (a)–(b). The Anti-Camera Shade. From *Punch*, 1890.
(a) Open, in innocent exposure.

Fig. 5-9. (b) Triggered shut to frustrate lurking photo-amateurs.

of social anthropology or billiards, as the original caption of Color Plate 5-10 suggests. Moreover, there were indeed occasions when the keen amateur, far from being booted from his chosen pitch, found himself there the focus of very friendly interest, as Fig. 5-11 bears witness.

The love affair between photography and travel was first prophetically foretold by Maurisset in 1839 (Fig. 1-2). Since then much serious thought has been given to the subject (see, for example, Fabian and Adam 1981, Hershkowitz 1980, and Henisch 1994), and it was inevitable that the topic should also become a favorite target of the humorist. In principle, there is no

FIG. 5-11. Amateur at the Center of Popular Interest. Wood engraving by H. Neuber, c. 1895. Scheid (1983). Courtesy of Uwe Scheid.

great difference between the exploration of the far corners of one's own country, and the exploration of the far-flung regions of the world, but, in practice, adventures on foreign soil were far more gratifying. They encouraged an enjoyable feeling of superiority on the part of the traveler, and permitted an emphasis on events in which the camera, wielded of course by an enlightened Westerner, left its special mark on lesser breeds. Fig. 2-5a is an example of this genre, and there were many others. Thus, Scheid (1983) presents a set of woodcuts from the *Illustrierte Chronik der Zeit* (1895) that make fun not only of the photographic explorer in Africa, but of the natives, cannibals all, as everyone knew. The tale is told with blinkered condescension, but without specific malice, long before the public had been sensitized to racial overtones and their potentially dangerous consequences. The woodcut series contains six pictures, each associated with a "poem"; three are reproduced in Fig. 5-12. Somewhere along the way, two natives approach and consider how the traveler might best be cooked; to grill or not to grill, that is the ques-

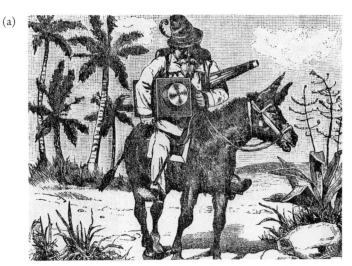

(a)

FIG. 5-12 (a)–(c). Adventure of a Snapshot Photographer, from *Illustrierte Chronik der Zeit*, c. 1895, and Scheid (1983). Three of six woodcuts. Courtesy of Uwe Scheid.

(a) The photographer sets out for Africa on a journey of research.

(b) He confronts two natives, father and son, who had already discussed among themselves how best to cook and prepare the intruder for dinner.

(c) The natives are frightened off by the sight of the unfamiliar camera, but the valiant explorer gets his masterpiece. Without the camera, he thinks, he might have been in a frying pan.

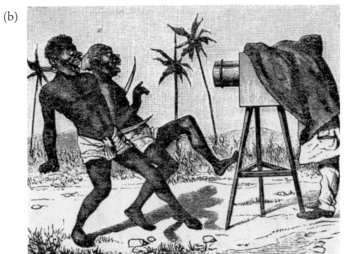

(b)

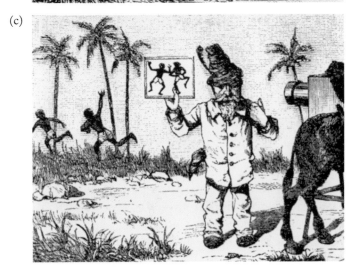

(c)

tion. But when they see his camera, poised to catch them, they flee, much to the photographer's relief. He muses, as he looks at the picture just made, miraculously printed on the spot in record time, long in advance of the Polaroid process: "An interesting subject," he says, "and if I hadn't had my camera I would be in the frying pan by now."

Other intrepid artists were less lucky. The reversal of fortune shown in Fig. 5-13a, in which predator becomes prey, has a very long history, rooted in medieval jokes where hares turn the tables on their human hunter and pop him into the stewpot. Morgan (1948) presents a cartoon in which two natives have just taken a snapshot of captured travelers, with one saying to the other: "If these shots don't sell, we'll have to eat the explorers." Nor were the locals, technologically sophisticated or otherwise, the only problem; there was always the climate. *The Philadelphia Photographer* of September 1869 (p. 32) issued a mock-serious travel advisory, to the effect that photographers visiting the North Pole should use some of the new *dry* plates, since wet plates would inevitably become icebound. Morgan incidentally pays tribute to a nineteenth-century explorer, alas unnamed and undated, who had the enterprise to mount his camera between the ears of a giraffe, "for bird's-eye surveys." Other quarries called for an approach much closer to the grounds (Fig. 5-13b). See also Frontispiece.

The more exotic the country visited, the more poignant the photographic experiences that were likely to be encountered by early travelers with the camera. No nation qualified more under that heading than China. The misfortunes of some amateurs there were reported on a page of cartoons that appeared in *The Illustrated London News* of March 7, 1891 (Fig. 5-14a). A plausible explanation for the dismal record is offered in each tiny sketch; disaster strikes at every turn, but never dims the cheerful mood. Fig. 5-14b depicts, *mutatis mutandis,* similar adventures en-

countered by a ship's doctor while photographing on the island of Rhodes during a pleasure cruise. Fig. 5-14c makes a different point, as East meets West with charming incongruity. The humor lies in the contrast between the age-old splendor of the costume worn by the cheerful snap-shooter, and the absolutely up-to-the-minute, state-of-the-art camera that he is holding.

Closer to home was Egypt, with its famed Pyramids. Public interest in the country, already keen, was sharpened still more when the Prince of Wales set off on a leisurely four-month tour of the region in 1862. As a sign of the times, an official photographer was appointed to accompany the party: Francis Bedford, whose work had found favor with the Queen. The royal progress was widely covered in the press, and *Punch* found room for a cartoon of the Official Photographer on location, his camera an only slightly distorted looking-glass reflection of his subject (Fig. 5-15a).

Egypt, indeed, had become so much closer to home by the end of the nineteenth century, for British travelers at least, that the amateur photographer there was in danger of being viewed as pest, rather than pioneer. Thomas (1980) has described less than friendly reaction to photographers of the Great Pyramid, found in Marie Corelli's novel *Ziska,* published in the 1890s. At the time, Egypt was fast turning into a popular winter resort for those living in colder climes who could afford such a temporary escape. Corelli, irritated by tourists in general, and photographers in particular, wrote:

For the benefit of those among the untravelled English, who have not yet broken a soda-water bottle against the Sphinx or eaten sandwiches to the immortal memory of Cheops, it may be as well to explain that the Mena House Hotel is a long, rambling, roomy building, situated within five minutes' walk from the Great Pyramid, and happily possessed of a golfing ground and a marble swimming-bath.

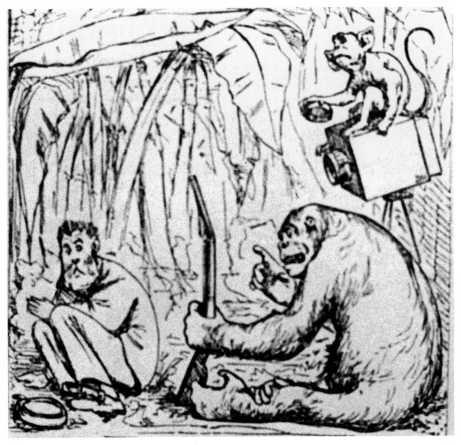

(a)

(b)

Fig. 5-13 (a)–(b). Smile Please.
 (a) From *Punch*, June 1, 1864, p. 221. See also Frontispiece for more role reversal.
 (b) Cartoon in André Hellé's *L'Arche de Noé,* 1925.

FIG. 5-14 (a)–(c). The Camera Far from Home.
(a) "Amateur Photographers in China." Cartoon by the Rev. R. O'Dowd Ross-Lewin, from *The Illustrated London News,* March 7, 1891.

FIG. 5-14. (b) A pleasure cruise to the island of Rhodes. Sketches by A. M. Horwood, published in *The Graphic*, London, October 27, 1888. Courtesy of S. F. Spira.

Fig. 5-14. (c) "Through Indian Eyes," from *Indian Sketch-Book* by Raven Hill, *Punch* Office, May 1903, p. 42. See also Sharma (1987). Raven Hill (1867–1942) had visited India on behalf of *Punch* in January of that year. Sharma mentions that the cartoon was drawn on the Delhi polo grounds, and Raven Hill's own inscription reads: "The official photographer of the Durbar endeavouring to get a snapshot of the International Polo Cup Jodhpore vs. Alwar."

That ubiquitous nuisance, the "amateur photographer" can here have his "dark room", for the development of his more or less imperfect "plates"; and there is a resident chaplain for the piously inclined. With a chaplain and a "dark room", what more can the aspiring soul of a modern tourist desire?

In a riposte, C. S. Middlemiss (1897), a geologist and keen amateur photographer, then stationed in Madras, India, wrote a piece of spirited doggerel, a counter attack on Corelli herself:

An Offending Novelist

I sob upon the sandy sea
Of Egypt's shingly deserts free.
For M. Corelli girds at me—
I am an amateur.

.

I ask why authoress so bold
Should such opinions of us hold,
And why on earth she wants to scold
The harmless amateur.

.

Fig. 5-15 (a)–(c). Exposures in Exotic Places.
(a) "The Sphinx Transfixed." *Punch*, June 7, 1862. Francis Bedford, here depicted, traveled with the Prince of Wales as his official photographer on a four-month royal visit to Egypt and the Middle East in 1862. *Caption:* "The great difficulty in photography is to get the Sitter to assume a Pleasing Expression of Countenance."

Middlemiss then offers a possible explanation: an irritating encounter with a man, possibly himself an amateur photographer, could be responsible for Corelli's attitude:

> Perchance, when in the sunlight glare,
> And she of Egypt took her share,
> Some ribald Kodaker was there,
> Some nincompoop—some Man.

.

Perhaps she had been caught by the camera in some embarrassing predicament:

> Or, in spite of recent statements met
> Within the press, did he then get
> Corelli and a mild cigarette
> On his "imperfect" plate?

> Or in some company absurd
> (Such things will hap, as I have heard)
> Corelli with some tourist herd
> Upon a donkey perched?

Alternatively, she might herself have made unsuccessful attempts to take photographs:

> Perchance she tried—ah! Breathe it not—
> With poor success t'accomplish what
> She now reviles in language hot—
> To take a photograph.

.

Middlemiss is satisfied with his explanation: "This riddle now I understand." See also Thomas (1990). Feeling very much an exile in India, far from his beloved England, Middlemiss

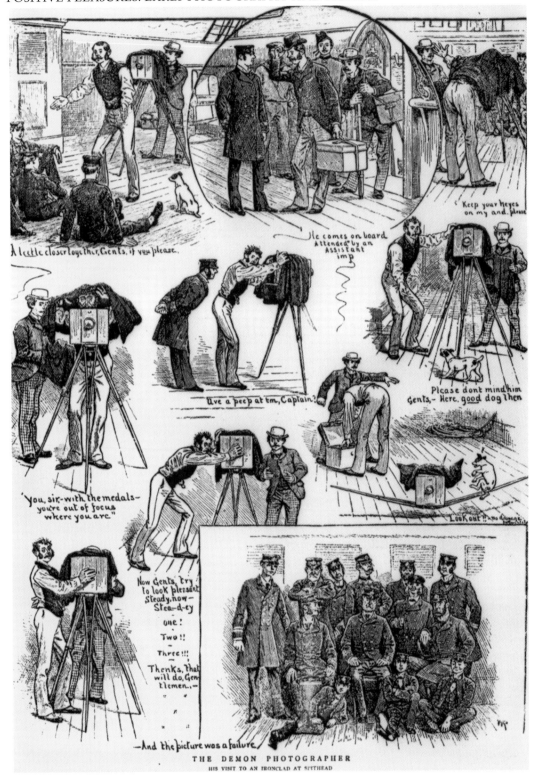

FIG. 5-15. (b) "The Demon Photographer" on a battleship in Spithead Harbor. From *The Graphic*, London, August 3, 1889. Courtesy of S. F. Spira.

Semper sub sole.
— *Par ces temps les plus brumeux, cartes-portraits instantanées ; superbes épreuves obtenues grâce à la limpidité de l'atmosphère. 15 fr. 50 la douzaine, ascension comprise.* 574

FIG. 5-15. (c) "Always Under the Sun." Color lithograph by Albert Guillaume (1873–1942) for a special issue of *L'Assiette au beurre*, No. 37, December 14, 1901, p. 574. Mann (1989).

had some things to say (c. 1897) to amateurs about the very different conditions they confront in the two countries:

Maxims for the Amateur

In England when the skies are blue,
And sunlight fills the air,
We go a courting Nature, who
Is then a damsel fair.

In haste with plates and lens we hie,
While she with light is crowned:
For oft this maid is very shy,
And oft in tears is found.

Her charms to hide, she oft insists,
In raiments closely drawn—
The drapery of cloud and mists
Or smoke from factory borne.

But India's radiant orb of fire
And arch of burnished brass
Do not encourage or inspire
Such energy alas!

No one in "haste" in India thinks,
The sun's too hot to "hie";
Whilst Nature is a forward minx
And not the least bit shy.

The brilliant liquid air displays
Her features all too plain,
And there's something in her gaze
That gives the artist pain.

He feels abashed before her bold
And reckless lack of dress:
Oh! for some "atmosphere" to fold
Her hopeless nakedness!

'Tis in a pleasure boat
On sunny reach to Thames,
To sound a loud and joyous note
Nor think of requiems;

And blessed the amateurs, who seek
Pictures by lock and weir,
By moor and ben, by crag and peak,
By lough and loch and mere.

But India has no river banks,
No gulleys, burns or becks. . . .

.

By the end of the nineteenth century, photographers had found their way into every nook and corner of the globe, every crack and cranny of daily life. The persistence of the peripatetic amateur was matched, even surpassed, by that of the professional. The camera in search of a client would go anywhere: on board ship, to cope with a recalcitrant crew (Fig. 5-15b), or even, in fantasy, up into the sky, to charm a captive sitter into compliance (Fig. 5-15c). The client here is just an affable anonymous gentleman, permitted to enjoy his session on the wing, in the privacy of an airborne studio, but the case would have been very different had there been a touch of notoriety about his name or situation. Practices associated with "Celebrity" and "Publicity" seem very modern scourges, but in fact they engaged and enraged the Victorian public in ways that are totally recognizable today. The difference is only one of degree. The predicament of an "aspiring young nobleman" of 1870, trying to escape the implacable attentions of the press corps in Fig. 5-16 strikes a familiar chord, more than a hundred years later.

No private citizen, however noble, can ever compete for the camera's attention against a figure prominent in public life. Color Plate 5-17, from *Le Petit Journal* of 1898, shows Kaiser Wilhelm II on his ceremonial visit to Jerusalem in that year, receiving homage from a horde of painterly as well as photographic journalists, each offering his own special kind of tribute. On the other side of the Atlantic, President Benjamin Harrison suffered, or enjoyed, the same experience; in a cartoon in *Puck's Library* of 1891 he addresses a crowd that consists entirely of cameras on tripods. That such situations would arise was foreseen from the first, and by none other than the great Nadar himself. It was clear to him in 1855 (Fig. 5-18) that the time was not far off when, on bad days, it would rain not sim-

FIG. 5-16. "The Penalty of Greatness; Mr. Punch's awful warning to aspiring young noblemen." *Punch,*
December 31, 1870.

FIG. 5-18. "Pluie de photographes," by Nadar (Gaspard-
Félix Tournachon). From the *Journal pour Rire,* 1855. Coke
(1995).

ply "cats and dogs," but photographers with the tools of their trade. That rain sprinkled everyone, but fell with full force only on the famous. A cover of *Punch* in 1888 (Fig. 5-19) shows the ultimate celebrity photo-session: Britannia's Lion, here a dashing but immensely dignified Dandylion, posed for the camera against the backdrop of potted palm and marble balustrade that was the prop-and-stay of every well-appointed portrait studio.

FIG. 5-19. The Ultimate Celebrity Portrait; British Majesty Before the Lens. (Mr. Punch's dog, unbeknownst to the artist at the time, was obviously a precursor of the modern Royal corgi.) *Punch,* Vol. 94, 1888.

Chapter 5 References and Notes

BEDE, C. (1853–54). *The Adventures of Mr. Verdant Green,* James Blackwood, London, Part II, p. 73.

BEDE, C. (1855). *Photographic Pleasures, Popularly Portrayed with Pen and Pencil,* T. Mc'Lean, 26 Haymarket, London. 1973 reprint by the American Photographic Book Publishing Company, Inc., Garden City, N.Y., p. 23.

COKE, V. D. (1995). Personal communication, acknowledged with thanks.

DUMAS, A. (1866). "Across Hungary," in Jane M. Rabb, *Literature and Photography; Interactions, 1840–1990,* University of New Mexico Press, Albuquerque, N.M., 1995, p. 78.

FABIAN, R., and ADAM, H. C. (1981). *Masters of Early Travel Photography,* Vendome Press, New York and Paris.

GREENBANK, P. (1897). "A Photographer's Nightmare," *The American Journal of Photography, and Photographic Times Almanac,* p. 23. Reprinted in *The Photographist,* No. 58, Spring 1983.

HENISCH, H. K. and B. A. (1994). *The Photographic Experience, 1839–1914; Images and Attitudes,* The Pennsylvania State University Press, University Park, Pa., pp. 396–430.

HERSHKOWITZ, R. (1980). *The British Photographer Abroad; the First Thirty Years,* Robert Hershkowitz Ltd., London.

JAY, B. (ed.) (1994). *Some Rollicking Bull; Light Verse and Worse on Victorian Photographs,* Nazraeli Press, Tucson (Ariz.) and Munich, pp. 27–28.

LEBECK, R. (1979). *Bitte recht freundlich,* Harenberg Kommunikationen, Dortmund, Germany.

MANN, C. (1989). "Always Under the Sun," *History of Photography,* Vol. 13, No. 1, p. 18.

MIDDLEMISS, C. S. (1897). "An Offending Novelist," in the *Journal of the Amateur Photographic Society of Madras,* Vol. III, August, p. 100.

MORGAN, W. D. (1948). *Photo-Cartoons; a Book of Wit, Humor, and Photo-Drollery,* Morgan & Morgan, Scarsdale, N.Y.

RATCLIFFE, L. M. (1903). "The Novice," *Photo-Era,* Vol. 10, No. 6, June.

ROBERTSON, P. (1989). "Initiation Night at the Up-to-Date Camera Club," *History of Photography,* Vol. 13, No. 3, pp. 249–51.

RODGERS, B. (1995). Personal communication, acknowledged with thanks.

RUBY, J. (1990). "John Bull, Photographer," *History of Photography,* Vol. 14, No. 2, p. 194.

RUBY, J. (1991). Personal communication, acknowledged with thanks.

SCHEID, U. (1983). *Als Photographieren noch ein Abenteuer war; aus den Kindertagen der Photographie,* Harenberg Kommunikationen, Dortmund, Germany, pp. 53, 65, 67, 73, 76, 87, 93, 111.

SEIBERLING, G. (1986). *Amateurs, Photography, and the Mid-Victorian Imagination,* University of Chicago Press, Chicago and London, p. 100.

SHARMA, B. B. (1987). "Through Indian Eyes," *History of Photography,* Vol. 11, No. 3, p. 246.

STARK, A. (1982). "Taking and Being Taken," *History of Photography,* Vol. 6, No. 2, p. 150.

STAVROS, M. (1995). Personal communication, acknowledged with thanks.

THOMAS, G. (1980). "Point—Counterpoint," in *History of Photography,* Vol. 4, No. 3, pp. 239–41.

THOMAS, G. (1990). "The Verses of C. S. Middlemiss," *The Photo-Historian,* No. 89, pp. 43–50.

WELLS, H. G. (1893). "The Art of Being Photographed," in Jane M. Rabb, *Literature and Photography; Interactions, 1840–1990,* University of New Mexico Press, Albuquerque, N.M., 1995, p. 126.

WEPRICH, T. (1995). Personal communication, acknowledged with thanks.

WOOLNOUGHT, J. J. (1896). *Anthony's Photographic Bulletin,* Vol. 8, pp. 67–72.

XANTHAKIS, A. X. (1988). *History of Greek Photography, 1839–1960.* Hellenic Library and Historical Archives Society, Athens, p. 152.

6

EXPOSURES IN JEST

Photography began life as humor's target, and just occasionally as humor's victim, but it soon contrived to amuse its audience by telling funny stories in its own language, its own special way. Of course, the photographic joke takes many forms; it can, for instance, be aimed at the practice of the art itself, the struggle with equipment in the darkroom or with clients in the studio, but it is true that this self-referential mode was left for the most part to the cartoonist's pen (Fig. 6-1a). Inasmuch as early photographic humor was concerned with photography itself, it had an affectionate quality; the absurdities of the new art were duly lampooned, but the attack was never intended to be lethal (Fig. 6-1b).

At times, the camera creates a joke by catching the unplanned incongruities of the passing moment and freezing them for future laughter. In such cases, we cannot always be sure of the photographer's intent; the only proof we have to offer that humor has been attempted is our own involuntary smile. At others, the photographer is a far more conscious stage manager, deliberately building a scene from props and gestures, and then using the camera simply to record the farce. Yet another kind of humor is spun from

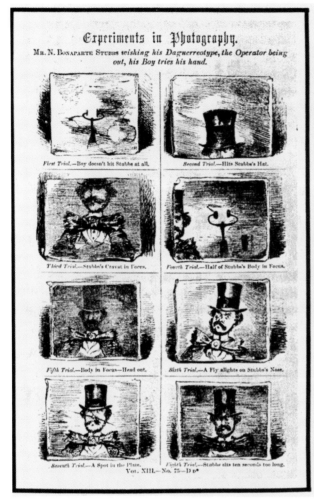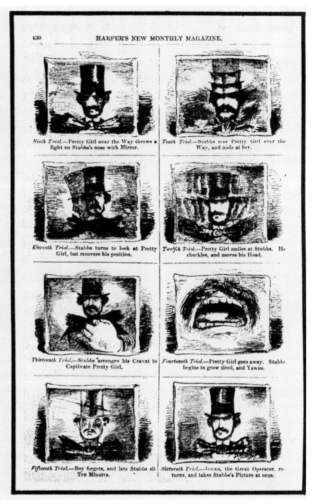

FIG. 6-1 (a)–(e). The New Art in Mono and Stereo. (a)
 (a) "Experiments in Photography," *Harper's New Monthly Magazine,* August 1856.

darkroom magic, and achieved by means of photomontage (see Chapters 3 and 7). The mystery of comedy, however, is that no classification can easily contain it. Humor generated by real people has a way of bursting through preconceptions, happily making and breaking its own rules.

What a single picture was unable to convey could often be presented to an appreciative public in the form of a picture series, with a beginning, middle, and end. From the mid-1850s onward, the photographed sit-com tended to take the form of stereo card series, each pair of cards dealing with a new stage of the "sit," and every card with a certain amount of the "com." Indeed, the popularity of the stereo card for entertainment and education became a humorists' target on its own account.

At the turn of the century and beyond, such cards, whether singly or in sets and series, were widely advertised, *inter alia* by the Sears, Roebuck Company. By that time, stereo had be-

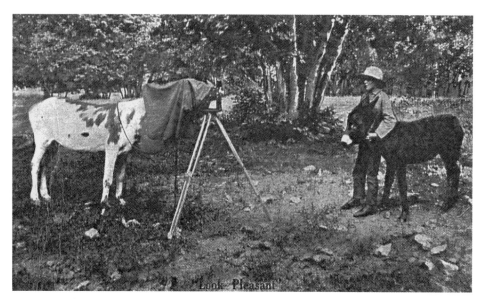

FIG. 6-1. (b) "Look Pleasant," postcard sent from Greeley, Colorado, on October 17, 1910. Screened print.

FIG. 6-1. (c) Sears, Roebuck advertisement of 1908. Earle (1979).

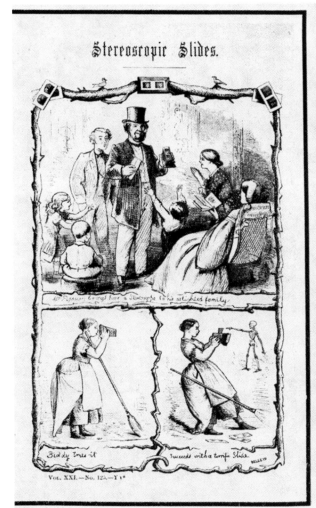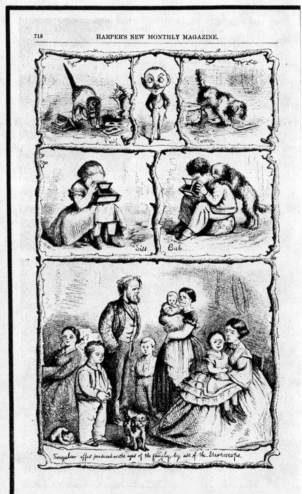

FIG. 6-1. (d) "Stereoscopic Slides," from *Harper's New Monthly Magazine,* October 1860. Palmquist (1980).

come not only the medium but a large part of the message. One advertisement (of about 1912) by Sears Roebuck was entitled "An Evening at Home with the Little Ones," and showed a mother with five children, all looking at stereo slides. In Fig. 6-1c the family has embarked on an armchair voyage around the world with their travel guide, the trusty stereoscope. When this advertisement was published, society had been deluged for years by an ever-increasing torrent of cards. In 1874, Kilburn Brothers listed more than 2,000 views at $2 to $2.50 per dozen. By 1910, the Griffith & Griffith Company of Philadelphia was offering as many as 10,000 titles; even so the Keystone View Company and Underwood & Underwood were the most important vendors at the turn of the century. See Earle (1979) for a general overview and an extended bibliography. The mania was already in an advanced state by 1860, when Fig. 6-1d appeared, to show an entire family, including the dog, made cross-eyed by too much viewing. By the

Fig. 6-1. (e) Stereo Photographs in Competition with the Real Thing. Cartoon by Gaar Williams, 1914. Earle (1979).

early years of the twentieth century, the wonders of the real world were finding it hard to compete with the mesmerizing magic of the stereoscope (Fig. 6-1e).

Of course, the stereo card was only one of many vehicles to carry photo-humor, albeit probably the most important and ubiquitous. The standard stereograph was in black and white, but there were also colored versions, often referred to as "chromos," a term used, for instance, in the advertisement shown in Fig. 6-2, which takes the form of a rebus. The nineteenth-century public loved to struggle with such problem pictures, and this one was devised to test the most advanced player. Patented by Crane & Company of Indianapolis, Indiana, in 1871, it could be modified to suit any studio, as a blank space had been built into the design, left to be filled with the all-important name and address

of the individual business. More than one photographer chose to use this ready-made puzzle as a hook to catch a customer. The prizes originally offered for the solution are no longer available, but the challenge for the reader remains. Although to the casual eye the problem now seems confusing, if not amusing, the code has been cracked by a modern photographer (Palmquist 1982).

The pictures of various types (Figs. 6-3 to 6-14) here shown are drawn from an enormous public and private repertoire, to which no personal selection can do justice. They illustrate, among other things, the variety of meanings that can be encompassed by the term "photographic humor," and all stem from a single seed, that self-evident truth to which the world paid lip-service: "The camera cannot lie." The companionable partnership between an elegant Western

FIG. 6-2. Photographic Prize Rebus; 1880s advertisement of G. K. Proctor, of Salem, Massachusetts. Colored cards were often referred to as "chromos."

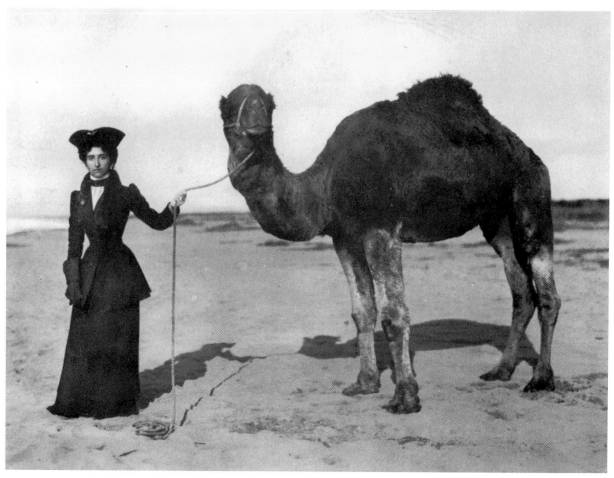

FIG. 6-3 (a)–(e). All the World's a Stage.
 (a) Lady with Camel, c. 1890. Alinari Brothers, Florence.

tourist and an aristocratic camel, recorded in Fig. 6-3a, seems disarmingly dotty to modern eyes, but we cannot be sure that the contemporary reaction in the 1890s would have been the same. It was simply a moment in time, caught by the camera and preserved, out of context, for posterity. On the other hand, we may safely assume that the little drama shown in Fig. 6-3b was staged for the sole purpose of provoking laughter, with the "truthful lens" providing irrefutable evidence that the action really did take place in a real classroom (Coke 1995). The entertainment was contrived by Louis Alphonse Davanne (1824–1912), a French chemist and noted amateur photographer who, in the 1850s, made both daguerreotypes and paper prints and, with other collaborators, including Lerebours, developed a photo-lithographic process in 1852 (Buerger 1989; Gernsheim 1969). A distinguished provenance, to be sure, but the same joke did valiant service in many other contexts, of which Color Plate 6-3f shows one.

FIG. 6-3. (b) Thereby Hangs a Tail. Photograph by Louis Alphonse Davanne (1824–1912), Paris. Date unknown, perhaps 1850s. Courtesy of Van Deren Coke. See also Color Plate 6-3 (f).

FIG. 6-3. (c) Riding into the Sunset. Cabinet card of the 1880s; unknown photographer, American.
(d) and (e) Small albumen prints, American, unknown photographer, c. 1870.

The incongruities of life, whether contrived or spontaneous, are charmingly celebrated in Figs. 6-3c and 6-3d, while Fig. 6-3e is more a tribute to the camera itself, because its humor stems from deliberate optical distortion. Fig. 6-4 is "photographic" in a different way; no clever play with a lens is involved, but the craze for stereo-photography sets the plot in motion. The strong family resemblance between this and Color Plate 5-1a is no coincidence; each is a variant of a joke that must have been old in the Stone Age. Fig. 6-5 has also been carefully composed,

but much less obviously; even if it lacks a certain sensual tension, it remains a humble tribute to devoted animal training. As the card's imprint confidently claims: "A little nonsense now and then is relished by the best of men."

Another comedy has been staged in the world of the painted photograph (Henisch 1996). Studio operators had a clear picture of the ideal sitter, one who paid up promptly and showed a proper appreciation of the finished product, with all the little refinements and improvements added by the deft retoucher. For their part, cli-

FIG. 6-4. Stereo Distraction. From an 1880s stereo slide issued by the I.C.-U Company Inc. of Chicago and New York. No. 886 of a series on a widely imitated popular theme.

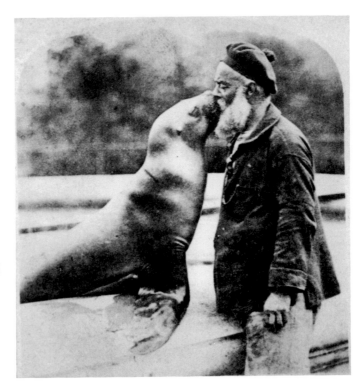

FIG. 6-5. Example from the Gems of Beauty and Art stereo series, 1881. Publisher not identified. Imprint: "Mirrored Fancies from Nature and Art—Grotesque of the Infernal—A little nonsense now and then is relished by the best of men." Part of a stereo pair.

ents had a far less lively interest in the commercial transaction, but a very clear idea of what the ideal portrait should look like. Regrettably, in the real world the two visions rarely matched, and Figs. 6-6 a and b show scenes from a dramatic studio series, in which an outraged client vents her displeasure on a disconcerted maestro.

There were several favorite kinds of stereo comedy, each made to a formula tried and true, and published in many versions. The public had a sweet tooth, and an insatiable appetite for pictures of small children endearingly engaged in grown-up occupations (Fig. 6-7). The activities of actual grown-ups, on the other hand, it preferred to take with a pinch of salt, and the realities of domestic bliss were exposed with robust good humor (Fig. 6-8). For centuries, one of the principal characters in the farce of married life had been the Henpecked Husband, and stereo humorists duly put him to work on the kitchen stove under strict supervision (Fig. 6-8c).

The Henpecked Husband's nemesis had always been the Bossy Wife but, as the nineteenth century drew to a close, his problems were compounded, because the Bossy Wife had become the New Woman, and acquired an arsenal of new weapons with which to bully him. Ideas about the New Woman were in the air, the clamor for votes, and jobs, and freedom was growing louder, and the always formidable female part of the household had become even less sweetly reasonable than before. In Fig. 6-8d, while the husband dolefully toils in the background at the washtub, she is taking her ease with the newspaper, a man's trilby hat cocked rakishly on her head, and her skirt outrageously hitched halfway up the leg. A New Woman, indeed. Pose and costume were essential elements in the iconography of this strange new breed. The professional photographer Frances B. Johnston (1864–1952) had herself pictured in the 1890s in much the same way. Seated by the fire, legs crossed, skirt high, man's cap on the back of her head, she smokes a cigar and holds a beer stein (Palmquist 1989). Self-reliant, self-assured, she is the em-

bodiment of dashing independence. Refreshing as such a figure might be in the world at large, she is obviously, in Fig. 6-8d, a menace on the home front.

In Fig. 6-8e, this blight on domestic bliss has become the menace of the open road. Today, we cannot be certain whether contemporaries broke into a smile at the very thought of a woman in command, or at the contrast between the large figure crowned with a flamboyant hat, and the tiny steering wheel she confidently grips. All we can be sure of, guided by our own response, is that smile they did.

Stereo humor belonged to the family of vaudeville and music-hall, pantomime and farce, and its roots tapped into the age-old, ever-fresh springs of comedy. As we have seen already, it shamelessly pillaged the past for such ancient themes as the battle of the sexes, but it also liked to be up-to-date. In the late nineteenth century, a new setting for the perils and pleasures of romance was the office, where businessmen and young girl secretaries were for the first time working side by side. Jealous wives, though far away at home, had a sixth sense for trouble, and the explosive combination of righteous wrath and wily countermeasures never failed to please its public (Fig. 6-9).

A similar tale was spun about another husband—or perhaps the same?—blown off course by a charming new cook, and the means his wife found to bring him back from the primrose path to the straight and narrow one of stern domestic duty (Henisch 1994; Fig. 6-10). The popularity of the plot is attested by the dozens of stereo versions in which it was staged. Miniature dramas of this kind, told in pictures, whether in sequence or in single frames (Fig. 6-11), and published in their thousands in the late nineteenth century, were being produced just in the years when the infant movie business was beginning to take its first steps. Stereo comedy and film farce were both new shoots on an old stock.

The world recorded by the camera's eye could be a very odd one, when optical distortion

(a)

(b)

Fig. 6-6 (a)–(b). The Last Straw. Colored photo-litho stereo cards (two of a series) depicting an outraged client in the studio. 1906, American, by Herman Kuntzen. Henisch (1996).

(a) "Certainly, madam, there you are."
 "Do you mean to say that chromo looks like me?"

(b) "Now, take your hideous old daub. I won't pay you a cent. No sir."

(a)

FIG. 6-7 (a)–(c). Almost Grown-up. Stereo drollery.
 (a) "She Gets the Kiss," published by M. H. Zahner of Niagara Falls, New York, 1889. "Sold only by Griffith & Griffith."
 (b) "Oh! Dear! washing for such a family will kill me," 1870s. Groups from Life series.

(b)

Fig. 6-7. (c) "The Band Rehearsal," 1870s. Groups from Life series.

turned familiar objects into fantasy. Shoes, for example, might seem to swell and fill the frame (Fig. 6-12a). The effect was often unintentional, brought about by bad luck or bad judgment, but the joke never lost its savor, and never failed to win a laugh. In *Three Men in a Boat,* Jerome K. Jerome (1889) describes what happens on the river when a photographer presses the button just as someone falls over in the craft:

> Our feet were undoubtedly the leading article in that photograph. Indeed, very little else was to be seen. They filled up the foreground entirely. . . . The owner of one steam launch, who had bespoke six copies, rescinded the order on seeing the negative. He said he would take them if anybody could show him his launch, but nobody could. It was somewhere behind George's right foot.

At other times, the distortion was quite deliberately achieved, and the artist-magician in the darkroom conjured up a strange surreal universe, governed by its own laws, one in which the known relationships of the physical world were turned upside down. The fabrication of such make-believe landscapes was often in the hands of amateurs, who whiled away many a wet Saturday afternoon or long winter evening, happily absorbed in their creation. The illustration shown, Fig. 6-12b, was made in America by an unnamed humorist, but there were fellow enthusiasts at work all over the world. Colonel Henry Wood (1834–1919), for example, was a British army officer with a taste for optical illusions, who devised (c. 1881) a still-life of six standard oil lamps arranged in a row, in which three of the globes have been replaced by the heads of two fellow officers and one little girl (Buckland 1974). In Fig. 6-12c we are allowed backstage, and shown the reality behind the illusion in this theater of the absurd.

Just as darkroom magic was able to turn real life into fantasy, so it could make an insubstantial phantom of the other world seem as solid and prosaic as the next-door neighbor. An oddly enjoyable "Journey Through Hell" was devised

(a)

(b)

FIG. 6-8 (a)–(e). Married Bliss, Roles Straight and Reversed.

(a) Stereo card of 1907, published by the Keystone View Company, one of a series on the theme. "In olden times, if Folks were good, the [compassionate and linguistically forgiving] Stork Would Bring a Baby Sweet and Fair."

(b) "They still sit up late, but somehow it is not as much fun as it used to be." Stereo card published 1903 by the H. C. White Co., North Bennington, Vermont.

FIG. 6-8. (c) "When a Man's Married His Trouble Begins," an age-old sentiment published 1901 by Geo. W. Griffith. Part of a stereo pair.

(d) "The New Woman," hilarious at the time, when it was clear to all and sundry that the roles are here ludicrously reversed. 1889. Part of a stereo pair. Earle (1979).

(c)

(d)

FIG. 6-8. (e) Woman at the Wheel, presented as a self-evident absurdity. Tintype, early 1900s. Courtesy of the Wm. B. Becker Collection.

by publishers in France, and issued as a series of tissue stereos between 1868 and 1874, proving so popular that many copies in stereo card-mounts were pirated and published up to 1880 (Darrah 1977). Tiny table-top scenes were staged, and peopled with diminutive monsters, skeletons, and pretty girls, all hell-bent on enjoying the good life in a bad place (Figs. 6-13 a and b).

To judge from such evidence, the camera had no problem in leading viewers down into the netherworld; it found also remarkably easy the task of bringing the ghosts of the dead back into the world of the living. In the first years of the new art, when the exposure time for making a photograph was many seconds, any figure in the scene that moved out of the frame before time was up was recorded in the negative as a just recognizable but indistinct form. Many such involuntary "ghosts" can be found in early photographs, but it was, rather surprisingly, the

eminently serious Sir David Brewster who, in his book, *The Stereoscope* (1856), majestically proposed the idea of deliberately creating them:

For the purpose of amusement the photographer might carry us even into the realms of the supernatural. His art enables him to give a spiritual appearance to one or more of his figures, and to exhibit them as "thin air" amid the solid realities of the stereoscopic picture.

Warming to his theme, Brewster went on to give an example:

While a party is engaged with their whist or their gossip, a female figure appears in the midst of them, with all the attributes of the Supernatural. Her form is transparent, every object or person beyond her being seen in shadowy but distinct outline.

It adds a special relish to the story of ghost pictures to know that these words, written by a

(a)

(b)

FIG. 6-9 (a)–(b). Office docudrama. Stereo *tableaux vivants,* c. 1900. Unknown photographer, published by Underwood & Underwood. Subtitles in six languages.
 (a) "No, your new typewriter [= typist] isn't pretty, John, but you'd better try and like her."
 (b) "Well, just to please my wife, I think perhaps I will." ("Para complacer a mi esposa, voy a hacer esto.")

FIG. 6-10. "Mr. and Mrs. Newly-Wed's New French Cook." Stereo *tableaux vivants,* 1900. American, unknown photographer. Story-telling picture series in ten parts, with subtitles in six languages. Published by Underwood & Underwood, Baltimore and Washington, D.C. As many as eight other companies made imitations, including one depicting black actors. See Darrah (1977).

(a)

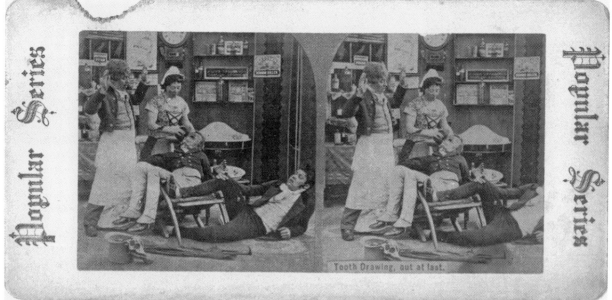

(b)

FIG. 6-11 (a)–(d). Assorted Stereo Photo-Mirth.

 (a) "In the Mouth of a Hippopotamus," Keystone Stereoscopic Series, 1870s. Reassuring imprint: "This native knows his subject, else he would never risk his hand in the beast's mouth."

 (b) "Tooth Drawing—out at last." Popular Series, c. 1870s.

FIG. 6-11. (c) "Fresh Fish." Popular Series, c. 1870s.

(1)

FIG. 6-11. (d) Stereo series by Underwood & Underwood, c. 1900.
 (1) Some are born great,

FIG. 6-11. (d) (2) Some achieve greatness,

FIG. 6-11. (d) (3) And some have greatness thrust upon them. Courtesy of the Wm. B. Becker Collection.

(a)

(b)

FIG. 6-12 (a)–(c). Distance Lends Enchantment.

(a) Stereo card issued by the Keystone Company of Meadville, Pennsylvania, 1890s. Ponderous and misleading imprint on back: "The picture on the reverse side of this card, which shows the feet entirely too large relative to the head, finally disproves the oft-repeated statement that the camera does not lie. When seen in a stereoscope, however, the feet are seen in their proper proportion. This proves that it is only the stereoscopic camera that can be relied upon for final accuracy."

(b) Carte-de-visite of the 1880s. In contrast to (a), this is a home-made product, with which someone, but evidently not the sitter, had a great deal of fun. Courtesy of Wm. B. Becker.

FIG. 6-12. (c) "How they swindle in Schwindeldorf." Cartoon from *Fliegende Blätter,* 1906. Courtesy of R. H. Krauss.

sober scientist and a pillar of the photographic establishment, opened the gates for a flood of images like the one shown in Fig. 6-14a, whose broad humor aimed simply at a quick laugh and a quick sale. Most people, practitioners and members of the general public alike, glanced at such pictures, and thought no more about the matter, but a few took the subject very seriously indeed. The idea that the camera could record something invisible to the naked eye was fascinating, and preoccupied many serious thinkers, whose desire to believe made them more credulous than those blessed with unsophisticated commonsense.

Sir Arthur Conan Doyle (1859–1930), famous creator of Sherlock Holmes and Dr. Watson, is a case in point. A number of factors made him predisposed to be fascinated by the possibility of capturing glimpses of the other world with the camera's lens. He was himself a keen amateur photographer, and a comprehensive anthology of his writings on this subject was published many years after his death; Doyle (1982). Both his father and his uncle, the brilliant artist Richard Doyle, filled their paintings and sketches with fairies and phantoms, while Doyle himself had deep personal interests in spiritualism and psychical research. With such a background, it is not really surprising that when, in 1920, he was shown some photographs, taken in the Yorkshire village of Cottingley, of two little girls playing with fairies, he became convinced that

(a)

FIG. 6-13 (a)–(b). Goblins and Devils in Stereo, c. 1870s.
 (a) La Vallée des Lutins (enfer)—The Valley of the Goblins (Hell). Published by Collection S.L.
 (b) Diableries ou voyage dans l'autre monde: Un Square en Enfer—A Garden in Hell. Part of a tissue stereo card, publisher not identified.

(b)

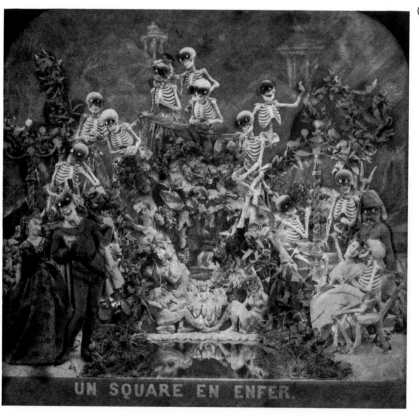

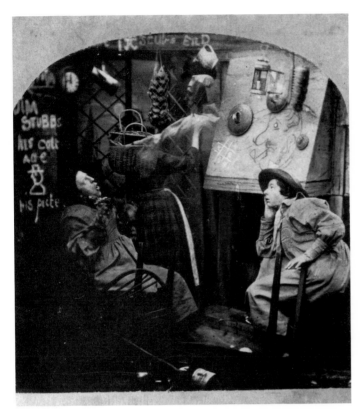

FIG. 6-14 (a)–(c). Assorted Ghosts in Stereo. (a) Jim Stubb's Ghost, c. 1850s. Publisher not identified. Part of a stereo pair. The scene, of a visit to a cunningman, or sorcerer, is probably based on some ballad or story popular at the time. Senelick (1996).

these were genuine records, and wrote a book, *The Coming of the Fairies,* in 1922, to champion their cause against the skeptics (see Gettings 1978). And yet Doyle knew perfectly well that photographs could not always be trusted to tell the truth; when in his own novel, *The Lost World,* he dealt with archaeological discoveries, he went so far as to claim that "you can fake a bone as easily as you can fake a photograph"; see Jones (1997). Though sufficiently knowledgeable to realize that the Cottingley pictures might have been contrived, he had evidently convinced himself that they were genuine.

Doyle's opinions on the subject were not universally shared, but his defendants included at least one prominent scientist of the day, Sir Oliver Lodge (Johnson 1927; Taylor 1894). Sadly, but to no cynic's surprise, the famous "Cottin-

gley" fairy photographs that impressed Sir Arthur so much were later revealed to have been faked (Klens 1983; Crawley 1982–83). Even so, Conan Doyle and his fairies proved to be of enduring interest, and are indeed the theme of a modern novel, *Photographing Fairies,* by S. Szilagi (1992).

Not many in the Western world of the last hundred years were very concerned about the question of fairies, but just about everybody had an interest in the fate of lost loved ones, and could be made passionately excited by the prospect of seeing them once more. Because emotional needs tend to make the victim gullible, ghost photography became a lucrative medium for assorted photo-portraitists, notably the famous William H. Mumler of Boston. A successful operator in the 1860s, Mumler attracted

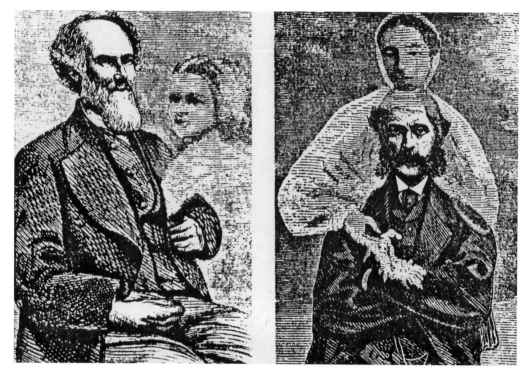

FIG. 6-14. (b) Mumler's Ghost Photography I. Ancestor-Spirits on the Plate. Examples from *Harper's Weekly,* May 8, 1869. Wood engravings after cartes-de-visite. William H. Mumler himself appears on the left.

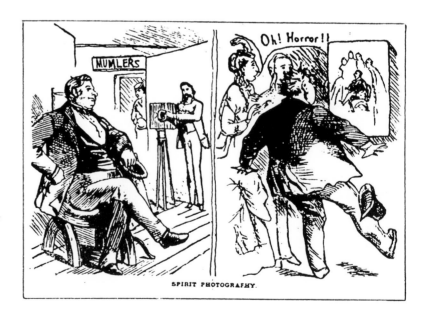

FIG. 6-14. (c) Mumler's Ghost Photography II. Cartoon from *Harper's Weekly,* 1869. Undesirable Spirit-Intruders on the Plate.

Left: "Mr. Dobbs, at the request of his Affianced, sits for his photograph."

Right: Result—Portrait of Dobbs, with his five Deceased Wives in Spirito!!!

public attention with his claim that he could capture in the camera not only the likeness of any customer, but also, and at the same time, the images of long-dead relatives. Unwary clients rewarded him richly for this skill, and Mumler certainly benefited from the fact that few people knew what their ancestors really looked like. In a celebrated court case of 1869, Mumler was put on trial for fraud; carelessly, he had offered for sale the "ghost" of a client's father-in-law, who had turned out to be still very much alive, without in the least resembling his *alter ego.* For *Harper's Weekly,* the trial was front-page news on May 8, 1869, with several examples of Mumler's work presented in the form of woodcuts; see Fig. 6-14b and Henisch (1978). In any event, there was no guarantee that only welcome ghosts would make their appearance on the plate. An 1869 cartoon in *Harper's Weekly* shows one of Mumler's clients who, recently engaged to be married, has a portrait taken at his fiancée's loving request. No fewer than five spirits responded to the call, each one the ghost of a previous wife (Jay 1991); "Five Deceased Wives in Spirito!!!", as *Harper's* put it (Fig. 6-14c). Mr. Dobbs, the discomfited customer, is flabbergasted when the evidence of his checkered matrimonial career looms reproachfully out of the shadows on the developed plate. Far away in Russia, a fellow philanderer in a similar situation saves his skin with quick wits and a grasp of darkroom procedure. In an 1856 farce by Count Vladimir Sollogub, *The Daguerreotype; or I Know All These Faces,* a lawyer on a visit to the photographic studio deliberately disturbs the unfixed image of his mistress, to make quite sure that the picture vanishes before his wife can spot it (Senelick 1991).

Unembarrassed by the court case, and unwilling to let a golden opportunity pass by, Mumler (1875) went on to turn his experiences as the most notorious ghost photographer of all into a book. While his career was still going strong, *Punch* (June 26, 1869, p. 265) published a letter to the editor from one, Pyrho, who felt that spirits might indeed exist or, as he succinctly put it:

"For instance, I am not positively certain that there may not be some proportion of truth amidst a great deal of mis-statement, and not a little lying, in the published accounts of the facts alleged in proof of the persuasion termed Spiritualism." However, he believed that since spirits do not emit enough light to be detected by the retina of the human eye, the idea that such light might decompose photographic chemicals "strains credulity."

Ghosts and other occult themes proved to be remarkably durable, in the face of enlightened skepticism, and Mumler had his imitators in other countries. Thus, for instance, Koppen (1987) describes German turn-of-the-century phantom photography by one, Albert Freiherr von Schrenk-Notzing, a well-known parapsychologist of the time, who claimed, in truth along with several other talented practitioners, to have succeeded in photographing ectoplasm. Even a man as refined and worldly as Thomas Mann, in his *The Magic Mountain* (1924), took Schrenk-Notzing seriously. And Henri Lartigue, whom many justly revere as an original force in modern photography, wrote as a boy: "Photographing is a magic thing, with a mysterious odium, strange and frightening." Such notions had a firm hold on sections of the public, and it is not altogether surprising that photographers were tempted into catering for them. For a general overview of "paranormal photography," see Krauss (1992 and 1995).

The discussion, so far, has dealt with certain workaday aspects of photographic humor, and it is instructive to contrast the pictures already presented with, for instance, Fig. 6-15a, to demonstrate how complex the notion of "photographic humor" really is. The scene is not overtly humorous at all; indeed, quite the contrary. It shows Sarah Bernhardt pretending to lie in state, while actually in the prime of her life (Ruby 1995). We do not know specifically what occasion prompted the photograph to be made, but we can be confident that it was not intended to amuse the viewer. A laugh, even a smile,

FIG. 6-15 (a)–(c). Images in Jest.
(a) Sarah Bernhardt in the prime of life, posing in a coffin. Unknown photographer, c. 1870s. Ruby (1995).

would in an instant have snapped the spell cast by the glamour of the great star. The joke, as it appears to us now, was originally a private one, shared by photographer and client as they stage-managed the dramatic scene. The idea probably came to the actress herself, as she was fond of coffins in her everyday life, kept one by her bedroom window, and often lay in it while learning her lines. Whatever its origin, the image was an inspired, if eccentric, publicity shot, of which copies were cherished by ardent admirers. Sarah

Bernhardt had every reason to congratulate herself on the success of her theatrical postmortem; at any rate, she thought it noteworthy enough to be included in her autobiography (Bernhardt 1907).

This is make-believe on a grand scale, meant to create a sensation in the great world. Figs. 6-15 b and c have no such pretensions. They are examples of make-believe at a modest level, aimed only to amuse private friends or provincial patrons. See also Cameron and Becker (1989).

FIG. 6-15. (b) Cabinet card of two men, one in drag, "taken by Miss Eagle, Portrait, Landscape and Architectural Photography." Courtesy of the Wm. B. Becker Collection.

FIG. 6-15. (c) Cabinet card of the 1880s by M. Schmedling of Chattanooga, Tennessee. Courtesy of the Wm. B. Becker Collection.

Yet another facet of this complex genre is represented by the collage, comprising a graphic and a photographic element (Fig. 6-16; Henisch 1994). By means of this versatile technique, the realism of the photograph and the whimsical freedom of the hand-drawn caricature could be readily combined. The original photographs were not necessarily made for amusement, but they were manifestly appropriated at some later date for use in that noble cause. The possibilities being endless, both for simple fun and savage satire, the practice proved irresistible from the first. A veritable feast of photomontage-in-jest, alas poorly annotated and badly printed, has been provided by Chéronnet (1945). See also Chapter 7.

The desired effects could be achieved either by deft scissors-and-paste work, in which photograph and sketch were joined together and then rephotographed or, with less effort, by setting up a painted pasteboard figure, with a strategically placed hole in it, and then persuading cheerful victims to pay good money for the privilege of using their heads to plug the gap (Fig. 6-16d; see also Fig. 3-2c).

The relationship between the camera and the pen could, however, be considerably less obvious. Thus, Linley Sambourne, one of *Punch*'s most popular humorists in the late nineteenth century, often chose his family and friends as models. He arranged them, recorded their poses with the camera, and then worked up the

(a)

Fig. 6-16 (a)–(h). Examples of Photomontage Humor, 1870s–1880s.

 (a) Carte-de-visite montage-caricature of a book-keeper, c. 1870s. American. Unknown artist.

 (b) Photography at the Fair. Tintype, American. Unknown photographer.

(b)

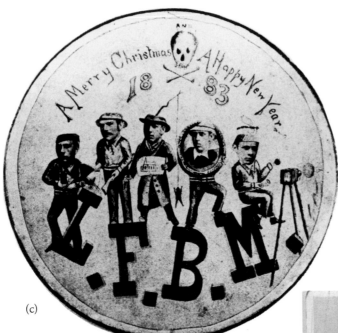

(c)

FIG. 6-16. (c) Photo-montage Christmas roundel of
1883. American, albumen print, 4 inches diameter. The
initials stand, presumably, for some collegiate or
fraternal association, not yet identified. The emphasis is
evidently on hobbies.

(d) Harmless fun at the seaside. Cabinet card of the
1880s. Unidentified photographer, American.

(d)

(e)

FIG. 6-16. (e) and (f) Unidentified photomontages [(e) from Lowell, Mass.], probably with political overtones.

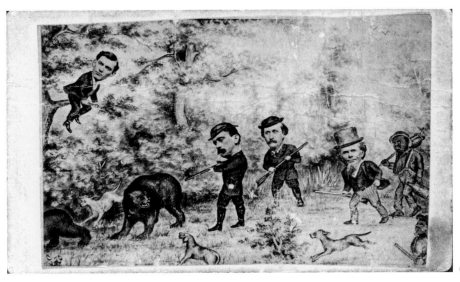

(f)

finished hand-drawn cartoon from these photographic notes. In Fig. 6-16g, for example, the attitude and costume of the "Modern Venus" have been taken directly from a photograph of Sambourne's wife (Nicholson 1988); see also Chapter 2). The last, and indeed least, of the links between the camera and the cartoon is to be found in those cases where a hand-drawn sketch is distributed to the public in photographic form. Fig. 6-16h is a humdrum seaside joke that has been photographed, printed on albumen paper, and offered for sale to an indulgent public as a carte-de-visite.

FIG. 6-16. (g) "The Modern Venus Attired by the Three Dis-graces," *Punch,* June 16, 1888. Sketch based on a photograph by Linley Sambourne.

FIG. 6-16. (h) "The Bathing Season. 'Jingo' is Minding my Clothes, and now he don't know me." Non-photographic joke, distributed, as an albumen print on a carte-de-visite, to a forgiving public, c. 1870.

It should be noted that the mere inclusion of a camera in a whimsical picture does not automatically qualify the work for membership of the "photographic humor" genre. A good example is Nadar's "Pierrot the Photographer" of 1854–55 (Fig. 6-17). See Hambourg et al. (1995) and Gosling (1976). Nadar, in partnership with his younger brother Adrien Tournachon, took a whole series of photographs of the famous Parisian mime artist Charles Debureau in the costume he had devised for Pierrot, the traditional commedia dell'arte character, with powdered face and loosely fitting white clothes. The series was made as publicity for Nadar's studio, and this picture of Pierrot with his camera is placed first in the sequence, as it is recorded in a surviv-

ing album. Nadar and others in his circle thought of Debureau as the embodiment of the romantic artist, who stood outside established society and yet was able to mirror its soul in his art.

Before photography, it was the camera obscura that was supposed to show life as it really is. In one instance, a character in the London panto-mime put on for the Christmas 1812 season, *Harlequin and the Red Dwarf,* is the Camera Obscura Man, who presents the audience with images of real and make-believe heroes (Wilsher 1977). After 1839, the camera took on the role of truth-teller to society. Here in Nadar's haunting composition, Pierrot is the spirit of comedy that directs the lens, and persuades us to face the truth by permitting us to smile at its terrors.

FIG. 6-17. Pierrot the Photographer, 1854–55, by Nadar and Adrien Tournachon. Gelatin-coated salt print. Courtesy of the Musée Carnavalet, Paris.

Chapter 6 References and Notes

BECKER, Wm. B. (1995). Personal communication, acknowledged with thanks.

BERNHARDT, S. (1907). *Memories of My Life, Being Personal, Professional and Social Recollections as Woman and Artist,* D. Appleton, New York, pp. 269–70.

BREWSTER, D. (1856). *The Stereoscope,* John Murray, London, p. 205.

BUCKLAND, G. (1974). *Reality Recorded; Early Documentary Photography,* New York Graphic Society, Greenwich, Conn., p. 117.

BUERGER, J. E. (1989). *French Daguerrotypes,* University of Chicago Press, Chicago and London, pp. 50, 148.

CAMERON, J. B., and BECKER, Wm. B. (1989).

Photography's Beginnings, Oakland University; Meadow Brook Art Gallery, Plates 141–46.

CHÉRONNET, L. (1945). *Petit Musée de la Curiosité photographique,* Editions Tel, Paris.

COKE, V. D. (1995). Personal communication, acknowledged with thanks.

CRAWLEY, G. (1982–83). "The Cottingley Fairies," ten articles on the subject, *British Journal of Photography,* December 1982–April 1983.

DARRAH, W. C. (1977). *The World of Stereographs,* W. C. Darrah, Publisher, Gettysburg, Pa., pp. 64–69.

DOYLE, Sir Arthur C. (1982). *Essays on Photography,* Introduction by J. A. Gibson and R. L. Green, Secker & Warburg, 54 Poland Street, London.

EARLE, E. W. (ed.) (1979). *Points of View; the Stereograph in America—A Cultural History,* Visual

Studies Workshop Press, Rochester, N.Y. / Gallery Association of New York State, pp. 8, 93.

GERNSHEIM, H. and A. (1969). *The History of Photography,* McGraw–Hill Book Company, New York, pp. 192, 545.

GETTINGS, F. (1978). *Ghosts in Photography,* Harmony Books, Boston and New York.

GOSLING, N. (1976). *Nadar,* Secker & Warburg, London, p. 47.

HAMBOURG, M. M., HEILBRUN, F., NÉAGU, P., *et al.* (1995). *Nadar,* Metropolitan Museum of Art, New York, pp. 224–25.

HENISCH, H. K. (1978). "Mumler's Spirit Photographs," *History of Photography,* Vol. 2, No. 2, Frontispiece.

HENISCH, H. K. and B. A. (1994). *The Photographic Experience, 1839–1914; Images and Attitudes,* The Pennsylvania State University Press, University Park, Pa., pp. 76, 290–91.

HENISCH, H. K. and B. A. (1996). *The Painted Photograph, 1839–1914; Origins, Techniques, Aspirations,* The Pennsylvania State University Press, University Park, Pa., chap. 6.

JAY, B. (1991). *Cyanide and Spirits, an Inside-out View of Early Photography,* Nazraeli Press, Munich, p. 14.

JEROME, J. K. (1889). *Three Men in a Boat,* Penguin Books, Harmondsworth, Middlesex, U.K., 1971 reprint, chap. 18.

JOHNSON, G. L. (1927). *The Great Problem and the Evidence for Its Solution,* Hutchinson & Company, Paternoster Row, London.

JONES, S. (1997). "Crooked Bones," in *New York Review of Books,* February 6, pp. 23–24.

KLENS, E. M. (1983). "The Manipulated Photograph, 1839–1939," unpublished thesis in art history, The Pennsylvania State University, chap. 4.

KOPPEN, E. (1987). *Literatur und Photographie; über Geschichte und Thematic einer Medienentdeckung,* J. B. Metzler, Stuttgart, Germany.

KRAUSS, R. H. (1992). *Jenseits von Licht und Schatten; die Rolle der Photographie bei bestimmten paranormalen Phänomenen—ein historischer Abriss,* Jonas Verlag, Marburg, Germany.

KRAUSS, R. H. (1995). *Beyond Light and Shadow,* Nazraeli Press, Munich. English version of Krauss 1992.

MUMLER, W. H. (1875). *The Personal Experiences of William H. Mumler in Spirit Photography,* Colby & Rich, Boston.

NICHOLSON, S. (1988). *A Victorian Household,* Barrie & Jenkins, London, p. 84.

PALMQUIST, P. E. (1980). "Photography, as seen by Caricaturists in Harper's New Monthly Magazine," *History of Photography,* Vol. 4, No. 4, pp. 325–28.

PALMQUIST, P. (1982). "Van Deusen's Photocryptogram," *History of Photography,* Vol. 6, No. 2, pp. 117, 118.

PALMQUIST, P. (1989). *Camera Fiends and Kodak Girls,* Midmarch Arts Press, New York, p. 79.

RUBY, J. (1995). *Secure the Shadow; Death and Photography in America,* MIT Press, Cambridge, Mass., pp. 34–35.

SCHEID, U. (1983). *Als Photographieren noch ein Abenteuer war; aus den Kindertagen der Photographie,* Harenberg Kommunikationen, Dortmund, Germany, p. 187.

SENELICK, L. (1991). "Photography in the Drama," in Jane M. Raab, *Literature and Photography; Interactions, 1840–1990,* University of New Mexico Press, Albuquerque, N.M. (1995), p. 554.

SENELICK, L. (1996). Personal communication, acknowledged with thanks.

SZILAGI, S. (1992). *Photographing Fairies,* Ballantine Books, New York.

TAYLOR, J. T. (1894). *The Veil Lifted, Modern Developments of Spirit Photography,* Whittacker & Company, White Hart Street, London.

WILSHER, A. (1977). "Words in Camera," *History of Photography,* Vol. 1, No. 1, p. 84.

7

PHOTO-SARCASM, PHOTO-SATIRE

Photography, with its proud claim that the camera not only never lies, but actually uncovers hidden truths, seemed from the start a fitting tool for the study of human society. Throughout the 1840s, journals of commentary on politics and current affairs were popping up like mushrooms, from Hungary to North America, each with its own variant on the generic, up-to-the-minute title, *The Daguerreotype* (Gernsheim 1984; see also Fig. 1-13b). A hint of the same underlying idea can be found in the "Almanack" included with the January issue of *Punch* in 1872, where Mr. Punch turns his camera on the passing year (Fig. 7-1). The design was by Linley

Sambourne (see also Fig. 6-16g), himself an enthusiastic photographer. In accordance with the laws of optics that, presumably, he knew so well, the date on the focusing screen is shown reversed, left to right, in the drawing, but in defiance of those laws, whether by intent or oversight, the numerals are upright instead of upside down.

It did not take long for humorists to find ways of using this instrument for the dissection of folly in high places, even though the first, fumbling jokes were more at the expense of photography's pretensions than of the statesmen targeted. For those who had known only the

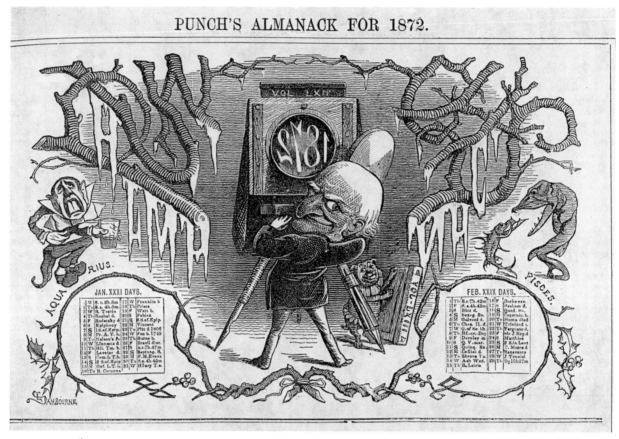

FIG. 7-1. "The Year in Camera," Punch's Almanack for 1872, *Punch,* Vol. 63, January. Cartoon by L. Sambourne.

traditional skills of artists and engravers, it was difficult to grasp how utterly different was the camera's solution to the problems of portraiture. And so, when *Punch* learned during the summer of 1848 of a proposal in Paris to make an individual daguerreotype of each Member of the National Assembly, 900 in all, the response was laughter and head-shaking over the Herculean labor imposed on poor Mr. Phoebus, the great Sun-Artist himself: "There is something awful in the task of running through 900 noses, filling in 1800 eyes . . . and biting in some 32,400 teeth. . . . Imagine the horror of having to take the impression of all the miscellaneous snubs, pugs, and other proboscal prominences of 900 Republican representatives . . ." (Anon. 1848).

Commentators may have been puzzled by the photographic process, but they had no trouble at all in grasping the bond between the new art and a nation's leaders. Politicians were bewitched by the camera long before they had learned the hard way that it is always wise to be wary in any love affair. From the beginning, they gave much thought to the problem of how to present themselves to the world in the best possible light. In an 1865 lithograph, for *Charivari,* Daumier has wicked fun at the expense of an Agricultural Committee member, posed for his official photograph against a garden wall, leaning gracefully on a spade, and with a large watering can ready at his feet for heavy duty (Fig. 7-2a).

LES BONS BOURGEOIS 1

Posant en membre du comice d'Agriculture de son département.

(a)

FIG. 7-2 (a)–(b). A New Era.

(a) Cartoon by Honoré Daumier for *Charivari*, 1865. A member of the Agricultural Committee poses for his official photograph, with spade and watering can as symbols of his office. Braive (1966).

FIG. 7-2. (b) A dangerous world ahead. Cartoon from *Charivari* of 1867 (p. 28), predicting that politicians of the future will have to mind their manners in front of cameras, as well as in front of stenographers.

Politicians, as a class, soon learned that the advent of photography had introduced a new element into their dealings with the public. Another *Charivari* cartoon, of 1867 (Fig. 7-2b), imagines the time when every politician will have to worry about a battery of photographers, as well as a battery of shorthand reporters, and mind his attitudes as well as his words. Such a cartoon has a double edge today. For contemporaries it was a flight of fancy, a satiric vision of the future; for modern viewers, of course, that future is now.

The new art offered tempting new ways to poke fun at politics. Its vocabulary, techniques, and conventions soon became sufficiently familiar to be of use as metaphors for behavior in the wider world beyond the studio walls. Once that point had been reached, all that remained for the humorist to do was to pick the right weapon, choose the photographic feature best fitted to the task at hand. In 1846, for example, *Punch* (Vol. 10, p. 209) recognized a certain correspondence between the notorious inconstancy of politicians and the transitory nature of expression caught by the camera. With an acid comment, and with reference to a recent political turnabout on the part of Sir Robert Peel, the Prime Minister, the journal suggested a new and public-spirited mission for photographic portraiture:

Political Photography

Our old political friends are so much in the habit of appearing with new faces, that it is really impossible to catch the various aspects under which they, from time to time, present themselves. We would suggest, therefore, that the photographic art, which is capable of catching the momentary expression of the features, should be applied to the Statesmen, with a view to giving something like permanency to political appearances. We know that such portraits are frequently not very flattering to the subjects, for the shadows are strongly marked, and the general tone is by no means prepossessing. Still, as a series of faithful political portraits, a collection made on the principle we suggest, would be one of considerable interest to those who might be curious to know what Sir R. PEEL was even a year ago. A photographic likeness of him, taken even at that comparatively recent period, would startle those who have only seen him in his recent character.

Behind the enigmatic sarcasm of this passage lay a major Parliamentary drama. Sir Robert Peel, a longtime supporter of the Corn Laws, slowly became convinced that they should be repealed, and introduced a bill for that purpose in January 1846. The storm of protest from powerful interest groups that was unleashed by this move failed to defeat the measure, but forced Peel himself out of office later in the year.

In 1860, *Punch* (Vol. 39, November 3, p. 179) selected *negative*, that staple noun in the photographic lexicon, as the needle with which to prick Sir Robert's second son, Frederick, who, though Britain's Chief Railway Commissioner, was a man with no distinguished track record on the public stage:

A Photograph whose Like was Never Seen

We read that there is a new invention (by an American, of course) that professes to print 12,000 photographs, or stereographs, in one hour, and all by means of a single negative. That must be almost as great a negative as FREDERICK PEEL himself—with this difference, that FREDERICK PEEL is a negative that has never yet made any satisfactory impression.

"Don't move!", the studio imperative heard throughout the world, was a phrase commandeered for service by several cartoonists. After the upheavals of the French Commune, a sketch by L. Chouguet, published in Paris on July 2, 1871, shows a photographer begging his politician-clients to sit still: "Ne bougeons plus!"

(Braive 1966). The same familiar phrase is used as the caption of a cartoon by Cham that appeared in *Charivari* on May 17, 1861 (Fig. 7-3). There, Austria and Italy have been coaxed in front of the camera for a joint portrait, the only situation in which both could be trusted not to make a move. The drawing appeared at a time when affairs on the Italian peninsula were in a state of flux. The campaign to drive out all foreign rulers and reunite the separate states into one nation was well under way, after Garibaldi's dramatically successful campaign in Sicily and the southern mainland during 1860. Austria, with all its dominions in Venetia and the north, was expected to defend its own interests, and the rest of Europe stood at the sidelines and bubbled with speculation about what would happen next.

On occasion, it was not a phrase but some photographic process that provided the germ of an idea for a joke, usually because that process was making headlines at the time. In 1883, William Schmidt of Brooklyn, New York, was awarded a patent for the first hand-held "Detective"-style box camera which, as later claimed by the manufacturers, "practically revolutionized the taking of instantaneous pictures" (Welling 1987). There was much discussion of the possibilities on both sides of the Atlantic, and in due course a new kind of reportage found its way into a cartoon.

The British political scene was (and, indeed, is) troubled by the perennial "Irish problem," and it goes without saying that photography was used, as it was in all other situations, to present a lighthearted, if not necessarily profound, commentary on the situation. On November 19, 1887, *Punch* addressed itself to "the troubles," taking its cue from a reader's letter that had just appeared in *The Times* of London, advocating that "Instantaneous Photography" should be used to record all political meetings (Fig. 7-4). Under the heading of "Negative Results," *Punch* reports (at some length) from a fictitious "Diary of an Irish Instantaneous Detective":

Thursday. —Attend a proclaimed meeting of the Land League at Kilhoolish. Manage to get inside room, and focus the Chairman, when somebody asks me what's my "business there at all." Explain that I've just come to take an instantaneous photograph of the proceedings, in a friendly way. Chairman takes off his coat, and jumps on to the table. Focus him again. Shouts out to me, "Is it a Frind ye call yerself? Thin, bedad, me boy, it's jist out of the window we'll put ye." A rush is made at me. Seize camera, hurriedly take pictures of scuffle in seventeen positions . . .

Ten years later, X-ray photography was the sensation of the hour, and so, on January 25, 1896, *Punch* followed fashion and showed the German Kaiser stopped in his tracks by an X-ray of John Bull's unbending backbone (Fig. 7-5).

The menace of Germany's power and pretensions cast an ever-deepening shadow over Europe in the years before the outbreak of World War I. There was no actual diplomatic breakdown, and Germany remained a prominent member of the European club until 1914, but fear of a formidable neighbor caused Britain and France to band together in many ways against a common danger. During the summer of 1905, their Entente Cordiale was displayed in a series of joint naval maneuvers, from which a suspicious Germany had been excluded. The uneasy relationship between the three nations is well caught in Fig. 7-6, set in Mr. Punch's open-air studio at the seaside.

Forty years earlier, the friendship between England and France was less cordial, despite, or perhaps because of, the fact that the two had fought as allies in the Crimean War of the mid-1850s. To be fair, the target of England's hostility was not so much France herself, as France's current leader, the Emperor Napoléon III, whose character and conduct contrived to ruffle many feathers. In an 1863 cartoon (Fig. 7-7), a

FIG. 7-3. "Don't move!", the irresistible command, applied outside the studio to immobilize
Austria and Italy in a political conflict. Cartoon by Cham from *Charivari*, May 17, 1861.

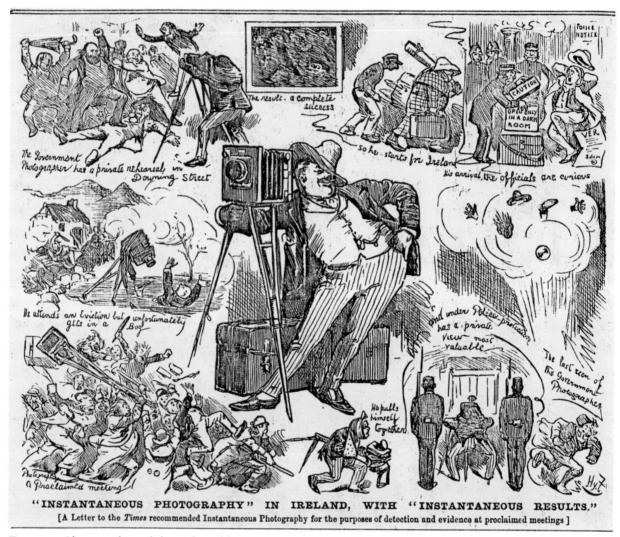

"INSTANTANEOUS PHOTOGRAPHY" IN IRELAND, WITH "INSTANTANEOUS RESULTS."

[A Letter to the *Times* recommended Instantaneous Photography for the purposes of detection and evidence at proclaimed meetings]

FIG. 7-4. Photography and the Irish Problem. Cartoon from *Punch* of November 19, 1887, accompanying extracts from a mock "Diary of an Irish Instantaneous Photographic Detective," in response to a suggestion that "instantaneous photography" be used to record all political meetings.

photographer and his client are shown in the middle of a portrait session. The sitter is, unmistakably, Napoléon III, looking properly imperial with his military cap and magnificent mustache. The photographer is only partially identified in the enigmatic caption: "The Latest Imperial Carte-de-Visite. Mr. K–ngl–ke (a Photographer): 'Oh! that pose won't do at all.

You must be much more in shade!' " The cartoon appeared in the February 7 issue of *Punch*, and may have been a little too enigmatic even at the time for, in the bound volume of the year's issues that came out twelve months later, the editor felt the need for an explanatory note: "Mr. Kinglake, Q.C., had written and spoken very disparagingly of the Emperor Napoleon in the

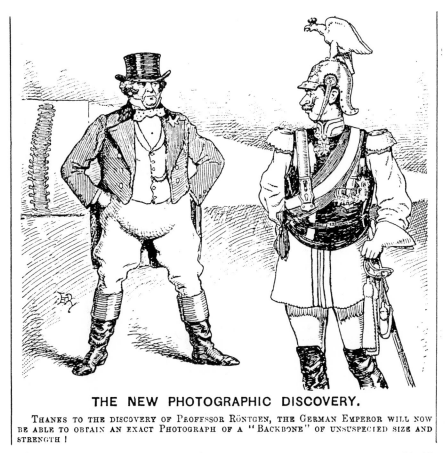

THE NEW PHOTOGRAPHIC DISCOVERY.

THANKS TO THE DISCOVERY OF PROFESSOR RÖNTGEN, THE GERMAN EMPEROR WILL NOW BE ABLE TO OBTAIN AN EXACT PHOTOGRAPH OF A "BACKBONE" OF UNSUSPECTED SIZE AND STRENGTH !

FIG. 7-5. X-ray photography, a new discovery. The German Kaiser stopped in his tracks by an X-ray photograph showing John Bull's unbending backbone. *Punch,* January 25, 1896, Vol. 110, p. 45. See also Fig. 2-15.

most remarkable book of the year, *The Invasion of the Crimea.*"

Although the Crimean War had ended seven years earlier, the joke was topical in 1863 because the first two volumes of Kinglake's authorized history of the campaign had been published just a few weeks before the cartoon was sketched. Despite its length, and its character as a sober, official chronicle, the book is brightened by flashes of mordant observation and personal prejudice. Napoléon III is introduced to the reader with a sustained barrage of contempt. The scorching portrait of yesterday's Gallant Ally burned itself into the memory of a generation,

and was to become the best-known feature of the entire history. This cartoon was just one of many channels through which rumors of the devastating reassessment reached an ever-widening public.

Fig. 7-8 appeared in *Charivari* in October 1860, the month when, after a joint British and French Expeditionary Force had marched into North China and burned down the Imperial Summer Palace in Peking, a treaty was imposed on the Emperor which, in effect, opened the whole of China to Western trade (Worswick 1978). The triumph of strong arm diplomacy is personified here in this French cartoon of the

Fig. 7-6. Germany's shadow complicating matters in Mr. Punch's open-air studio by the seaside. *Punch*, July 12, 1905, Vol. 129.

THE LATEST IMPERIAL CARTE DE VISITE.

Mr. K—ngl-ke (a Photographer). "OH! THAT POSE WON'T DO AT ALL. YOU MUST BE MUCH MORE IN SHADE!"

FIG. 7-7. "The Latest Imperial Carte-de-Visite," *Punch,* February 7, 1863. Napoléon III in the hot seat.

Chinese Emperor, caught in ambush as he steps outside by a crowd of Western cameras. The scene is a fantasy which, like a pearl, has grown around a grain of fact. Although no such roving band of reporters accompanied the European armies, there was a photographer, the intrepid Felice Beato, who did manage to take a picture, not, indeed, of the Emperor himself, but of his brother, Prince Kung. Beato's enterprise caused a moment of panic, because the prince, when he saw the camera taking aim, thought that a large gun had been trained on him (Anon. 1861).

Some cartoonists tried to brew laughter from a blend of funny words and funny images, but others soon grasped that there were more labor-saving ways to coax a smile out of the viewer. The most unpromising photograph, taken for any purpose, could be made to seem amusing when placed in the right setting. Caption and context did all the work, while the image itself retained a dignified sobriety. Fig. 7-9 is a collage, devised as home-front propaganda in Germany at the outbreak of World War I. Straightforward pictures of Germany's enemies, the allied Heads of State, have been arranged as three parts of one whole, over a title which, literally translated,

FIG. 7-8. The Chinese Emperor, caught in ambush by Western photo-reporters, following the victory of a British-French expeditionary force. Cartoon by Cham from *Charivari*, October 1860.

reads "A Clean Cloverleaf" but implies the very opposite: "An Unsavory Trio." The assemblage conveys that the three men are like peas in a pod and share a dangerous depravity, when in fact they shared remarkably little, except a common fear of Germany's intentions. A political point is made with even less effort in Fig. 7-10, which shows an official portrait of President Theodore Roosevelt, framed in a lavatory seat, a silent but surely not uncritical commentary on his performance while in power.

The importance of context is demonstrated by its absence. Without such control, response is uncertain, and the point of any joke is blunted. Fig. 7-11 is a good example of the problems caused for the viewer by a lack of guidance. The carte-de-visite was designed for use as ammunition in a propaganda war, waged in America

during the mid-1870s between supporters of the return to the gold standard and those in favor of paper money, the "greenbacks" that had been issued by the government to finance the Civil War. In this example, one of many distributed by such anti-greenback groups as the Honest Money League, greenbackers are represented by grasshoppers, which are knocking down a farmer and carrying off his crops, while a starving wife and children stand helplessly by. (Filippelli 1981)

Straightforward information about the issues that dominated the decade provide sufficient explanation of the scene's message, but puzzling questions go unanswered. The card was issued by Downing's Gallery in Topeka, Kansas, which was prime greenback territory, so why is it that the villains of the piece are grasshoppers, and why is the photographer recording the carnage himself a grasshopper? There is nothing on the card to help us and, at any rate for the time being, its mysteries remain unsolved.

In another case, something that seems to be a joke was published for all the world to see, and yet, without annotation, its true significance for the author cannot be recovered. The carte-de-visite (by F. Freehafer of Shoeneck) shown in Fig. 7-12a looks like a routine studio item, a picture of two workingmen seated companionably side by side. The special feature is the imprint on the back (Fig. 7-12b), and even that is at first glance an ordinary advertising jingle of the sort used by many portrait studios. The wording and meter, however, are anything but routine:

> Arouse, ye people from the street,
> Come take the American Artist's seat . . .

echoes in a fairly straightforward way the text and cadence of the "Internationale," the socialist hymn written and composed in France in 1871. The English version begins with:

> Arise, ye pris'ners of starvation,
> Arise, ye wretched of the earth. . . .

FIG. 7-9. "A Clean Cloverleaf," actually implying "An Unsavory Trio." German propaganda postcard collage of Poincaré, Tsar Nicholas II, and King George V, who were allied against Germany in World War I. Ades (1976).

The chances are that no profound revolutionary connection was intended between the anthem of the worldwide workers' movement and the advertisement of a provincial studio, and yet the correspondences are too great to be regarded as coincidental. Somewhere, some photographer, whether Mr. Freehafer or another, liked the tune, or the sentiment, or both, and then used them in enlightened self-interest. Yet another possibility remains, namely that Mr. Freehafer was amused by the somewhat simple-minded text of the political hymn, and was making fun

FIG. 7-10. Theodore Roosevelt in Three Dimensions. Pach Brothers, New York, 1904. Three-dimensional photograph on paper, unidentified process. 7 × 9 inches. Portrait framed in a lavatory seat by someone who was evidently not a wholehearted admirer of the President.

of it by adapting it to his own less than earth-shaking concerns.

Words and pictures were traditional tools, common to all cartoonists, but the darkroom magic of manipulation and montage was photography's special instrument, its own distinctive contribution to the art of political comedy. The carte-de-visite reproduced in Fig. 7-13 shows a bust ingeniously composed of three heads, fused together in such a way that only four eyes are visible. At the base runs an inscription in French:

> Quatre yeux seulement?
> C'est que l'un des trois n'y voyait pas clair!

> (Only four eyes? That's because one of the three didn't see clearly there!)

The outer two heads belong to William I of Prussia, who became German Emperor in 1871,

Fig. 7-11. Grangers versus Hoppers, by George Downing, c. 1874–75, Topeka, Kansas. Albumen carte-de-visite. Filippelli (1981). George Downing worked first as an assistant to J. Lee Knight of Topeka in 1870, and then opened a studio of his own there in 1874–75.

and to his Chancellor, Otto von Bismarck. The one in the middle, squashed between the others, is that of Napoléon III, Emperor of France.

It is probable that the cartoon celebrates the crushing defeat of France, and the forced abdication of Napoléon in the Franco-Prussian War of 1870. Exactly where and in what form it made its first appearance is not known, but the French motto suggests that it was designed for a French audience. The fact that the firm of Unterberger of Innsbruck chose to distribute it as a carte-de-visite indicates their confidence that it would find favor with a wider public. Austria had no reason to love Napoléon III, having suffered defeat at his hands at the Battle of Solferino in 1859, and having smarted ever since under his interference in her Italian dominions. Her relations with Prussia were not entirely happy either, as she had been humiliated by Wilhelm and Bismarck in 1866, but political necessity forced her into an alliance with her powerful neighbor,

and she found it tactful at this time to name many streets in her cities after the alarming Bismarck. Moreover, pan-German sentiments among Austrians were strong and widespread, and expressed themselves as total support for Prussia in this conflict. The Unterberger company must have calculated that a cartoon mocking Napoléon's downfall would be relished by their Austrian customers (Sommergruber 1981).

Because of its ability to generate suggestive juxtapositions and imaginative exaggerations with the imprint of photographic realism, photomontage soon became a powerful weapon in the service of political humor, although it did not always meet with unqualified approval. Thus, *The American Journal of Photography* (October 1, 1864) commented on some examples issued in the course of the current Presidential campaign in a tone that suggests distinct disdain for both the candidates and the cartoons:

(a) (b)

FIG. 7-12. Revolutionary sentiments in Shoeneck. Carte-de-visite of two workingmen (a), with an advertising poem on the verso (b) whose text and cadence echo the 1871 French socialist hymn, the Internationale.

Comic Photographs

We have received specimens of a couple of comic photographs of a political design, got up to amuse people who admire comic art. One represents McClellan, Fremont, Lincoln, and Butler, grinning through horses collars for the Presidency, the ugliest to win; under which rule it is an even thing between Lincoln and Butler. The other picture represents Jeff. Davis and Satan, playing a game of chess. The humor of the picture, we suppose, lies in the figure of Mr. Lincoln, who is represented as a "winged angel"! The circulation of this picture among juveniles would be likely to discourage the singing of the hymn, "I want to be an Angel", if Old Abe is a specimen.

Photomontage is a demanding art, and great care must be expended to achieve a seamless whole, one that does not create more interpretational problems than it purports to solve. Consummate artists, like Rejlander (Fig. 3-6), managed it, but for the most part it was easier by far

to take the mixed media path in cases like those shown in Fig. 6-16, and combine photographed heads with lightly sketched-in bodies. With art's freedom and photography's inherent link to the real world, a spirited cartoon could be rushed into print with small effort and at high speed.

Many examples of this kind could be drawn from the political realm. Thus, Fig. 7-14 is a thumbnail commentary on a small but potentially dangerous rift that had opened between the United States and Great Britain in November 1861, during the first year of the American Civil War. In that month, Jefferson Davis, President of the Confederacy, dispatched his envoys, William Mason and John Slidell, to speak for the South's cause in London and Paris. The steamer carrying the two from Charleston slipped safely past the federal controls and landed in Cuba. There, Mason and Slidell boarded a British mail packet, the *Trent*, and set sail for England on November 7. Then the trouble began. The next day, an American steamer under the dashing Commodore Wilkes appeared out of the blue. Shots were fired, a boarding party of marines climbed onto the deck of the *Trent,* arrested the two envoys, and briskly departed.

The American public was enchanted, and the British were enraged. Her Majesty's government bristled to do battle. Lord John Russell, the Foreign Secretary, prepared a stiff dispatch for the U.S. government on November 29, with hints of outright war. Fortunately, a draft of his letter was sent to Windsor Castle, where Prince Albert found a reason to soften its tone. The wife and daughter of Slidell were already in London, and from them it was discovered that Commodore Wilkes had acted on his own initiative, not under direct orders from the U.S. government. Albert was able to offer Lincoln the chance to extricate America from a very awkward situation. In January 1862, Lincoln, preoccupied with more than enough trouble at home, apologized to Britain and released the prisoners.

The carte-de-visite illustrated here (Fig. 7-14) was produced in New York, one of several

FIG. 7-13. "Three by Four"; Kaiser Wilhelm I, Napoléon III, and Bismarck. Albumen print carte-de-visite of a "photomontage sculpture," ingeniously composed of three heads fused so as to make only four eyes visible. Published by the firm of Franz Unterberger of Innsbruck, Austria, c. 1870. Sommergruber (1981).

rushed into print to make a quick killing out of the episode. The picture it offers looks like a drawing but, as the imprint on the back points out, "The Portraits of Earl Russell, Mason, Slidell and Sec'y Seward are Photography." The American public was angered by their government's capitulation, and the card captures this mood of bitterness.

(a)

(b)

FIG. 7-14. "The Great Surrender," published by E. Anthony, 501 Broadway, New York, 1862. Albumen carte-de-visite, (a) recto and (b) verso.

A second example of political photomontage (Fig. 7-15) commemorates a brief and uneasy alliance between Austria and Prussia in 1864. At the beginning of that year, the two agreed to joint action against Denmark. The campaign was successful but, even at the moment of triumph, the partnership showed signs of strain. By 1865 the allies were eyeing each other with the hostility that was to lead in the following year to the defeat of Austria and the triumph of Prussia. On the card, the union between the two countries is represented as a wedding between the Austrian Foreign Minister, Rechberg, and Prussia's Prime Minister, Bismarck. Beneath the awkward pair is written: "We have the honor to announce our liaison, which took place on January 14th 1864, in the Taxis Palace in Frankfurt a.M., and we request your sympathy." Perhaps Bismarck himself saw a copy of the cartoon; certainly he used the same image when he spoke of the alliance, just before the divorce in 1865: "I think it wiser to continue the existing marriage with Austria

FIG. 7-15. "Marriage of Convenience," 1864. Probably Austrian. Albumen carte-de-visite. Cartoon alluding to an uneasy agreement between Austria and Prussia on joint action against Denmark; here the two statesmen (Bismarck, called Bisberg, and Rechberg, called Rechmark) are about to take their vows. Maas (1975).

FIG. 7-16. Jefferson Davis, captured in woman's clothes by Federal troops, on May 10, 1865. Albumen carte-de-visite by Webster & Popkins, 293 Main Street, Hartford, Connecticut.

for the time being, despite little domestic quarrels'' (Taylor 1967). See Figs. 6-16 e and f for other examples of political photomontage.

These cards, on the Austro-Prussian coalition and on the "Trent Affair," had a very brief lifespan; they made contemporary viewers smile or shake their heads, but left no lasting impression. The incidents they commented on loomed large at the time, but soon shrank to insignificance in retrospect. However, another (Fig. 7-16) was one of many cartoons that, all striking the same note

at the same time, smashed a reputation and permanently distorted perceptions of a leading figure in a political drama.

Jefferson Davis, president of the Southern Confederacy, was caught by federal troups in Georgia on May 10, 1865. The event capped a momentous month, marked by the surrender of the Southern forces and the assassination of President Lincoln. The capture was made at dawn, and took the Davis party by surprise. Still half-asleep, Davis pulled on some clothes in the

dark, and stepped out of his tent to face the Northern soldiers. With disastrous bad luck, he had snatched up and thrown over his tunic not a man's cape but his wife's shawl. The mistake was to dog his reputation from that day to this. The humiliating circumstances of the arrest provided a long-awaited occasion for Union supporters to vent their rage, a release that took the form of contemptuous editorials and satirical cartoons. All laid brutal emphasis on the clothing; the incidental shawl became a full dress, sometimes (as here) with a crinoline hoop added for good measure. The proud Davis, whose judgment had been flawed but whose courage had never been doubted, was transformed into a coward, huddled for safety in a demeaning disguise. Forever after that May dawn, Davis has been condemned to scuttle through popular history, clutching his skirts and his shawl, shriveled by the scorn of the North and the shame of the South (Collins and Wilsher 1984).

Humor comes in many shades and speaks in many voices. "Laugh and the world laughs with you" is a cheering cliché that covers only certain kinds of comedy. As the Davis example shows, there are other, more savage varieties, designed expressly to divide and demonize, to encourage one side and demoralize the other. It was clear from the start that photomontage could be a helpful tool for ruining reputations, and Jefferson Davis was not by any means the only victim. In the aftermath of the Paris Commune in 1871, Eugène Appert, a professional photographer and a supporter of the Government, produced a series of "documentary" re-creations of certain key events in the short life of that movement. By combining the photographed heads of its leaders, and of its most celebrated victims, with the bodies of professional models, he was able to stage-manage and re-photograph scenes in which the Communards were cast as villains in a melodrama. The complexity of the real story was simplified into a stark black-and-white morality play, a duel between outright good and outright evil (English 1984). Appert's creations

were distributed throughout France, no doubt to the amusement of some, but they served mainly to darken the public's perception of the Commune for many years to come.

A less far-reaching but equally malicious campaign had been waged in Rome a few years earlier, to pay off old scores and open new wounds during the tumultuous decade of partisan politics that led to the unification of Italy in 1870 (Collins 1985). In 1862, scandalous photomontage cartoons were assembled, in which the former Queen of Naples was made to appear in compromising situations with an assortment of prominent lovers, including Pope Pius IX himself. The venomous little pictures, all ostensibly amusing, were intended to humiliate the Queen and besmirch her circle, because she represented forces that had to be destroyed before Italy could become a sovereign nation. Austrian by birth, she was a symbol of Austria's dominion over the northern Italian states, and by marriage she was linked to another hated foreign power, the Bourbon family, which until 1861 had ruled over the Kingdom of the Two Sicilies.

The cartoons were made for partisan purposes, and were offensive by design, but the response to such pictures was also partisan; it is always easier to enjoy the mortification of an enemy than of a friend. Because the pictures had been produced in Rome, capital of the Papal State, and attacked the Pope and his political supporters, there was a sharp reaction from the Vatican, and new regulations were laid down for the practice, inside the state, of all kinds of photography, even the most innocuous. Although the pictures were by any measure distasteful, it is legitimate to wonder whether the official response would have been quite so severe had they been aimed in another direction. As *Punch* slyly murmured in its December 21, 1861, issue: "Would his Eminence have interfered with the licentious photographers if they had placed the head of Garibaldi . . . in the same vile relations as those in which they put the upper storeys of . . . the Queen of Naples and his Holiness?"

FIG. 7-17. "Metropolis," by Paul Citroën (1923). Copyright 1995. Estate of Paul Citroën / Licensed by VAGA, New York. Moeshart (1995). See also Ades (1976).

As this handful of examples shows, photomontage and photo-collage were alive and well in the nineteenth century, but it was in the years just after World War I that they attained new levels of daring and sophistication, under the influence of the Dadaists, and in the hands of such artists as John Heartfield, Hannah Höch, George Grosz, Paul Citroën, and Raoul Hausmann. These artists, and others, used the same techniques on which graphic humor had traditionally relied, but most of the creations were not "funny" or entertaining, having decisively crossed the (often thin) dividing line between humor and satire. Mostly they were eye-opening and disturbing statements in campaigns against a variety of evils, militarism, nationalism, exploitative industrialization, reckless urbanization, and enforced artistic uniformity. They are impressive documents of their time, and occasionally triumphs of the photographic imagination, but they display none of the disarming naiveté that one ordinarily associates with the term "early photography"; see, for example, Ades (1976), Burgin (1981), Kahn (1985), and Pachnicke and Honnef (1992). Fig. 7-17, a celebrated collage from the hands of Paul Citroën, will serve as an example, a million miles from the aesthetic principles that motivated Oscar Rejlander, inventor of the art in the mid-1850s.

Political life is inherently partisan; the more important the issue, the deeper the convictions and the more desperate the situation, the more ferocious are the methods used to conduct the debate. In the theater of politics, photography had stepped into a role already developed by its sibling arts. It enlarged the possibilities, but found no need to change the core.

Chapter 7 References and Notes

ADES, D. (1976). *Photomontage,* Thames & Hudson, London, p. 7, Plate 56.

ANON. (1848). "Phoebus at Hide and Seek," *Punch,* Vol. 15, p. 86.

ANON. (1861). Report in *The Illustrated London News,* January 5, p. 18, on the signing of a peace treaty between Great Britain and China.

BRAIVE, M. (1966). *The Era of the Photograph,* Thames & Hudson, London, pp. 18, 70.

BURGIN, V., *et al.* (1981). *Photography/Politics One,* Photography Workshop, London.

COLLINS, K. (1985). "Photography and Politics in Rome: the Edict of 1861 and the Scandalous Montages of 1861–1862," *History of Photography,* Vol. 9, No. 4, pp. 295–304.

COLLINS, K., and WILSHER, A. (1984). "Petticoat Politics," *History of Photography,* Vol. 8, No. 3, pp. 237–43.

ENGLISH, D. E. (1984). *Political Uses of Photography in the Third French Republic, 1871–1914,* UMI Research Press, Ann Arbor, Mich., pp. 33–34.

FILIPPELLI, R. (1981). "Greenback Shutterbug," *History of Photography,* Vol. 5, No. 3, p. 263.

GERNSHEIM, H. (1984). *Incunabula of British Photographic Literature, 1839–1875,* Scolar Press, London, p. 147.

KAHN, D. (1985). *John Heartfield; Art and Mass Media,* Tanam Press, New York.

MAAS, E. (1975). Personal communication, acknowledged with thanks.

MOESHART, H. J. (1995). Studie- en Documentatiecentrum voor Fotografie, Leiden, Netherlands. Personal communication and assistance, acknowledged with thanks.

PACHNICKE, P., and HONNEF, K. (eds.) (1992). *John Heartfield,* Harry N. Abrams Inc., New York.

SOMMERGRUBER, W. (1981). Herr Sommergruber's help in the elucidation of this photographic puzzle is gratefully acknowledged.

TAYLOR, A. J. P. (1967). *Bismarck,* Vintage Books, New York, p. 77.

WELLING, W. (1987). *Photography in America; the Formative Years, 1839–1900,* University of New Mexico Press, Albuquerque, N.M., p. 285.

WORSWICK, C. (1978). *Imperial China; Photographs, 1850–1912,* Scolar Press, London, pp. 138–39.

8

PHOTO-FALLOUT

PUBLICITY, FASHION, MUSIC, REFLECTIONS ON THE PRINTED PAGE

Photography worked its way with remarkable speed into every nook and corner of the everyday world, and humor followed in its footsteps. It was sensed from the first that there was laughter to be found and profit to be made in the linkage of age-old human concerns with this latest technological marvel. Life is a serious business, much in need of light relief, and new jokes are precious contributions to the pleasures of the passing hour.

Photographers unbent even among themselves from time to time, and an occasional gleam of humor brightens the sober pages of the technical literature. Bruce and Braithwaite (1913), for ex-

ample, puncture the pretensions of the manipulated photograph when they recommend to their readers a selection of retouching knives for use in what they cheerfully refer to as "Negafake" work (Henisch 1996). Throughout the era of wet-plate photography, designated by Gernsheim (1969a) as "the culinary period," extraordinary recipes, with extraordinary ingredients, were concocted to help the collodion on the photographic plates retain its moisture for as long as possible. Keeping plates moist avoided the necessity of wetting them *in situ* immediately before each exposure (Henisch 1994). In due course, treacle, malt, raspberry juice, raisin

FIG. 8-1. Cabinet card of the 1890s, American.
Photographer unidentified, except by his self-confident
nom-de-plume.

syrup, pine-kernel juice, milk, licorice juice, chestnut juice, ginger wine, beer, tea, coffee, and gum arabic were all pressed into service, not to mention opium and morphine. As late as the turn of the century, Sir William Abney (1898 and 1901) described the action of an eggwhite-coffee-fruit-sugar mix or, alternatively, eggwhite and ammonium hydrate "mixed immediately before use with an equal amount of beer or stout." At one point in the fevered search for the perfect elixir, James Mudd (1866) demurely slipped into the debate a proposal for a gin-and-water recipe that, understandably, was agreed to have many pleasant side-effects. "The question of photography as a fine art will now be indis-

putable, for our commonest works will now be always *spirituelle,*" one appreciative reader commented.

In the battle for business, photographers, like others in the market (see also Chapter 4), knew that humor is a weapon tried and true. Jokes lead to smiles, and smiles have a way of turning casual passers-by into captive customers. Whether any given joke is by, or on, any given photographer is not always clear. It is now hard to tell what exactly determined the choice of the studio name scrawled so boldly on the card mount of Fig. 8-1: delusions of grandeur, or sheer desperation? No matter, it certainly makes the collector smile today. Moreover, Rembrandt was by no means the only master to whom such hopeful homage was paid. In faraway Warsaw, Murillo was the name of choice, used by the late-nineteenth-century studio of Kühle, Miksche, and Türk.

Operators in quest of eye-catching material plucked inspiration from the most unlikely sources. A letter appeared in the *Cape Monitor* of South Africa, on January 2, 1858, offering for consideration "the accompanying trifle": "Conundrum—'Why is York, the Photographic Artist, like the celebrated Robespierre of the French Revolution? Because he feels a pleasure in taking off people's heads.'" The ponderous pleasantry caught on; several photographers in the Cape Town area urged customers to come in and "lose their heads," while one, William Waller, went even further in a bloodcurdling advertisement published by the *Fort Beaufort Advocate* on March 31, 1860, announcing that he would be "Happy to Take Off the Heads of the People" (Bull and Denfield 1970).

The anxious apologist could claim that a frail thread here binds the catchphrases of revolution with those of studio commerce, but in most cases it is clear that no strenuous effort has been made to achieve the perfect match, or indeed any match at all, between text, image, and product. Instead, there is touching faith in the captivating charm of incongruity. A sturdy little jar of

(a)

FIG. 8-2 (a)–(c). Camera Commerce.

(a) Advertisement for Liebig's Meat Extract, Lithograph, n.d. (c. 1890). Probably British.

(b) Organic telephone system, on a metal business card for Alex. Uhle. American, early twentieth century. "Hello Central! Give me 990." "Ring off. The line is busy." Recto and verso.

(b) recto

(b) verso

Liebig's Meat Extract looms on the screen in a magic lantern show at a children's fancy-dress party (Fig. 8-2a). Alex Uhle summons the faithful to his Liquor Sample Room with a photographic set-up scene featuring a boy, a girl, one donkey, one foal, and a very early telephone exchange (Fig. 8-2b; see also Fig. 6-15c). Far more amusing, just because it is far more ingenious, is the c. 1890 advertisement in Fig. 8-2c, where the majestic corset of the period has been metamorphosed into a monumental cactus container, part of a studio backdrop being photographed by two fashion-conscious *putti*. Whatever the busi-

ness, the aim was to please, and coax the client into willing obedience to one of photography's insistent imperatives: "Smile Please!", an invitation tempting enough when issued by a charming man (Fig. 8-3a), and irresistible when offered by an even more charming little dog (Color Plate 8-3b).

One of the most disarmingly dotty brainwaves to sweep the photographic trade was the idea of the Human Billboard. A living, breathing mannequin, preferably female and preferably pretty, was selected to advertise a studio's wares. Placed in some conspicuous position, out in the street

FIG. 8-2. (c) Advertisement for a Warner Brothers corset, c. 1890. Courtesy of the Warshaw Collection, Washington, D.C.

or up in a window, and dressed in a startling costume spangled with choice samples from the photographer's stock, this Poster Person was difficult to overlook, impossible to ignore (Fig. 8-4). The concept was not entirely new, for there are delightful trade cards of the seventeenth and eighteenth centuries that pay homage to a craft by assembling its characteristic equipment into one little figure—a tall, thin chandler built from tall, thin candles, or a cook made entirely from pots and pans. It is a far cry, however, from such emblems, sketched by an artist's practiced pen, to the all-too-solid substance of the provincial photographer's resolute assistant. The unbridgeable divide between the poetry of fancy and the prose of real life is part of the human comedy, and laughter bubbles up to fill the gap.

The Spirit of Photography found similar embodiment, far from the hard realities of Main Street merchandising, in the frivolities of fancy dress. At costume parties, anyone with the charm and confidence to wear a camera, whether stylishly cocked on the head or wedged into the waistline, was sure to be the focus of attention (Color Plate 8-5; see also Braive 1966, p. 21). Men, more cowardly or more conventional, rarely risked ridicule in such photographic modes, but it is known that the arbiter of fashion in Paris, the great Jean-Philippe Worth himself, once appeared at a party as a "Negative," in a black shirt, worn with a white suit, white top hat, and white, powdered hair (Cooper 1995).

Comedy and costume are natural partners, for

FIG. 8-3 (a). Critters and Their Clients I. Photographer E. Desmarais, complete with dicky-bird to mesmerize his victim. Depot Square, Woon. (Woonsocket?), Rhode Island, 1890s.
 See also Color Plate 8-3 (b).

the vagaries of fashion supply an endless stream of jokes. The crinoline craze of the 1860s was a special favorite among cartoonists; see also Fig. 3-6. In ideal circumstances, the crinoline was an enchanting invention. Its light, firm support buoyed up the weight of an enormous skirt, and allowed the dress to float and sway with every movement of its wearer in the most seductive way. But in everyday situations the crinoline could be more of a problem than a pleasure, because the frame was so wide, and so unyielding, that it could not be squeezed into small spaces.

Fig. 8-6a shows just one of the many stereo set-ups that offered solutions to the problem of "Getting on the Bus," while Color Plate 8-6b demonstrates the charm that made all the bother worthwhile.

Of all the publicity campaigns conducted on behalf of photography, by far the most successful was the one that launched the revolutionary Kodak camera in the 1880s. When the sheet music shown in Fig. 8-7 was issued, the camera was only three years old, and its famous advertising slogan was made part of the song's lyrics:

FIG. 8-4. Photo-fashion and photo-advertising. "The Masquerade," by Thomas
Houseworth & Company, San Francisco. Cabinet card from the Houseworth
Celebrities Series (note hemline inscription). 1880s. Palmquist Collection. (Palmquist
1990, 1991)

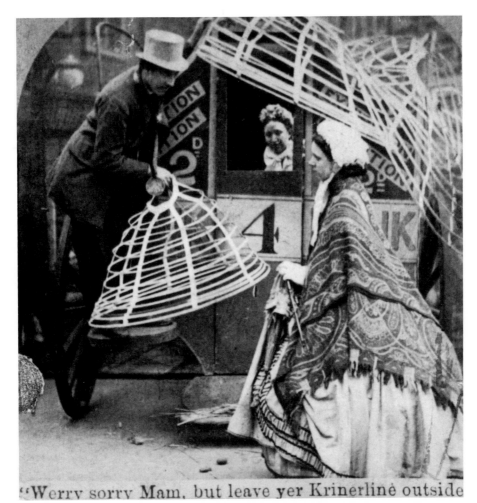

FIG. 8-6 (a). The Incredible Crinoline I. Problems of Accommodation. Half of a stereo card, labeled "Groups from Life." No date or publisher. 1860s. Probably English.
See also Color Plate 8-6 (b).

Isn't it simple? Isn't it quick?
Such a small box, it must be a trick!
How do you work it? What is the test?
You press the button; we do the rest.

The key phrase soon entered the language (see Weintraub 1987) and was used in many other works, from cartoons to Gilbert and Sullivan's last collaborative venture, *Utopia, Limited* (1893):

Oh, maids of high and low degree,
Whose social code is rather free,
Please look at us and you will see
What good young ladies ought to be!

If evidence you would possess
Of what is maiden bashfulness,
You only need a button press—
And *we* do all the rest. (Fig. 8-8a)

FIG. 8-7. "You Press the Button," by W. S. Mullaly, composer. After 1892. Published by Willis Woodward & Company of Broadway, New York. Lithograph, 11 × 8½ inches. The title echoes the famous Kodak advertising slogan "You press the button, and we do the rest." Words by Webster Fulton. Republished 1980 by the Historical Group of the Royal Photographic Society, Bath, U.K., and by the California Museum of Photography at Riverside. Diage (1980).

The catchphrase caught on and so, inevitably, an inspired American cartoon of 1891 chose as its subject a funeral parlor in the Wild West, angling for business with the reassuring slogan "You kick the bucket—we do the rest" (Fig. 8-8b).

From the same decade came several music-hall songs about studio farces and flirtations, of which a fair sample is *The Gay Photographer,* "Popular Song with Imitation Banjo Accompaniment" (Fig. 8-9), composed by George Grossmith Jr. and published by J. Bath of 40 Great Marlborough Street, London. A small imprint

on the sheet music inside explains that the imitative role, not only of a banjo, but of a penny whistle, is assigned to the "Pianoforte accompaniment" (Gidal 1990). The text is a moral tale, with many a lesson (but not in poetry) still valid to this day:

The Gay Photographer

Miss Jenkins was a lovely maid in
 Kensington located,
And there never was a fellow who could
 win her heart, all mankind she hated;
Some forty lovers sought her hand, but she
 baffled all their hopes,
So the forty lovers left this world by means
 of forty ropes.

But there came upon the scene a gay
 photographer,
There came upon the scene a gay
 photographer,
There wasn't a biographer,
Nor e'en a lexicographer,
Who did not write about this gay
 photographer.

Miss Jenkins went to the studio of Mr.
 Peter Guffin,
And he won her heart by taking of her
 photograph for nuffin,
But heartless was this man of art,
 to her he did confess,
That he'd won the hearts of many other
 nice young girls, by the very same
 process.

.

She said, "I'll be his ruin, though to perish
 be my lot."
Then she swallowed all his photographic
 chemicals,
 and died upon the spot.
So here's a moral for all young maids,
 which you'll very plainly see,
Don't go to a photographic studio,
 for to be taken free.

(a) (b)

FIG. 8-8 (a)–(b). The Kodak Craze.

(a) Modest Maidens caught by Kodak. Cartoon by W. S. Gilbert from *Utopia, Limited* (1893), by W. S. Gilbert and A. Sullivan.

(b) Funeral parlor trade slogan for the photographic age: "You kick the bucket—we do the rest." Cartoon by R. Jonny from *Puck's Library,* "Fads and Fancies," 1891. Collins (1986).

Or you may also meet a gay photographer,
Yes! You may also meet a gay
 photographer,
There wasn't a biographer,
Nor e'en a lexicographer,
Who didn't write about this gay
 photographer.

Song and music (four sheets) cost four shillings, a bargain maybe, but not actually a trivial amount of money at the time. Also from London (and likewise sold at four shillings), we have from the 1890s *The Photographic Fiend,* a "humorous song" about photographic flirtation, written and composed by Herbert Harraden, and published by Robert Cooks and Company, of Regent Street. "We take supper in the darkroom" is one of its poignant paroles.

The enthusiasm for such story-songs was international. Braive (1966), for example, mentions an early French piece, alas undated: *La photographie sur papier,* a "comic scene" by Jules

Couplet, published in Paris. In another little farce, *Chez le Photographe en Renom,* a stream of difficult clients pours in and out of a fashionable studio. Each arrives in high hopes and leaves in high dudgeon, indignantly refusing to recognize the "likeness" offered by the weary operator. Only Mademoiselle Blanc de Cygne, nineteen years old and pretty as a rosebud, can manage a smile when she peeps at her own portrait. (Bertall 1874)

In Germany, there were several variations on the theme. Thus, one of the cornerstones of German poetic literature, Schiller's "Das Lied von der Glocke," became the rhythmic template of a photographic parody in the mid-1860s, which was first recited on November 24, 1865, at a celebration of the Berlin Photographischer Verein: "Das Lied von der Photographie, in sechs Aufnahmen." No author is given, but the poem is believed to be the work of Dr. Emil Jacobsen (1836–1906), a well-known chemist and Secretary of the Photographischer Verein. It was reis-

FIG. 8-9. *The Gay Photographer,* a popular song by George Grossmith Jr. Published by J. Bath of 40, Great Marlborough Street, London, 1890s. Gidal (1990).

sued in 1878 in a modified form, signed "Anonymous A.S." (Stenger 1938). Even a revered "cornerstone" can be viewed in different lights, and Koppen (1987), for instance, does not regard "Das Lied von der Glocke," for all its fame, as a poetic masterpiece. It was the fame that made it a perfect target. A comparison of the first stanzas will illustrate Jacobsen's style. Thus, Schiller:

> Fest gemauert in der Erden
> Steht die Form aus Lehm gebrannt.
> Heute muß die Glocke werden!
> Frisch, Gesellen, seyd zur Hand!
> Von der Stirne heiß
> Rinnen muß der Schweiß,
> Soll das Werk den Meister loben;
> Doch der Segen kommt von oben.

Jacobsen echoes this as:

> Aufgebaut aus Glas und Eisen
> Steht das neue Atelier,
> Ach! bis "fertig" es geheissen,
> War geleert das Portemonaie,
> Denn die böse Welt
> Giebt nichts ohne Geld;
> Gott allein nur ist zu loben,
> Gratis giebt er's Licht von oben.

Even before the picture is finished, the client's purse is empty. Everything costs money in this world; only God deserves praise, for supplying sunlight free-of-charge (Jacobsen 1866).

Under the pen name "Isaaksen," Jacobsen had already been, in 1864, a co-author (with "Lerche," *alias* H. W. Vogel) of a comedy in two acts: "Das Zukunftsatelier oder die Photographie als Eheprokurator" ("The Future Studio; or Photography as a Marriage-Broker"). In this play, an impecunious photographer invents the process of "Knallotypie," meant to signify photography in the dark, though the term itself suggests nothing of the kind. When not disguised as a dramatist, Hermann Wilhelm Vogel was the world-famous photo-chemist, inventor of ortho-chromatic media and, as it happened, onetime mentor of Alfred Stieglitz.

Jacobsen's pastiche of "Das Lied von der Glocke" is not actually the only one; there is also a contemporary piece by Ernst Klotz, entitled "Die Fotografenmoritat," all about a young lady, Lenchen, at the photographer's, with an innocent beginning and a tragic end. Indeed, the word *Moritat* denotes something between a horror story and a moral tale, and its recital should in principle be accompanied by music from a barrel organ (here impracticable).

Die Fotografenmoritat

> Lenchen ging zum Fotografen,
> Denn sie wünschte ein Portrait,
> Wo sie drauf für ihren braven
> Funker Fritz sich ähnlich säh'.
>
> Möglichst schön soll der sie finden,
> Drum von vorn und im Profil,
> Links und rechts und auch von hinten
> Reizend war ihr Mienenspiel,
>
> Und der Fotograf, Herr Lammer,
> Nahm sie, weil sie darum bat,
> Mit in seine Dunkelkammer,
> Wo er sie entwickeln tat.
>
> Halb entwickelt erst im Bade
> Schwamm sie rum als Negativ,
> Als durch Zufall ihr Soldate
> Vorn im Atelierraum rief:
>
> "Ist denn keiner hier im Laden,
> Dass ich mich einmal en face,
> Wie doch alle Kameraden,
> Für mein Lenchen Knipsen lass?"
>
> Lenchen stürzte aus der Kammer,
> Schmiegte sich um seinen Hals,
> Und der Fotograf, Herr Lammer,
> Zeigte sich nun ebenfalls.
>
> Fritz, der von Entwickeln, Wässern
> Und Fixieren nichts versteht,
> Glaubt, dass sie mit diesem bessern
> Herrn ihn schändlich hintergeht!

Riss den Säbel aus der Scheide,
Lammer griff ein Blechstativ,
Und so fochten sie nun beide,
Während Lenchen "Hilfe!" rief.

Fochten, dass die Funken stieben,
Lammer ward erst her und hin,
Dann im Kreis ums Fass getrieben,
Wo das Blitzlichtpulver drin.

Und ein Funke fiel in selbes,
Dass es zischt und kracht und pufft,
Rotes sahhman, Schwarzes, Gelbes,
Denn das Haus flog in die Luft.

Ach, was ist es für ein Jammer,
Wenn ein Bräutigam so dumm,
Dass er von der Dunkelkammer
Gar nicht weiss, wozu, warum.

Lieben können und vermehren
Sie sich heut' noch durch ein Kind.
Wenn sie nicht gestorben wären,
Was sie aber leider sind.

In brief, Miss Lenchen sits for her portrait, then follows the photographer, Herr Lammer, into the darkroom to watch herself "being developed," swimming in the dish "as a negative." Unfortunately, her special friend, a soldier by the name of Fritz (what else?), arrives at the studio to have his own picture taken. He sees Lenchen and Herr Lammer as they emerge from the darkroom, and suspects, nay, assumes the worst. Out comes his sword, and Mr. Lammer is left to defend himself with a metal tripod while Lenchen cries "Help!" Sparks fly, and ignite the reservoir of flashlight powder. The house is blown up. Oh, how they could have lived and multiplied, had they not all died in the mishap—which they did. R.I.P. (Schürer 1991)

One of photography's excursions into the realm of opera is represented by Richard Genée's *Die Prinzessin von Kannibalien, oder Narrheit und Fotografie,* a "burlesque opera in two acts." Genée (1823–95) composed it in Vienna during the 1870s, and Koppen (1987) de-

scribes the work as "remarkably inconsequential," which may explain its disappearance from the modern repertoire. The photographic hero of the piece is called Albumin, but there is actually little else that is specifically "photographic." There is, however, a scene in which the court of the Cannibal-Emperor has a group picture made. Koppen quotes a few lines of the chorus:

Pst! Haltet still,—nicht gemuckt,
Mit der Wimper nicht gezuckt,
Mit dem Aug' nicht gezwickt,
Jeden Laut—unterdrückt
Nicht geseufzt,—nicht gehustet,
Nicht geniest,—nicht gepustet,
 Nicht gelacht,
 Athmet sacht;
 Nicht geschneuzt,
 Ob's Euch reizt,
Sonst—wird—ähnlich nie
Die—Fo—tografie!

In brief: don't fidget, sigh, cough, sneeze or laugh; an elaborate and whimsical exhortation to keep still, or else a proper photograph (a good likeness) will never be made.

This kind of set-piece, in which photography was used from time to time as a theme, or at least as a thread to bind the story, was popular everywhere, but the new art became such a familiar feature of the contemporary scene that it also made its presence felt in a thousand unexpected contexts. At some unspecified date, probably in the 1850s, E. Nissan & Company, of 111 Nassau Street, New York, issued its own version of "The Husband's Commandments." This venerable joke-list of instructions to a wife in need of guidance must have been old in the Garden of Eden ("Thou shalt accept no gifts from strange serpents"), and so Mr. Nissan tried to breathe new life at least into rule number two, "Thou shalt not have a daguerreotype or any other likeness of any man but thy husband."

That charming minor art-form, the illustrated letter, yields several thumbnail impressions of

photographers at work and play. One is shown in Fig. 2-2, and another is tucked into a note written in London on June 4, 1895, by Beatrix Potter. It is addressed to Noël Moore, the lucky recipient of those far more famous letters from which sprang *Peter Rabbit* (1902) and all his friends and relations. This one contains no seed of any story in the Potter canon, but it is enlivened with a little sketch of the writer herself, "busy taking photographs with Cousin Alice" (Fig. 8-10). Beatrix Potter learned to handle a camera with competence under the tuition of her own father, a gifted amateur, and often used photographs as preliminary studies for her paintings (Wilsher 1985). Before she became famous as an author, she sold a few designs to greeting-card publishers, and in one of these, made for the German firm of Ernest Nister and Company in 1894, drew some background details for her composition from a photograph by Frank Sutcliffe of Whitby.

The black cloth and tripod in this example are just tiny additions, touched in to make the reader smile, but in another letter, also intended to amuse young eyes, a photographic term has been woven into the text as an integral part of the joke. In 1864, Catherine Sinclair, a children's author forgotten today but popular in her time, designed a rebus letter (Fig. 8-11) in which on line 8 the currently fashionable term "carte-de-visite" has been pictured, in the confident belief that it was by then so familiar that its inclusion would pose no problem for juvenile code-crackers.

Although, as the present offerings must surely demonstrate, there have been many jokes about photography, it was only natural that those pioneering ventures that defined the genre in the early years attracted most attention. This may be why one not particularly distinguished specimen found its way into the pages of a novel. Edward Bradley (1827–89), the clergyman who, under the pen name Cuthbert Bede, delighted readers for years with learned notes about customs and curiosities, from mince pies to toy theaters, pub-

lished in 1855 that bible for every photo-historian today, the first humorous treatment of the new art, *Photographic Pleasures.* The germ of the book came from a handful of cartoons that Cuthbert Bede had drawn for *Punch* in 1853. One of these, "Portrait of a Distinguished Photographer," appearing on May 21 of that year, shows an enthusiast bent under his dark cloth, blissfully unaware that a bull is about to butt him in the rear (see Fig. 5-3c). The sketch must have caused much merriment in the parlors of England, for Charles Kingsley specially refers to it in his novel *Two Years Ago,* published four years later:

> Oh, never mind; Mr. Mellot has gone wandering down the glen with his apparatus, and my Elsley has gone wandering after him, and will find him in due time, with his head in a black bag, and a great bull just going to charge him from behind, like that hapless man in *Punch.* (Kingsley 1857)

Just as photography left its mark on the world, so, in turn, its own image was touched by current fashion. Ever since the late eighteenth century, the revival of interest in the Middle Ages had grown steadily, and by the 1850s this tide of taste was reaching its high-water mark. Any feature of modern life could be medievalized; crenellated cupboards and gargoyled umbrella stands filled the homes of the faithful. In such an atmosphere, it is not surprising to find that up-to-date figure, the photographer, occasionally cast as a character in a medieval romance. Inspired by the somewhat strained connection between the gun-cotton used in solution for the collodion process, and Sir Robert Cotton, the great seventeenth-century collector of manuscripts, Cuthbert Bede came up with a cartoon showing "A Mediaeval Photographer, from an Illumination in the (Gun-)Cotton MSS" (Fig. 8-12).

Not to be outdone, Lewis Carroll (probably in the 1850s) wrote "The Ladye's History," a short story presented as a "Legend of 'Scot-

FIG. 8-10. Illustrated letter sent by Beatrix Potter, famous author of children's stories, in 1895. Courtesy of the Pierpont Morgan Library, New York (MA 2009, Beatrix Potter).

FIG. 8-11. Catherine Sinclair, "A First of April Nonsense Letter," in rebus form. London, 1864. 7 × 5 inches. By permission of the British Library (No. 012804-N-13). Note the reference in line 8 to a carte-de-visite, a term by then universally understood.

land,' " first recorded in 1325. In this is told the tale of an itinerant photographer-troubadour, who went from castle to castle offering his magic:

Now yt chaunced that a certyn Artist, hight Lorenzo, came toe that Quarter, having wyth hym a merveillous machine called by men a

Chimera (that ys, a fabulous and wholly incredible thing;) where wyth hee took manie pictures, each yn a single stroke of Tyme. . . .

Poor Lorenzo is thrown into a dungeon because he fails to deliver the goods: he cannot produce a full-length portrait in which both head and feet are clearly visible. In due course he becomes a

FIG. 8-12. "Photography in a Legendary Light; a Mediaeval Photographer, from an Illumination in the (Gun-)Cotton MSS." Cuthbert Bede, *Photographic Pleasures* (1855).

ghost, and so, with a sort of rough justice, does his exacting client. She is condemned to stalk the battlements until that day, far in the future, when another young lady will be

> fotograffed aright—
> Hedde and Feet bee both yn sight.
> (Gernsheim 1969b)

At the other end of the scale, the coming of the railroad, like the coming of photography, changed the world and the way its possibilities could be perceived. The two developments were often bracketed together in the public's mind, and each was thought of, depending on mood, as a modern marvel or a modern menace. On the whole, optimism prevailed, and pride in progress, but at times a note of regret, half-humorous, half-sad, can be heard, mourning the loss of something precious as old ways were inexorably swept away by inventions and improvements:

> Where boys and girls pursued their sports
> A locomotive puffs and snorts,
> And gets my malediction;

The turf is dust—the elves are fled—
The ponds have shrunk—and tastes have
 spread
To photograph and fiction.
> (Locker 1857; Fig. 8-13)

One of the ways in which photography changed perceptions was by its introduction of the multiple image. Marvelous as it had been to discover that anyone, with very modest outlay, could obtain a single portrait, it became even more extraordinary to realize that many copies of the same image could be bought at scarcely greater cost. As is usual in human affairs, the bulk buy was desired and despised in equal measure. Satisfaction at a bargain, and disdain for anything too readily available, fought for the upper hand in every mind. During the 1860s, when cartes-de-visite were bought and sold in the thousands, operators, in cut-throat competition, slashed their prices to the bone. When it came to reprints, fifteen individual portraits for $1.50, and fifteen further duplicates of those for $1.00, seem to have been the going rates charged by provincial studios in America. Such numbers

were difficult to shape into a graceful verse; with some discourtesy to the poetic muse, C. G. Blatt's Photographic Emporium of Bernville, Pennsylvania, made this enticing claim:

> He knows that you must laugh,
> Fifteen pictures for one and a half.
> Duplicates fifteen for one dollar,
> That's the way the people holler.

Far away in London, the firm of Alfred W. Bennett in 1865 took aim at a much more sophisticated clientele, and advertised "Photographic Portraits of Men of Eminence in Literature, Science, and Art," at twenty-four per guinea. The sharp eye of W. S. Gilbert spotted the notice, and this rueful little commentary on the craze duly appeared in the comic magazine *Fun* on December 23 of the same year:

> To Euphrosyne
> With My Carte-de-visite
>
> I've heard EUPHROSYNE declare
> That handsome men, both dark and fair,
> Are dear at three a penny.
> I've searched the world, and this I know,
> That nowhere, at a price so low,
> Could I discover any.
>
> Men ridiculed my folly, when
> I asked the price of handsome men,
> And christened me a ninny.
> Til PHOCAS KAMMERER I tried,
> And found the article supplied
> At twenty-four a guinea!
>
> <div align="right">(Gilbert 1970)</div>

From the first, photographers made bold claims for themselves, as standard-bearers of the truth, and trumpeted the benefits their new art would shower upon mankind. Writers, on the whole, after the first shock of the invention had been absorbed, wasted little time on photography's marvels, rightly sensing that its disasters and pretensions would prove to be a happier

FIG. 8-13. Frontispiece design by Randolph Caldecott for the 1881 edition of Frederick Locker's *London Lyrics.* The scene illustrates the poem "Bramble-Rise," 1857.

hunting ground. Jokes familiar today, about the uneasy relationship between the photographer and the camera, became established early:

> Harris rushed for his camera, and of course could not find it; he never can when he wants it. Whenever we see Harris scuttling up and down like a lost dog, shouting "Where's my camera? Don't either of you remember where I put my camera?"—then we know that for the first time that day he has come across something worth photographing. Later on, he remembered that it was in his bag; that is where it would be on an occasion like this. (Jerome 1900)

Technical flaws in finished masterpieces were pounced on with purrs of delight. None was so common in early photographs as the blurring of a subject that simply would not stay still. Lewis

Carroll, himself a passionate photographer, knew exactly what was likely to go wrong in a landscape picture, and described it in "A Photographer's Day Out" (1860):

Eagerly, tremblingly, I covered my head with the hood, and commenced the development. Trees rather misty—well! the wind had blown them about a little; *that* wouldn't show much—the farmer? Well, *he* had walked on a yard or two, and I should be sorry to state how many arms and legs he appeared with— never mind! Call him a spider, a centipede, anything—the cow? I must, however reluctantly, confess that the cow had three heads, and though such an animal may be curious, it is *not* picturesque. However, there could be no mistake about the cottage; its chimneys were all that could be desired. (Gernsheim 1969b)

Much appreciated were feet, hands, and heads that seemed to swell up and fill the foreground of the picture (Fig. 6-12a). Even more heartless merriment was provoked by the disembodied foot, or arm, or elbow, the unwanted parts of some unwanted anatomy, left on a picture after careless trimming. Frederick Locker, a friend of Thackeray and popular minor poet in his own right, produced an engaging poem on the theme, first printed in 1872 (Locker 1884). Called "Our Photographs," it tells the sad story of a love affair between the narrator and his beloved, Di. All goes well at first, and they are photographed sitting together while he recites some of his own poems. This idyll is rudely shattered by the appearance of the insufferable Smith, who wins Di's fickle heart. With shameless disloyalty, she gives him the precious photograph, diplomatically doctored:

> I've seen it in Smith's pocket book!
> Just think! her hat, her tender look,
> Are now that Brute's!
> Before she gave it, off she cut

> My body, head and lyrics, but
> She was obliged, the little Slut,
> To leave my boots.

The portrait shown in Fig. 8-14 was made, to be sure, without humorous intent, but the fragment of the boot (bottom left) illustrates the lady's dilemma.

In the normal course of events, the most likely setting in which to spot such aggravating little flaws was that household bible, the family album. Lip-service was always dutifully paid to the power of photography to bind relatives together, but there was an awkward gap between theory and practice, and the wonderful new art could jar the harmony of any household. Lewis Carroll, in 1857, with a bow to Longfellow, rattled off "Hiawatha's Photographing" (Gernsheim 1969b), and caught the indignation of a family when they set eyes at last on the unfortunate photographer's masterpiece:

> Then they joined and all abused it,
> Unrestrainedly abused it,
> As the worst and ugliest picture
> They could possibly have dreamed of.

> Giving one such strange expressions—
> Sullen, stupid, pert expressions.
> Really anyone would take us
> (Anyone that did not know us)
> For the most *unpleasant* people.

It seems only fitting that the irresistibly imitable *Hiawatha* was itself inspired by a photograph. Longfellow was moved to write this poem after he was given a daguerreotype of the Minehaha Falls in Minnesota Territory, made in 1851 by Alexander Hesler of Chicago. Hesler went back to the Falls and made some salt prints of the scene from albumen and glass negatives (Naef 1975). These prints, in turn, were mounted in *The Photographic and Fine Art Journal* in 1857, accompanied by four lines from "The Song of Hiawatha."

FIG. 8-14. Censored Image. Portrait of a lady, right-hand side of a once larger picture. American, 1882. Unknown photographer. Gelatin silver print. Note the tip of the boot (*bottom left*), belonging to the lady's erstwhile companion.

Carroll's bravura performance is well-known, but there are many minor variations on the theme. A graceful contribution to *Punch* chooses the moment when mirth over other people's oddities turns to silence at the shock of meeting one's own awful younger self, caught in amber on the album page:

> And then before my scornful eye
> A smirking youth appeared,
> Flaunting a loose aesthetic tie
> And embryonic beard;
> With laughter I began to shake,
> Noting the watch-chain (weighty)
> And all the things that went to make
> A "nut" in 1880.
>
> I looked upon the other side,
> Still tittering, to see
> What branch the fellow occupied
> Upon our family tree;
> A name was scrawled across the card
> With flourishes in plenty,
> And lo! it was the present bard
> Himself at five-and-twenty.
> (Hodgkinson 1914)

Of all the portraits in a family album, baby pictures on occasion were the ones to cause the most distress. Everyone loved them, of course, so long as they were of somebody else. Daumier, in his 1847 cartoon, "Papa contemplant l'image de son image," shows a proud father beaming over a daguerreotype of his newborn son, but the question must be asked: would Papa have been smiling quite so broadly over a picture of himself, at such a tender age? Once they have grown up, babies tend to take a distinctly dimmer view of their own first portraits. To cringe in private is bad enough, but to blush in public is mortification indeed; family treasures and misguided love have much to answer for. That horrid social convention, the baby picture party, had become well established by the end of the century, and its arcane delights were celebrated

FIG. 8-15. The Fertile Egg. Cabinet-card montage made by James Thompson Bigler of Nebraska. March 31, 1896.

in the *Pittsburgh Morning Post* of March 14, 1897:

> The mother of a leader in Chicago society was asked to send the earliest photograph of her son, . . . a little card of her boy at the age of 3 weeks in a wash bowl. The mortified leader of society nearly fainted when he recognized his first picture, on view for 300 of Chicago's ultras. (Harris 1897; Weprich 1991)

The indignant gloom felt by any guest when forced to confront such evidence of a former self as shown, for instance, in Fig. 8-15 is easily understood, and deserves compassion.

To put the best face forward for the album record was everybody's goal: "You owe it to yourself and to your offspring . . . that no pressman's camera shall produce a picture . . . that can bring a flush of pleasure to the face of your worst enemy" (Jenkins 1911). Nature, unfortunately, was not always cooperative, and the camera could be unkind. Corrective measures were called for, and the photographer was pressed to forget about truth, and to remember all he had ever learned about the remedial powers of retouching. As one desperate customer declared:

> Well, I lack loveliness (and so do you),
> It is for that that I demand your skill.
> Art should create; where Nature's
> charms are few,
> It is for Art to show what She can do.
> (Dum-Dum 1913)

Alas, there is only so much improvement that even Art can manage to supply, and the poor, puzzled client may have to brace for double disappointment:

> Lately I gave the camera-man
> One last conclusive show:
> He was to trace my final face
> For after-men to know.
> The deed was done; I looked—and got
> A really nasty blow.
>
> Plump and highbrowed I knew I was,
> But not half-bald and fat.
> Those lines! That nose! Could they be
> those
> I wear beneath my hat?
> And, horrified, "Kind heavens!" I cried,
> "It can't have come to that!"
>
> Back went they; but next day arrived
> Still deadlier printed lies;
> A blasting sight! By day and night
> Their memory never dies.
> That Clapham Junction of a brow!
> Those bagged and bleary eyes!

And with them came a note that made
 Still worse his wanton act;
The earlier lot had given me what,
 Said he, my features lacked,
Till Art "re-touched". These latest showed
 The Unmitigated Fact.

 (Anon. 1913)

Not surprisingly, in the light of this tug-of-war, it was hard to deliver a decisive verdict in the vexed case of Reality Plain versus Reality Improved. Sadakichi Hartmann (1867–1944), novelist, dramatist, poet, and art critic, who wrote extensively about the American Photo-Secession movement (Hartmann 1978), addressed himself at one stage to the special problem of overpainting, with a lighthearted bow to the Bard:

A Monologue

To paint or photograph—that is the
 question:
Whether 'tis more to my advantage to
 color
Photographic accidents and call them
 paintings,
Or squeeze the bulb against a sea of critics
And by exposure kill them? To paint—to
 "snap":—
No more: and, by a snap, to say we end
The heartache, and the thousand natural
 shocks
That art is heir to—'tis a consummation
Devoutly to be wish'd. To paint—to snap;
Perchance to tell the truth:—aye! there's
 the rub.

 (Hartmann 1904)

In the nineteenth century, photography was a new element in society, but it did not long remain a strange one. With startling speed it left its mark on every branch of activity, intellectual, artistic, and practical, and scored the greatest success by transforming itself from a marvel into a commonplace. Once established as a permanent feature in the everyday world, it might be disliked, but it could not be ignored. Its very existence added new flavor and new forms to the human comedy, changed some details, but left the old ground-rules intact. No wonder humorists of every kind focused on this potent theme, and breathed a fervent "Thank you very much!" (Fig. 8-16).

FIG. 8-16. "Comic Physiognomist," by W. S. Gilbert, from "The Men We Meet" series in *Fun* 5, n.s. (May 18, 1867), p. 105.

Chapter 8 References and Notes

ABNEY, Sir William de W. (1898). In the *Jahrbuch für Photographie und Reproduktionstechnik,* Halle, p. 276.

ABNEY, Sir William de W. (1901). *A Treatise on Photography,* Longmans, Green & Company, London (10th edition), p. 171.

ANON. (1913). "Put to the Proof," *Punch,* July 9.

BEDE, C. (1855). *Photographic Pleasures, Popularly Portrayed with Pen and Pencil,* T. Mc'Lean, 26 Haymarket, London. 1973 reprint by the American Photographic Book Publishing Company, Inc., Garden City, N.Y., frontispiece and p. 18.

BERTALL (Charles Albert d'Arnoult). (1874). *La Comédie de Notre Temps,* E. Plon & Cie., Paris, pp. 445–64.

BRAIVE, M. F. (1966). *The Era of the Photograph,* Thames & Hudson, London, pp. 21, 69.

BRUCE, T. S., and BRAITHWAITE, A. (1913). *The Art of Retouching Photographic Negatives, etc.,* by Robert Johnson, Revised and Rewritten by Bruce and Braithwaite, Marion & Co. Ltd., Soho Square, London.

BULL, M., and DENFIELD, J. (1970). *Secure the Shadow; the Story of Cape Photography, from its Beginnings to the End of 1870,* Terence McNally, Cape Town, p. 120.

COLLINS, K. (1986). Personal communication, acknowledged with thanks.

COOPER, C. (1995). Personal communication, acknowledged with thanks.

DIAGE, K. V. (1980). Personal communication, acknowledged with thanks.

DUM-DUM (Major John Kendall). (1913). "To a Beauty Photographer," *Punch,* April 16.

GERNSHEIM, H. and A. (1969a). *The History of Photography,* McGraw-Hill Book Company, New York, p. 324.

GERNSHEIM, H. (1969b). *Lewis Carroll, Photographer,* Dover Publications, New York, pp. 116–17, 118–20, 125.

GIDAL, T. N. (1990). Personal communication, acknowledged with thanks.

GILBERT, W. S. (1970). *The Bab Ballads,* ed. James Ellis, Belknap Press, Harvard University Press, Cambridge, Mass., pp. 69, 322.

HARRIS, F. (1897). "New Form of Baby Show," *Pittsburgh Morning Post,* March 14, p. 27, cols. 1–2.

HARTMANN, S. (1904). "A Monologue," *Camera Work,* No. 6, April, p. 25.

HARTMANN, S. (1978). *The Valiant Knights of Daguerre,* University of California Press, Berkeley, Calif.

HENISCH, H. K. and B. A. (1994). *The Photographic Experience, 1839–1914; Images and Attitudes,* The Pennsylvania State University Press, University Park, Pa., pp. 55–60.

HENISCH, H. K. and B. A. (1996). *The Painted Photograph, 1839–1914; Origins, Techniques, Aspirations,* The Pennsylvania State University Press, University Park, Pa., chap. 3, fig. 3–1.

HODGKINSON, T. (1914). "A Time Exposure," *Punch,* June 17.

JACOBSEN, E. (1866). "Das Lied von der Photographie, in sechs Aufnahmen von einem Farbigen," published under the nom-de-plume "Anonymous," *Photographische Lieder,* Breslau. See also Koppen (1987).

JENKINS, E. (1911). "Pose-Culture," *Punch,* August 9.

JEROME, J. K. (1900). *Three Men on the Bummel,* Penguin Books, Harmondsworth, Middlesex, U.K. 1984 reprint, chap. 8.

KINGSLEY, C. (1857). *Two Years Ago,* 1899 edition by J. F. Taylor & Company, New York, p. 182.

KOPPEN, E. (1987). *Literatur und Photographie; über Geschichte und Thematik einer Medienentdeckung,* J. B. Metzler, Stuttgart, Germany.

LOCKER, F. (1857). "Bramble-Rise," in *London Lyrics,* publisher unknown, Privately printed at the Chiswick Press, London, 1881.

LOCKER, F. (1884). "Our Photographs," in *The Poems,* White, Stokes & Allen, New York, pp. 241–42.

MUDD, J. (1866). *The Collodio-Albumen Process,* London (Publisher unknown).

NAEF, W. (1975). *Era of Exploration,* Albright-Knox Art Gallery, Buffalo, N.Y., p. 20.

PALMQUIST, P. E. (1990). *Shadow Catchers; A Dictionary of Women in California Photography Before 1901,* Palmquist, Arcata, pp. 72, 140.

PALMQUIST, P. E. (1991). Personal communication, acknowledged with thanks.

SCHÜRER, E. (1991). Personal communication, acknowledged with thanks.

STENGER, E. (1938). *Die Photographie in Kultur und Technik,* Verlag E. A. Seemann, Leipzig, p. 179.

WEINTRAUB, S. (1987). "Utopia, Limited," *History of Photography,* Vol. 11, No. 3, p. 236.

WEPRICH, T. (1991). Personal communication, acknowledged with thanks.

WILSHER, A. (1985). "The Potters and Photography," *History of Photography,* Vol. 9, No. 3, pp. 223–25.

INDEX